Frances Pheasant-Kelly is Senior Lecturer in Film Studies and Course Leader for the MA in Film Studies at the University of Wolverhampton. She holds a PhD in Film Studies from the University of East Anglia and is the author of *Fantasy Film Post-9/11* (2013).

ABJECT SPACES IN AMERICAN CINEMA

Institutional Settings, Identity and Psychoanalysis in Film

FRANCES PHEASANT-KELLY

I.B. TAURIS

LONDON · NEW YORK

Published in 2013 by I.B.Tauris & Co Ltd
6 Salem Road, London W2 4BU
175 Fifth Avenue, New York NY 10010
www.ibtauris.com

Distributed in the United States and Canada Exclusively by Palgrave Macmillan,
175 Fifth Avenue, New York, NY 10010

International Library of Cultural Studies 18

ISBN: 978 1 84885 597 7

A full CIP record for this book is available from the British Library
A full CIP record for this book is available from the Library of Congress

Library of Congress catalog card: available

Camera-ready copy edited and supplied by
Oxford Publishing Services, Oxford
Printed and bound by CPI Group (UK) Ltd, Croydon, CR0 4YY

Contents

Acronyms and Abbreviations

BFI	British Film Institute
CCTV	closed circuit television
ECT	electroconvulsive therapy
EEG	electroencephalogram
ICU	intensive care unit
IMDb	Internet Movie Database
JFK	John F. Kennedy
OR8	operating theatre in *Coma*
SAIS	School of Advanced International Studies
USMC	United States Marine Corps

Acknowledgements

I am grateful to a number of people who have helped in the production of this book. I am especially indebted to Mark Jancovich for his inspiration and encouragement. In addition, my thanks go to the University of Wolverhampton for its extensive support. In particular, I wish to thank my Film Studies' colleagues, Eleanor Andrews, Stella Hockenhull, Ken Page, and Pritpal Sembi for their helpful advice. Thanks also go to Michael Kelly for his support and to Lance Hanson and Scott Martin for their valuable insights. I am particularly grateful to Jason and Selina Cohen for their invaluable editing assistance. Finally, my sincere thanks go to Jenna Steventon and the team at I.B.Tauris, especially Maria Marsh.

Introduction: Institutions, Abjection and Subjectivity

Fictional films set in institutions invariably feature scenes of violence, suicide, cruelty or escape, which seems inconsistent with the usual orderliness of real life institutions. Inevitably, however, the excessive control that pervades the on-screen institute leads to visual chaos and narrative disruption. These traits seem universal to the American institution film, the 'institution film' being, for the purposes of this book, one in which the institution is central to narrative organization. Indeed, such patterns of transgression appear regularly throughout the genre's well-established history, especially in films set in asylums and prisons. It is therefore relevant to diverge from typical Foucauldian analyses of the institution, which tend to focus on order, regulation and panoptic modes of surveillance, to a theoretical model that centres on the implications of repression. Julia Kristeva's theory of abjection[1] provides such a model, which I utilize in this book to explain how fictional institutions order space. Since this approach challenges Foucauldian perspectives, I also consider any tensions that arise between these two apparently opposing viewpoints.

In general, the chaos that emerges in fictional institutions is a consequence of attempts to regulate socially, remould, or 'break' the identity of the inmate. Sometimes this is achieved through seemingly innocuous regimes of drug administration, or often through more radical measures that may involve overt brutality, extended solitary confinement (the 'hole' features regularly in prison narratives) or intrusive surveillance. These aspects are important in providing narrative interest to what would otherwise

1

be mundane and highly repetitive scenarios, though at times they may reflect the practices of real institutions.

In many ways, the filmic institution assumes a parental role, controlling not only the physical body through drugs and pre-scribed body movement, but also returning the inmate to an essentially infantile psychosexual state. This results from restric-tions to conversation, limitations to private space or enforced uniformity of clothing (or even a lack of clothing). Frequently, it stems from the repression of sexual desire. Such suppression of individuality usually leads to inmate resistance and efforts to break away from the institution. Therefore, the institution's highly repressive and regulated spaces are prone to rupture, with any compromise to identity generally leading to efforts to reclaim it.

These characteristics are typically found in *One Flew Over the Cuckoo's Nest* (1975) directed by Milos Forman, a film that sees its protagonist, Randle McMurphy (Jack Nicholson), a psychiatric inpatient, undergo electroconvulsive therapy (ECT) for no apparent good reason. In fact, Head Nurse Ratched (Louise Fletcher) implements this therapy merely because McMurphy resists her cruel, controlling practices, causing McMurphy to suffer irreversible brain damage. As an act of compassion, Chief Bromden (Will Sampson), a friend and fellow patient, suffocates McMurphy, breaks down the window of the asylum and escapes. His escape signals the culmination of many years of repression within the asylum under the dominating rule of Nurse Ratched. This repres-sion is largely attributable to her inflexible and controlling regime, which she achieves through the administration of various alleged forms of 'treatment' such as group therapy, medication and ECT. Ratched further exercises her power through the oppressive sur-veillance of the patients, but also operates at a more subversive level, regulating their privileges, repressing their libido through drugs and generally suppressing all aspects of individuality. As a result, the patients exhibit infantile characteristics, suggested

2

through various aspects of the *mise-en-scène*. They are often seen wearing only white underwear, are susceptible to frequent tantrums, and their physical stature and behaviour, especially of Martini (Danny DeVito) and Cheswick (Sydney Lassick), are childlike. Their infantilism is also represented through problems mastering speech; Chief Bromden is apparently 'deaf and dumb' and Billy Bibbitt (Brad Dourif) speaks with a pronounced stutter, while the rest of the group seem mostly reluctant to say anything during group therapy sessions.

Ratched manifests as a monstrous version of femininity, signified visually by her twin-horned hairstyle and cold, unblinking eyes. Indeed, in the spectator's first visual encounter with Ratched, she appears in a flowing black cape and black hat. In marked contrast, McMurphy, who resists her controlling practices, seems humane and compassionate and, despite being a convicted rapist, easily gains the spectator's sympathies. He remains the sole figure of adult masculinity on the ward, suggested by the fact that he is the only patient to wear his own clothes, a typical means of expressing an individual, gendered identity. His masculinity is also emphasized physically (he escapes by scaling a high barrier), and he has been incarcerated because, as he claims, '[he] fight[s] and fuck[s] too much'. Indeed, he becomes a father figure to the other patients and encourages them to engage in experiences that develop their masculine egos. McMurphy is not merely the good father but becomes almost a Christ-like figure, helping the patients overcome their various social inadequacies. Although Ratched's efforts to control McMurphy and repress his sexuality repeatedly fail, she still exerts a strong influence over the other patients, particularly Billy Bibbitt.

The repression that the patients undergo leads inevitably to points of rupture; either they escape from the institution or are given to irrational, temperamental outbursts or, more significantly, murderous or suicidal actions. These disorderly episodes, however, also generate pleasure and lead to liberating events that encourage masculine activities related to adulthood, such as the fishing trip.

The party is another significant occasion at which the patients' experiences of alcohol and sex, including Billy's first sexual encounter, transiently transform their lives. These incidents are positive because they alleviate repression; even Billy Bibbitt's stammer temporarily disappears because of his newfound sexuality. The physical transgression of boundaries also relieves tension, exemplified when McMurphy breaks the glass of the nurses' station to retrieve Cheswick's cigarettes in an attempt to pacify him during one of his many tantrums. The violation of the nurses' station anticipates the final point of release when Bromden hurls a hydrotherapy unit through the asylum window and subsequently escapes. Renewed repression by the monstrous Ratched, however, brings about abjection and chaos, as Billy kills himself and McMurphy tries to strangle Ratched. The narrative revolves around these episodes of repression and transgression, which provide transient relief or pleasure, but also lead to abjection.

One Flew Over the Cuckoo's Nest exhibits many features common to the institution film, especially in its inclination to disruption. Apart from such commonalities of theme, figure behaviour and narrative pattern, the fictional institution also tends to possess distinctive spatial qualities. In addition to a system of highly regulated spaces that are subject to various levels and means of control, a network of underground tunnels often underlies the formal, visible architecture, these sometimes resembling the interior convoluted nature of the physical body. In other cases, the labyrinthine workings of the institution may reflect the pathologically or criminally disturbed mind, or the primitive nature of the id. Despite these connotations, however, descent into the underground passages, secret tunnels and sewers of the institution frequently provides a temporary reprieve from the intense surveillance that dominates the upper levels, as well as offering a means of escape. Indeed, escape features prominently in the fictional institution though there are times when the individual becomes institutionalized and is reluctant to leave its

4

comforting security. The desire to escape has parallels with the infant's desire to separate from the maternal body and again suggests the parental nature of the institution. Overall, these various aspects of the institution film and its tendency for disorder are consistent with Kristeva's[2] theory of abjection, which has multiple meanings but chiefly centres on the abject world of the infant and its subsequent striving for a coherent subjectivity.

Kristeva is one of the key exponents of abjection and discusses its various manifestations in *The Powers of Horror* as well as in some of her later works. Abjection, according to her, arises from the process of a child becoming autonomous of his or her mother. Rejection of the maternal body constitutes one form of abjection, but the child also begins to recognize and exclude various sources of bodily contamination. These include the detritus of the body, particularly bodily fluids and excrement, but they may extend to other forms of 'difference'.

Indeed, in this book I contend that the institution film is an obvious site for abjection, with such notions becoming pertinent immediately one perceives the institution as a place that separates normal from other. This exclusion of 'otherness' takes place on a significant scale in Western society, with the insane, criminal and sick allocated to specific sites. Despite a recent reversal in this trend, film still makes much of the institutionalization of the aberrant mind and body (though, occasionally, films such as *A Beautiful Mind* (2001) break with this pattern). It follows that filmic spaces concerned with separating out aspects of aberration, namely the institution, would be appropriate places in which to locate abjection.

Kristeva's study of abjection has a number of influences. It engages primarily with the earlier ideas of anthropologist Mary Douglas,[3] who discusses abjection in the context of the taboos and rituals of ancient cultures. In her seminal work, *Purity and Danger*, Douglas elaborates on religious abominations associated with 'unclean' food, and the ritualizing of certain impure fluids such as

quote

blood in sacrifice, as well as the importance of bodily margins, orifices and their vulnerability to impurity. Kristeva incorporates Douglas's notion of 'purity and danger' within her own account of abjection, attributing its source to all that threatens integrity of the self. For Kristeva, this similarly includes the detritus of the body but especially 'excrement and menstrual [blood]'.[4] Like Douglas,[5] she further identifies the exclusion of certain foods and religious abominations as ways to sustain a 'clean and proper body'. The ultimate threat for Kristeva is the corpse;

> the corpse, that which has irremediably come a cropper, is cesspool, and death ... if dung signifies the other side of the border, the place where I am not and which permits me to be, the corpse ... is a border that has encroached upon everything. It is no longer I who expel, 'I' is expelled.[6]

She also describes how involuntary bodily actions that arise in reaction to encountering the abject, such as gagging at the skin on the surface of milk, are ways of protecting the self from contamination. Indeed, like Douglas, Kristeva focuses on excluding the abject through maintaining homogeneous boundaries. Consequently, any transgression that 'disturbs identity, system, order',[7] and that 'does not respect borders, positions, rules',[8] is liable to abjection. Her delineation of the abject thus includes examples such as 'the traitor, the liar, the criminal with a good conscience, the shameless rapist, the killer who claims he is a saviour'.[9] Maternal abjection is a particularly important facet of her work, Kristeva noting how,

> the abject confronts us ... with our earliest attempts to release the hold of maternal entity even before existing outside of her, thanks to the autonomy of language. It is a violent, clumsy breaking away, with the constant risk of falling back under the sway of a power that is securing as it is stifling.[10]

The ultimate separation is childbirth, Kristeva describing the 'desirable and terrifying, nourishing and murderous, fascinating and abject inside of the maternal body'.[11]

Kristeva's views on the abject feminine body have elicited significant debate in film studies. One of the key theorists relevant to such discussion is Barbara Creed, who examines a number of films, mostly of the horror genre, in relation to what she terms the 'monstrous-feminine'. She defines certain key areas in which the horror film draws on notions of abjection, namely the soulless corpse, the transgression of the border and the abject mother, but it is the latter that engages the attention of most of her arguments. In her essay about *Alien*, she describes a *mise-en-scène* of 'womb-like imagery' in 'the long winding tunnels leading to inner chambers, the rows of hatching eggs, the body of the mother-ship'.[12] Creed asserts that the horror of the *Alien* monster therefore relates to the feminine body and that the abject mother manifests in a number of ways;

> she is there in the text's scenarios of the primal scene of birth and death; she is there in her many guises as the treacherous mother, the oral sadistic mother, the mother as primordial abyss; and she is there in the film's images of blood, of the all-devouring vagina, the toothed vagina, the vagina as Pandora's box; and finally she is there in the chameleon figure of the alien, the monster as fetish object of and for the mother. But it is the archaic mother, the reproductive/generative mother, who haunts the *mise-en-scène* of the film's first section, with its emphasis on different representations of the primal scene.[13]

Creed goes on to consider various aspects of 'the monstrous feminine' in a range of horror films, including *The Exorcist* (which Friedkin directed in 1973) and *Carrie* (directed by De Palma in 1976). While she therefore tends to reduce the abject to negative

7

representations of the feminine body, her work is highly significant, as it has brought the concept of abjection, previously limited to literature and language, into the sphere of popular culture.

Creed is not unique in her connection of spaces of horror with the feminine body. Indeed, uterine metaphors abound in theoretical analyses of film spaces, especially those with negative connotations, which often bring up Sigmund Freud's study of the uncanny. Freud is another important influence on Kristeva, and her concept of abjection, while primarily drawing on Douglas's *Purity and Danger*, also has some obvious parallels with Freud's study of 'The Uncanny'.[14] 'The Uncanny' is one of the most significant works in the field of psychoanalysis concerning uterine metaphors, and usually informs related studies. While Freud identifies different forms of uncanniness, feelings of unease generated by examples such as the ghost, the double, and the automaton, he argues that the original 'home', the mother's body, may also be considered uncanny, or '*unheimlich*'. He suggests that it is a 'forgotten' place (through repression of traumatic memories) but still familiar. Because of its association with trauma and castration anxiety, Freud asserts that the uncanny 'is undoubtedly related to what is frightening – to what arouses dread and horror'.[15] In film studies, therefore, there are often links between the uncanny house in film and uterine imagery, with certain spaces having particularly traumatizing connotations, especially the cellar and the attic. These spaces are usually sites of fear, especially in the horror genre, with violation of the home forming part of the genre's recurring iconography. It is hence logical that theorists such as Creed should also forge links between the horror genre and uterine imagery in discussions of abjection. Indeed, there are numerous cinematic examples of these, including, among many others, *The Birds* (1963); *Girl, Interrupted* (1999); *L.A. Confidential* (1997); *Misery* (1990); *Presumed Innocent* (1990); *Psycho* (1960); *Shallow Grave* (1994); *The Silence of the Lambs* (1991); and *The Virgin Suicides* (1999). Clearly, Freud's writings on the uncanny are closely aligned

with abject space, and several theorists besides Creed[16] explore the links between maternal imagery and abject or uncanny space. In one example, Laura Mulvey[17] demarcates the cellar as an abject space in her description of Lila's (Vera Miles) exploration of the Gothic house in *Psycho*. Referring to the myth of Pandora's Box as an analogy for inner female space, she asserts that, 'it is the female body that has come, not exclusively, but predominantly to represent the shudder aroused by liquidity and decay'.[18] Also referring to *Psycho*, Slavoj Žižek[19] aligns the three levels of the Gothic house with the id, ego and superego, the cellar representing the id as a repository of basic instincts. Michael Fiddler,[20] in his study of *The Shawshank Redemption*, argues that the prison represents a uterine uncanny space from which Andy Dufresne is reborn. Brian Jarvis,[21] like Fiddler, posits the prison as a 'maternal vessel'[22] while Elizabeth Young[23] likens abject space to the female body in her analysis of *The Silence of the Lambs*.

Although there are close associations between abject and uncanny spaces, Freud's view of the uncanny as a repressed, traumatic memory does not incite the same degree of revulsion encountered in Kristeva's version of repression. Kristeva herself notes, 'essentially different from "uncanniness" more violent, too, abjection is elaborated through a failure to recognize its kin; nothing is familiar, not even the shadow of a memory'.[24] Furthermore, the abject's threat of re-emergence requires constant vigilance to keep it in place. This is unlike Freud's study in which uncanny memories may remain repressed.

However, it is important to note that while bodily fluids and disgust constitute a distinctive and essential aspect of abjection, this is not the sole focus of Kristeva's use of the term. Despite the tendency for previous filmic analyses to deploy the term 'abjection' in relation to the horror and science fiction genres, Kristeva neither limits notions of abjection to the visceral body nor ties it to a particular genre. Rather, for her, the central meaning of abjection emerges in relation to subjectivity and the transition to an adult identity. The use

of abjection in this book is therefore distinct from previous inter-
pretations because it considers Kristeva's concept of the abject in
relation to subjectivity and space. Since threat to identity is a
consistent theme within the fictional institution, in this book I argue
that institutional spaces in film are intrinsically liable to abjection.

Here, the use of the term abjection is distinct in several other
ways. For example, Kristeva[25] specifies that abjection may be asso-
ciated with mental illness, in particular during the recovery from
borderline personality disorder. Yet studies on the issue of mental
illness or abjection in film have not explored this aspect. Second, in
this book I directly apply Kristeva's concept of abjection to the area
of theology as well as including an attention to ritual as an essential
feature of abject space. These are important areas of Kristeva's work
in which she explains how the Bible and the Virgin Mary[26] are closely
linked to abjection, stressing the importance of rites to sanctify the
abject. A third aspect of abjection that demands closer analysis is
racism. This is a significant subject to Kristeva in that she refers to it
through the work of Céline and implicates it in several of her other
works, including *Strangers to Ourselves* (1991), and *Nations without
Nationalism* (1993). Although racism as a form of abjection is well
documented in the literature, there has been, as far as I am aware, no
discussion of its manifestation in the institution film to date.

Furthermore, this study is also distinct in that it broadens
Kristeva's original concept in arguing that old age and end-of-life
trajectories are abject. This dimension has clear parallels with an
infantile lack of subjectivity, but it is one that Kristeva fails to
address and is also an area that film studies has generally neglected.

Finally, while Kristeva suggests that the abject is not only intrin-
sically fascinating but also essential to the maintenance of sub-
jectivity, previous critical analysis largely tends to ignore this facet. I
contend that within the institution film, abject space is generally a
site of liberation or catharsis and may therefore have positive
effects. Moreover, I suggest that representations of abjection may

manifest not only within the *mise-en-scène*, but also through cinema-tography, music, language and the use of text. Music and language are important elements of Kristeva's transition from semiotic to the symbolic (which involves maternal abjection) but have not been considered previously in relation to fictional film or films set in institutions.

In short, I propose a broader application of abjection than has previously been the case. This is not to say that it is a generalized concept or that it may arise in all types of films. Rather, abjection emerges in films in which space, institutions and subjectivity inter-sect. Because the threat to subjectivity is a significant feature of the 'institution film', both through exclusion from society and through restrictions to personal space, dress, sexuality and behaviour, it is an appropriate context in which to consider space as abject.

Fundamental to the institution film and the concept of abjection is the boundary. Boundaries are important to any spatial analysis but are particularly salient to the development of subjectivity, having socio-cultural as well as psychosexual implications. In the context of everyday life, boundary maintenance is intrinsic to the social and cultural development of the individual, and constitutes part of what Norbert Elias[27] terms a 'civilising process'. While Elias describes this process in the broader context of its evolution since the Middle Ages, he also discusses it in terms of the contemporary individual. He explains how self-discipline of the body is learnt through socializing processes adopted from the habits and con-straints of the parents, and is usually marked by the passing from infancy through to adulthood. The civilizing process is concerned with repressing certain aspects of the self, predominantly those concerned with bodily function that may incite disgust, as well as public displays of emotion. Elias notes that 'with this growing divi-sion of behaviour into what is and what is not publicly permitted, the psychic structure of people is also transformed. The prohi-bitions supported by social sanctions are reproduced in individuals

11

as self-controls'.[28] The child's development is discernible in a growing awareness of bodily functions and a sense of shame or privacy associated with these, manifesting in the demarcation of boundaries and the segregation of specific spaces for these functions.

For David Sibley[29] too, boundaries are important, though his work deals with exclusion of marginalized groups rather than the activities of the individual. He engages directly with Kristevan theory in the context of peripheral urban space, which he claims is unstable and liable to transgression. Thus, while Douglas and Kristeva's analyses of the boundary tend to centre on the body and its exclusion of contaminating substances, Sibley extends these ideas to margins and borders within the field of cultural geography. He states that homogeneous, uniform spaces are pure, while peripheral spaces, because of their borderline status, are liable to incursion by marginalized groups that are perceived of as contaminating or dangerous. Consequently, while borders and frontiers are sites of exclusion, they have a tendency to abjection. Referring to Kristeva and Douglas,[30] Sibley asserts that

> difference in a strongly classified and strongly framed assemblage would be seen as deviance and a threat to the power structure. In order to minimize or to counter threat, the threat of pollution, spatial boundaries would be strong and there would be a consciousness of boundaries and spatial order. In other words, the strongly classified environment is one where abjection is most likely to be experienced.[31]

He argues that powerful groups attempt to purify space by the construction of socio-spatial boundaries and claims that sites where such separation is difficult 'create liminal zones or spaces of ambiguity and discontinuity. ... For the individual or group socialized into believing that the separation of categories is necessary or desirable, the liminal zone is a source of anxiety. It is a zone of abjection.'[32]

12

In exploring various images of difference, Sibley notes how certain groups have been interchangeably linked together to encompass notions of defilement, and that 'today, disease, homosexuals and Black Africans have been similarly bracketed together'.[33] Moreover, he extends the link between difference and place to that of nature/culture, asserting that 'relegating dominated groups to nature – women, Australian Aborigines, Gypsies, African slaves – excludes them from civilized society.'[34] Sibley also attempts to apply such concepts within a filmic context, citing *Taxi Driver* (Scorsese, 1976) as an example, wherein prostitutes are a similarly excluded group. His work is not only germane to a study of institutions as sites that also involve exclusionary practices, but also to elements of racism found in one of the films examined in this book.

Part of a child's development is concerned with recognizing not only the importance of spatial boundaries, but also boundaries the body determines in the processes of sphincteral training and bodily hygiene. Such development relates to what Freud[35] terms anal control with psychosexual development being marked by a concern with bodily orifices. He asserts that in the adult, there is a repression of unconscious desires, which are usually of a sexual nature, and these often threaten to re-emerge. The child works through various stages of these archaic desires in its psychosexual development. These include the oral, anal and genital stage. The child must go through these stages and ultimately relinquish its mother to take up his or her normal adult place in society, but may become fixated at any of these stages. In the context of this book, an individual must similarly separate him- or herself from the maternal body of the institution, or work through abjection to achieve a coherent adult identity. Otherwise, he or she may remain fixated at a particular stage of development. Thus, Freud's description of the relationship between bodily control and subjectivity has commonalities with Kristeva's[36] discussion of abjection.

There are therefore similarities and overlaps between theoretical

approaches to the transition from childhood to adulthood and the appropriation of certain socio-cultural habits and rituals. However, Kristeva's theory has a broader focus on notions of boundary formation. The boundary for her takes account of such diverse subjects as the deviant mind, the borderline personality, the decay of flesh and childbirth. Further, Kristeva's demarcation of maternal abjection depends on a distinction between what she terms semiotic and symbolic forms, best exemplified through the acquisition of language. According to Kristeva, the semiotic refers to the early stages of the maternal world and the symbolic to the paternal sphere. The transition from one to the other is contiguous with the acquisition of language. This broadening of psychosexual development thus extends well beyond the socializing processes that Elias suggests. While in this book I acknowledge the significant influence of Freud's work on Kristeva's study and will engage with it as appropriate, her attention to the border remains central to a consideration of space and subjectivity within the institution film.

The significance of the boundary to the institution film is usually evident, either narratively or visually, in its opening scenes. One of the key shots of the prison narrative is a sense of overwhelming separation from the outside world when the prisoner first crosses the threshold of the prison. This is apparent either through the sound of (usually large) gates closing or, typically, as in *The Shawshank Redemption* (1994, directed by Frank Darabont), the protagonist's point of view as he looks upward at the dominating entrance portal. The organization of an institution is also emphasized, with the spectator usually made aware of its spaces through the protagonist's point of view. In filmic institutions, these spaces are predisposed towards a specific narrative function, though, in most cases, they still cohere to a generically panoptic model.

The panoptic model has been a central apparatus of the institutional age and it directly informed Michel Foucault's[37] analysis of the real institution. Foucault considered the ways in which the

institution regulated bodies through its physical construction, and therefore established a relationship between space and control. While institutions are spaces implicitly concerned with the enforced discipline of the body, Foucault[38] suggests that the typical panoptic structure of the institution also encourages internalized disciplinary processes; because prisoners do not know exactly when they are being observed they adjust their actions anyway (much in the same way that speed cameras operate). In films, this panoptic model may vary to accommodate the narrative, in some cases overtly emphasizing the disciplinary gaze, or in others focusing on the isolating features of institutional space. Some films may neglect the panoptic arrangement altogether, and instead negotiate the many, commonly labyrinthine, spaces of the institution as a way of propelling the narrative (and characters) forward.

In certain films, this mode of surveillance may be overlaid with genre dependent inflections such as the Gothic architecture of the prison and asylum in *The Shawshank Redemption* and *Girl, Interrupted* (1999). In futuristic films, we may see it replaced by digital surveillance, evident in the prisons of *Fortress* (1993, directed by S. Gordon) and *Minority Report* (2002, directed by Steven Spielberg). However, the fundamental concept of regulation through monitoring still persists.

In considering Foucault's analysis of institutions in combination with a psychoanalytic approach to interpreting film, a number of tensions arise. Fundamentally, these two approaches are opposed. Not only do they constitute essentially different modes of analysis, but they are also polemical in content and nature, with one concerned with uniformity and the other with aberration. Kristeva's theory of abjection considers both gender and race, and Freud focuses on sexuality and gender, while Foucault's work on institutions appears impartial to all these aspects. Moreover, Foucault centres on the collective body and the environment of the institution, while Kristeva and Freud focus on the individual in relation

to the maternal or parental world. For Foucault, generalized surveillance, physical coordination and knowledge govern the institutional body, while Kristeva's maternal world is concerned with mapping the abject, corporeal body.

These two approaches are further dissonant in that Foucault is a critic of Freudianism and though Foucault's concerns with ordering and discipline are similar to those of Freud and Kristeva, his ideas are essentially anti-psychoanalytic. For Foucault, Freudianism is rooted in a repression of sexuality, with perversion resulting from repression. In contrast, Foucault considers power to be a productive phenomenon, creating efficient, ordered subjects. The bringing together of two apparently irreconcilable approaches thus has various implications.

In this book I aim to correlate these two divergent approaches in relation to certain filmic contexts, since, though order and conformity may underpin real institutions, this is not the case in their filmic counterparts. Fictional film is more interested in aberration and, indeed, such aberration commonly underlies conventional narrative patterns. Where these approaches converge is in the control exerted through surveillance, knowledge and space. These aspects of control, in line with Foucault's reasoning behind real institutions, aim to reduce aberration and encourage uniformity. However, in institution film narratives, excessive or even sadistic control generates narrative disorder. Such disorder generally arises in the reclamation of space, subjectivity and, often, liberation from the institution. Frequently, these involve the struggles of the individual against the institution. Narrative films therefore tend to be concerned with individuals, witnessed through devices that enable the spectator to identify with the protagonist, as in the use of close-up and point-of-view shots and voiceover. This is not to say that some films disregard the collective body, but that, in general, a focus on one or more key characters characterizes mainstream narrative film. Further, studies of the examples used in this book show that gender and race are

significant in relation to the institution film and both are implicated in abjection. Finally, while institution narratives show evidence of a surveillant gaze closely associated with the maintenance of order, this often entails sexual desire. This desire is sometimes homoerotic in nature and usually coupled with sadistic impulses. Such a gaze therefore relates more to Freudian than Foucauldian perspectives. Even where fictional institutions appear to conform to a Foucauldian model, they seem inherently susceptible to disarray and breakdown.

Ultimately, therefore, it is possible to consider Foucault's view of power as a way of ordering disorder. While his approach is not overtly repressive, it has parallels with Freudian psychoanalysis in that it entails an element of control. A repeated narrative in Foucault's work is of a vital, chaotic, exciting world that is constantly under restraint. He makes frequent reference to the other as deviant, strange and occupying spaces (heterotopias) that are separate from the 'normal' world.[39] Therefore, while Freud and Foucault may appear incompatible, there is common ground in the way they link control to the pathologicalization of difference. In a sense, Foucault is obsessed with the abject and uses space and hygiene as an attempt to distinguish between normal and other. In short, Foucault rejects the Freudian model of repression but still maintains a concern with systems of order as a mode of 'containing' the inherently chaotic.

Despite acknowledging parallels between Foucault and Freud, in this book I conclude that, while the films discussed here emphasize Foucault's ideas on power, in fictional institutions disorder rather than order prevails. A useful example of this is the uniform display of apparently healthy bodies at the Jefferson Institute in *Coma* (1978) (discussed later in this book, see Figure 1). This scene demonstrates the convergence of the ideas of Foucault and Kristeva, since the highly controlled and uniformly arranged bodies are subjectively 'dead' and exist at the border between life and death.

In summary, the 'institution films' discussed in this book initially

appear to conform to Foucault's model of discipline, but ultimately they demonstrate that constrictions of space, intrusive surveillance and knowledge of the individual fail as control mechanisms. The resultant reclamation of space relates to abjection in several ways. Space may be abject in that it involves either a return to a symbolically uterine state, or loss of subjectivity. Alternatively, the institution may function as a controlling maternal body, an aspect that may dictate the expression of the *mise-en-scène*. Further, the space itself may have links with death or decay or with premeditated cruelty. Thus, while Foucault is commonly associated with institutions, this work reappraises his ideas in relation to fictional institutions and shows that repression of autonomy arising from excessive control leads to the production of abject space.

In this book I thus analyse film texts about institutions using Kristeva's theory of abjection. I explore a range of settings, from total institutions[40] such as the prison, to everyday institutions such as the school and family, looking at how they give meaning and order space. The films analysed here include *Bubba Ho-tep* (2002), *Carrie* (1976), *Coma* (1978), *Full Metal Jacket* (1987), *Girl, Interrupted* (1999), *The Last Castle* (2001), *Lock Up* (1989), *Remember the Titans* (2000) and *The Shawshank Redemption* (1994). The choice of films rests on their setting being wholly or predominantly in institutions and on the latter being central to narrative progression. There are several other criteria for the selection of examples to be included in this analysis. First, to avoid discrepancies in visual representation arising through differences in culture and censorship, I create focus through nationality rather than conduct a generalized survey of institutions in film. Second, I also restrict the period of the films' production to avoid similar variance associated with cultural shifts, production codes and restraints over time. Cinematographic conventions and technological developments that change with time may also affect modes of representation.

Since abjection is a consistent feature of the 'institution genre', I

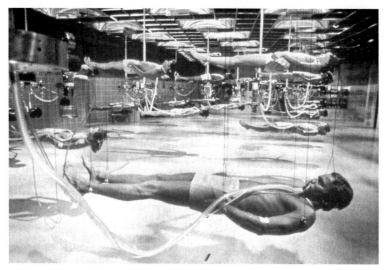

Figure 1 *Coma* (Michael Crichton, 1978) © Turner Entertainment Co. A Warner
Bros. Entertainment Company. All Rights Reserved.

could have included earlier institution films, well-known examples
being *The Great Escape* (1963), *The Birdman from Alcatraz* (1962), *The
Snake Pit* (1948) and *Papillon* (1973). However, for reasons of con-
sistency as stated above, and because censorship laws now allow for
more explicit representation of abjection, I have limited this variable.

I therefore refer to American films from the 1970s to the present
to focus on a national context and limited period of production.
Establishing these limits allows one to examine a wide variety of
films in relation to significant variables such as type of institution,
gender and aspect of abjection. The most important element in the
choice of films related to genre and type of institution. The films
here represent a series of different institutional spaces and extend
across various genres, ranging from horror, science fiction,
melodrama and action through to the prison film. Crucially, they
illustrate diverse aspects of abjection. Further, these films include a
range of texts about masculinity and femininity in which abjection is
generally associated with the institution as a feminized, maternal

space from which a man has to escape or, on occasion, a mascul-inized, patriarchal space that oppresses women.

This book is divided into three sections. The training institution is examined first, and includes the films *Carrie*, *Full Metal Jacket* and *Remember the Titans*, which address either the marginalization of the feminine body, the emasculated body or the racial body. In the second section I analyse *The Shawshank Redemption*, *Lock Up* and *The Last Castle*, which are all penal institutions. These represent three different kinds of prison and modes of discipline – rehabilitation in *The Shawshank Redemption*, brutality in *Lock Up*, and a dependence on intrusive surveillance in *The Last Castle*. In the third and final section I examine the care institution and consider the boundary as a source of abjection. Here, *Coma* is concerned with the border between life and death, *Girl, Interrupted* centres on the border between madness and sanity and *Bubba Ho-tep* examines the diseased male reproductive body.

In the conclusion I suggest that the concept of abjection in the institution film addresses many of those aspects that Kristeva discusses in *Powers of Horror* while also asserting that Kristeva's theory has some limitations. In addition, I acknowledge the potentially positive aspects of the abject; a point that emerges from this study is the political message apparent in most of the films. Certainly, several of the films examined comment adversely on aspects of the individual institution. This implicates a politicized dimension in the way that institutional spaces are represented. Finally, I conclude that in scenarios where repression exists, the abject always threatens to emerge and therefore suggests the inevitability of abject space in institutional settings. In effect, this book is intended to demonstrate and explain the representation of such abject spaces within fictional institutions.

PART I

BECOMING A MAN/WOMAN: SPACES OF TRAINING

According to Kristeva, abjection is a necessary part of the process of attaining coherent subjectivity. Logically, therefore, institutions that contribute to the development of a coherent adult identity provide ideal opportunities for examining abjection. Places of training abound in cinema, ranging from films of the high school genre to those set in the military boot camp, and are sites that address the individual's various physical, social or educational aspirations. Here, a range of genres, including *Carrie*, *Remember the Titans* and *Full Metal Jacket*, illustrates how the transition to adulthood leads to the production of abject space.

In general, Foucauldian analysis dominates scholarly accounts of the institution in relation to training and education. Foucault describes how 'rank' begins to define the great form of distribution of individuals in the educational order – rows or ranks of pupils in classrooms, corridors and courtyards[1] – and asserts that this homogenization was a direct result of a number of disciplinary processes that aimed to render the body 'docile'. These included adherence to a timetable, the correlation of body and gesture, and exhaustive use of the body within space as ways of exercising order and maximizing efficiency. As a result, educational space became highly regulated. In the high school film examined here, there is evidence of a similarly exacting control, with regulation maintained by timetables, codes of conduct and negotiation of space. Yet, within

this highly homogenized structure are processes and rituals to encourage individualization and development towards a stable social adult identity.

In the context of training, Foucault also refers to the precise physical control of the military body, which he defines as 'body-object articulation'.[2] He describes the movement associated with, for example, the rifle drill, and explains that the soldier should, 'raise the rifle with the right hand, bringing it close to the body so as to hold it perpendicular with the right knee, the end of the barrel at eye height, grasping it by striking it with the right hand.'[3] Such instruction is evident in *Full Metal Jacket*, in which a repeated failure to master this eventually leads to chaos. Although Foucault draws attention to an intense spatial ordering of the body, the process of training in Western societies is not solely concerned with physical control, but also involves appropriate social conduct. A fundamental aspect of educational regimes relates to personal hygiene, which is intrinsic to notions of Western civilized behaviour.[4] The contemporary rigour of this regimen results, in part, from health education films of the early twentieth century. Boon[5] describes the intense proliferation of such films in the interwar years (1919–39), commenting that they 'did not simply represent medicine and health, they were conceived as instruments'.[6] Boon observes how the films suggest an association between health and morality, and order and cleanliness. Social training films also appeared in the classroom. In a study of the intersection of cinema, genre and youth, James Hay[7] notes how, in the 1950s, the classroom became another site of behavioural control; 'classroom films in the 1950s, were a technology adapted, by all kinds of professionals, to making the school and classroom a proper setting for linking moral and behavioural training about fashioning, developing, and conducting oneself properly in different social settings and activities.'[8]

Hay observes how these films prescribed social modes of behaviour, frequently in relation to gender, noting 'classroom films

were often about gendered regimens for self-improvement and usually were used for gender-specific screenings (for example *As Boys Grow, Molly Grows Up, The Story of Menstruation*)."[9] His study illustrates how real life training institutions are therefore concerned not only with the physical and educational enhancement of the body but also with ordering or repressing its various functions, especially those pertaining to the 'lower bodily stratum'.[10]

A particular aspect of such regulation relates to the feminine reproductive body. In some cultures, menstruating women are segregated[11] while in Western society there has been a tendency to suppress elements of the feminine reproductive body. Lack of control associated with the body in current culture, particularly in relation to hygiene and weight, is also often perceived as undesirable, whereas the sanitized, weight-controlled body is the ideal. Bodily regulation therefore concerns not only suppressing links with function, but also with food intake and exercise. Gail Weiss[12] links these two aspects via her discussion of anorexia, which, in the female, controls body image and simultaneously negates menstruation.

It is with the regulation of the 'lower body stratum' that *Carrie* is concerned, while *Full Metal Jacket* and *Remember the Titans* explore the articulation and mastery of the physical body in space. In this part, therefore, I examine three different types of training institution – that concerned with education and the social control of the body; sport and the physical development and control of the body; and the precise ordering typical of the military institution. These films address both female and male dominated institutions of different genres, namely the horror genre, the war film, and the sports training film. Each suggests that mastery of the physical aspects of the body is essential to attaining a coherent adult identity, while failure of control, mediated through various spatial scenarios, equates to an inability to achieve adulthood.

Chapter 1

Schooling and the Feminine Body: *Carrie*

The film *Carrie* (1976, directed by Brian De Palma), considered one of the most successful horror films of the 1970s,[1] has been the subject of much critical debate. In part, this centres on the destabilization of the American home and family unit apparent in the film.[2] It inevitably attracts comments on its deployment of Hitchcockian themes and stylistic devices,[3] while other critical attention centres on either its generic characteristics,[4] or its Gothic tendencies.[5]

The film tells the story of a young girl, Carrie White (Sissy Spacek), who develops telekinetic powers at the time of her menarche. Oppressed by her mother, who frequently locks her in a prayer closet, and derided by her school peers, she is the victim of a student plot to humiliate her. Her school peers plan to crown her prom queen and then, by suspending a bucket from the rafters above the stage of the prom, spill pig's blood over her. When this occurs, she retaliates by summoning up her telekinetic powers, causing widespread mayhem and death at the prom. Consequently, scenes related to the female reproductive body have also generated significant discussion.[6] The implication of the feminine body as a source of chaos inevitably prompts accusations of misogyny,[7] especially as the film is interspersed with several narratively superfluous scenes of voyeurism.

Because of the relationship established between aspects of the female body and disorder, Creed[8] adopts *Carrie* as a central text with

25

which to illustrate her discussion of abjection. Drawing on one of Kristeva's[9] key points about abjection, namely the one relating to menstruation, Creed's analysis of the film seems to corroborate Kristeva's argument with regard to the abject female body. Its theme of maternal abjection is the other main reason for its inclusion in Creed's anthology. An inability to break away from the mother figure arrests Carrie's developing adult identity, and returns her to an infantilized state. As Creed notes, 'by refusing to relinquish her [the mother's] hold on her child, she prevents it taking up its right and proper place in relation to the symbolic.'[10] In short, Creed's overall argument in relation to *Carrie* is that episodes of transgression in the film invariably relate to either the menstruating or the maternal body, which subsequently become sources of horror.

There is no doubt that Creed's argument is relevant in the context of Kristeva's notion of the abject. Her approach, however, varies from that of Kristeva because she expounds on links between witchcraft and femininity as explanations of irrational behaviour. These episodes of transgression specifically involve Carrie's telekinetic powers and lead her mother (Piper Laurie) to label her as a witch, an aspect that Creed develops in her reading of *Carrie* as an example of the monstrous-feminine. In many respects, however, this is incongruous, not least since the mother herself has witch-like qualities. Margaret White has long flowing hair, wears dark clothing and her figure behaviour mostly entails sweeping, unnatural movements. We often see her through extreme camera angles, thus heightening her appearance as evil and irrational, while Carrie persistently appears innocent and victimized. Although Creed also recognizes Carrie as a victim, she tends to centre on her supernatural powers, using this to corroborate her abject femininity.

In addition, there are other abject elements of the film, which often relate to the film's spatial dimensions. Kristeva's[11] explanation of the feminine body and maternal world as abject are derived from the child's relationship with the mother and an inability to recog-

nize itself as a separate entity. Carrie attempts to break away from her claustrophobic home life by venturing into new spaces that are specifically associated with the development of subjectivity and sexuality. While Creed takes account of the uterine nature of the prayer closet within the film, she does not discuss the implications of space further. This is unusual since, typically for the horror genre, there is a marked emphasis on space, especially the constriction associated with the White family's house and the oppositional freedom of the prom ball. Indeed, in horror discourse generally, the spaces of *Carrie* have attracted little attention, though Rick Worland comments on the paradox of the closet in *Carrie*, interpreting it as both womb and tomb. The boundary of the closet is therefore implicated as both protective but constraining.[12] Worland also highlights similarities between the spaces of *Carrie* and those of Gothic literature. For example, in discussing Carrie's home, he describes the Gothic character of its interior archways. Furthermore, he observes how in horror narratives, the house, like the castle or manor of Gothic literature, is often destroyed, noting, 'the catastrophic finale may mark liberation from the injustices, debaucheries, and crushing guilt of the past.'[13] Valdine Clemens extends this relationship by suggesting that the Gothic castle is analogous to the maternal body, and that 'the dark tunnels and underground passages of Gothic edifices represent descent into the unconscious, away from the socially constructed self and toward the uncivilized, the primitive. Violence, pursuit and rape occur in these lower depths, yet they are also the realms where valuable discoveries are made.'[14]

Clearly, a theme of abjection again emerges in relation to certain spaces, especially in correlations between the maternal body and Gothic architecture. In *Carrie*, the home similarly becomes an extension of the maternal body, with the mother's death reflected in its collapse.

While I do not intend to oppose Creed's analysis of *Carrie*, I aim

27

to rationalize her argument in relation to space and reconsider sources of monstrosity in the film, as well as comment on the theological implications of abjection. The significance of space to Carrie's adult identity is not only evident in the destruction of both the school and Carrie's home, but is also expedited through the social space of the school prom.

The high school prom is a focal point of American socio-cultural tradition, important as a rite of passage and in establishing a coherent body image. Amy Best's[15] analysis of the prom may explain the representation of its spaces in *Carrie*, suggesting ways that we can read the development of Carrie's adult sexuality and subjectivity through her spatial negotiation of the prom ball. As Best asserts, 'largely designated as a feminine space of spectacle and pageantry, the prom emerges as a place where girls announce themselves to their immediate social world, make a dramatic statement about who they are.'[16] The relationship between space and subjectivity becomes evident in the chaos that occurs there following Carrie's public humiliation, with Carrie subverting expectations of conventionally 'safe' spaces.

Furthermore, while abjection is allied to space rather than solely the feminine body, other characters are arguably depicted as more monstrous than Carrie, namely Chris Hargenson (Nancy Allen), Norma Watson (P. J. Soles) and Sue Snell (Amy Irving). While men appear easily manipulated, they too are shown to be capable of abominable acts, namely that of animal slaughter. Moreover, the religious references that permeate the film frequently invoke abject spaces (hell) or abject acts, and there is repeated reference to the blood of Christ and the sins of the flesh. In *Powers of Horror*, Kristeva describes how abjection arises in relation to sacrifice, animal slaughter and bloodshed, aspects that feature prominently in *Carrie*. The interpretation of the feminine body as the sole source of monstrosity is therefore debatable.

Thus, while abjection is an irrefutable aspect of both the horror

genre and the feminine body, I suggest that, in a broader context, space in Carrie is implicated in abjection insofar as it relates to self-image and ego formation. Therefore, in this chapter I explain how Carrie's subjectivity directly relates to her negotiation of various social spaces. It charts her development from an infantile state to the transient femininity that she attains at the prom. However, in her reversion to an infantilized state, she ultimately returns to the semiotic space of the prayer closet. Her subjectivity thus reflects the space to which she has access. Within spaces of restriction, she is childlike, while in spaces of freedom there is clear evidence of an adult identity constituted through the conventions of femininity. However, when private space becomes public (as in the shower scene and, effectively, in its reiteration at the prom), she becomes a source of abjection through the cruelty of the others. Ultimately, her school peers provoke the chaos that she mediates through her telekinetic powers.

While the central source of Carrie's repression arises in relation to her home, her student colleagues also revile and oppress her. Two separate and opposing institutions, the home and school, thus govern Carrie. The school trains her to be orderly, controlled and socially constrained; Miss Collins (Betty Buckley) tells Carrie to 'grow up, stand up and take care of yourself.' Such instruction reflects Peter Stallybrass and Allon White's discussion of the bourgeois body in which they describe how

the vertical axis of the bourgeois body is primarily emphasized in the education of the child: as s/he grows up/is cleaned up, the lower body stratum is regulated or denied, as far as possible, by the correct posture ('stand up straight', 'don't squat', 'don't kneel on all fours' – the postures of servants and savages), and by the censoring of lower 'bodily' references along with bodily wastes.[17]

Carrie's mother, on the other hand, encourages Carrie to repress any signs of adult desire or bodily function. Therefore, while the film does not display the overt control and physical domination associated with total institutions, such as the prison, it demonstrates a suppression of adult sexuality within the domestic sphere. Furthermore, Carrie's mother is reluctant to allow her to socialize with other students, forbids her from attending the prom, and forces her to pray for atonement for her 'sins'. Her mother therefore not only controls her actions, but also compels her to subscribe to the religious fanaticism she upholds. The use of canted, low angle shots of her in these scenes emphasizes the overpowering force of the maternal body.

Vivian Sobchack[18] identifies the threat the home presents, especially the parental figure, as a generic pattern characteristic of several horror films of that time. Describing similar depictions of a decentralized family unit in *Rosemary's Baby* (1968) and *The Shining* (1980), Sobchack attributes this to shifts in American society. She comments, 'that drama [associated with the child figure] emerges from the crisis experienced by American bourgeois patriarchy since the late 1960s and is marked by the related disintegration and transfiguration of the traditional American bourgeois family'.[19] Because of this, Sobchack continues, 'the time and place of horror and anxiety, wonder and hope, have been brought back into the American home'.[20]

The home is certainly a place of austerity and restriction in *Carrie*, especially with regard to the adolescent and sexual body. When Carrie confronts her mother about her own ignorance of reproduction, Margaret White responds with a biblical diatribe about 'the sins of women' and 'the curse of blood'. Carrie's anxiety arising from her mother's doctrine causes her to shatter a mirror using her telekinetic powers. Her resultant fractured reflection symbolizes her repressed and incomplete identity (particularly her sexual identity), a metaphor that resurfaces in the prom chaos scene

through the deployment of a split screen. Spatial constriction frequently escalates Carrie's anxiety because, though her mother is overtly religious, she often locks Carrie in a prayer cupboard.

Carrie's oppression thus has parallels in the various spaces of both the home and the school, the constraining nature of the home illustrated visually through cinematography, especially through the frequent use of overhead shots and close framing. Low-key lighting and the *mise-en-scène* of Gothic architecture and dark confining spaces further contribute to the claustrophobia of the Whites' house. The architecture of the house is interesting in that it magnifies certain tropes of space evident in other institutions, for it is a dark, foreboding place with secret internal spaces and narrow staircases. In some ways, it parallels the labyrinthine underground spaces of other institutions and does eventually sink underground. For Carrie, the internal, highly restricting spaces of the home are, however, ambivalent. While they are traumatizing and repressing, occasionally they provide her with sanctuary, perhaps as her only source of private space. It is interesting to note that she withdraws to the uterine space of the prayer cupboard at the end of the film. It some ways, its space is synonymous with the maternal figure, providing both comfort and restriction and, like Kristeva's explanation of the abject mother, offers 'the sway of a power that is securing as it is stifling'.[21] Indeed, the mother primarily governs Carrie's world, for there is little mention of her father in the earlier part of the film. Her mother continually tries to repress Carrie's sexuality by controlling the social spaces she inhabits. Carrie, however, resists her mother's control by moving through forbidden spaces and feminizing her body. When this fails, she controls the spaces themselves, rendering them chaotic and eventually destroying her own home.

In contrast to the home, the school is generally characterized by more open, lighter spaces. There are, however, several points in the film where these also become abject, notably in the opening locker

room scene and, apocalyptically, at the school prom. Conversely, in other spaces that include the sports court, the sports field and the classroom, bodies remain under tight control, both spatially and temporally.

The opening scenes immediately establish the school as a site of order. Indeed, the significance of space to *Carrie* emerges in an early crane shot of the volleyball court, which maps out space in relation to the organization of bodies.[22] Here, physical control of the body is an important contribution to team performance, with Carrie failing in this respect when she drops the ball. Because of this, Chris Hargenson, Carrie's peer and adversary, taunts her with the words, 'eat shit'. The other students therefore link Carrie with disgust from the start of the film and continue to associate her with excrement. They spray graffiti over the gym that reads, 'Carrie White eats shit', leading Miss Collins, the gym mistress, to admonish them with the words, 'you did a really shitty thing, a really shitty thing'. Excrement and menstruation, as discussed earlier in this book, relate to the maternal mapping of the body and are thus relevant to Creed's argument of Carrie as abject. However, other characters are also associated with excrement. Chris addresses Billy Nolan repeatedly as a 'stupid shit' and 'dumb shit'. Furthermore, while the disorder of the menstruating body is a central feature, the theme of blood in the context of religion is prominent. Margaret White refers to menstruation but also to 'spreading the gospel of God's salvation through Christ's blood'.

From the outset Carrie is marked as different, especially in relation to the cruel and vain Chris Hargenson. Hargenson is obsessed with her looks and frequently checks her appearance in a mirror. An emphasis on her highly sexualized nature contrasts with the infantilized, asexualized Carrie. Unlike the other female characters, Carrie does not wear make-up, wears loose-fitting sackcloth clothing and has straight unstyled hair. Her slight stature further suggests her childlike status, and her pale complexion and blond hair con-

tribute to her portrayal as an innocent victim. Her figure behaviour, with closed body movements and frequent shots with her arms wrapped closely around herself, accentuates her lack of confidence. She is set apart from the rest of the students in other ways.

In the early scenes of the film she is not only literally isolated from the others (she wanders alone through the library and sits by herself), but is also cinematographically separated. In the few scenes in which she accompanies other students, framing makes her appear trapped and insignificant. For example, in the classroom sequence, Tommy Ross dominates the foreground of the frame, while Carrie, diminished through perspective, appears at its edge. This cinematographic entrapment is especially evident in domestic scenes that feature her mother. Carrie, again appearing constrained by space, is framed within doorways, arches, mirrors or other structures. Moreover, in group situations she tends to be situated at the periphery. For example, in the opening sequence she is at the back of the volleyball court, in class she sits at the rear, and at the prom she is positioned at the outer edges. These spatial scenarios therefore seem to correlate with a lack of ego.

Most of the spaces in the school are highly regulated. Typically, classroom scenes show desks in orderly rows, while on the athletics field, the authoritarian Miss Collins enforces a rigid physical discipline as she choreographs and coordinates the girls' bodies during fitness sessions. While exercising, the camera frames the girls at thigh level, a technique repeated frequently throughout the film, for example in the 'shorts scene' in the headmaster's office and later, when Mrs White kneels before Carrie. The persistent low-level cinematography perhaps refers to notions of lower body strata that pervade the film, as relevant to menstruation, shit, hell and pig's blood. Low-level framing also occurs in the initial shower scene, opposing the focus on high angle shots that also feature prominently.

The exercise scene again reinforces control of the body as

desirable, with notions of 'fitting-in' and conformity as the ideal. A refusal to conform costs Chris Hargenson her prom tickets and causes her to transpose this chastisement to Carrie by plotting the 'pig's blood scheme' at the school prom. Miss Collins therefore uses the body as a space of control that contrasts with Margaret White's punishment of containing the body within an enclosed space, and thus she arguably functions as an alternative maternal figure within the space of the school.

This is suggested, for example, in the shower scene where she reassures Carrie and, later, when she encourages Carrie to wear make-up and restyle her hair, thus guiding her towards an adult sexuality. Following the shower scene chaos, Carrie is called in to see the headmaster who repeatedly calls her Cassie Wright (instead of Carrie White), suggesting her insignificance. This increasingly irritates Carrie, causing her to move an ashtray telekinetically through the air. The headmaster, simultaneously viewing Miss Collins's bloodstained shorts, shown in close-up, appears both shocked and disgusted. He sends Carrie home, telling her to take care of herself. The film therefore suggests the feminine body as offensive and out of place, since within the context of the school bodies are made to move predictably and with control. Any aberration of the physical or social body is seen as deviant and other.

While spaces of order are associated with the school, and often men (the classroom and the headmaster's office), spaces of disorder relate to femininity (the prom, the shower scene and the Whites' house), best exemplified by the locker room scene. Here, slow motion cinematography and a highly unstructured *mise-en-scène* signify disorderliness. Towels and clothing appear to float randomly through the air and bodies are etherealized and nymph like. MacKinnon comments on the myth of Eden in relation to this sequence, suggesting, perhaps, the innocence of youth.[23] The *mise-en-scène* may also imply the intrinsic capability of the feminine body

for disorder and therefore anticipates the incipient chaos of the shower scene, one of the many allusions to Hitchcock's *Psycho*. As she showers, Carrie begins to menstruate and appears horrified. Rushing out of the shower with blood on her hands, there is hysterical revulsion among the rest of the group. The other students recoil in disgust and then symbolically stone Carrie with sanitary products, shouting, 'plug it up, plug it up', while Carrie, appearing unaware of the process of menstruation, cries hysterically. Creed notes the stoning metaphor,[24] which supports her view of Carrie as a monstrous witch. Furthermore, Carrie's supernatural capability, signalled by the shattering of a light overhead, parallels the onset of her menstruation.

The shattering of the light transforms the dream-like quality of the locker room into a harsh reality, with its disorderliness exacerbated by Carrie's telekinetic display. The abrupt juncture of these scenes marks Carrie's shift from innocence to shame and is potentially a marker of the thetic break. Kristeva describes the thetic moment as one of transition from the semiotic maternal world to the symbolic paternal sphere, usually marked by the acquisition of language.[25] However, Carrie is unable to achieve this shift and the shower area becomes oppressive to her, implied by close framing. As the other girls crowd in, she retreats further back into the shower, the camera framing her even more tightly. Sinking to the floor, she assumes a foetal position, while the gym teacher, Miss Collins, tries to comfort her, calling her 'baby' and thus further emphasizing Carrie's childlike status.

In an effort to help Carrie overcome her social inadequacy (though the reason for this remains ambivalent), Sue Snell asks Tommy Ross to escort Carrie to the prom. After some persuasion, Carrie agrees, but as she gets ready for it her mother forbids her to go, expressing disgust at her feminized appearance. Margaret White's comment to Carrie that 'after the blood come the boys, like dogs, trying to find out where that smell comes from', again lends

support to Creed's claim of the abject feminine body. Carrie's highly feminized and angelic appearance, however, discounts her as monstrous. Moreover, the pairing of Carrie with Tommy Ross, who is blond, romantic and similarly angelic in appearance, is antithetical to the cruel and barbaric, dark-haired Billy Nolan and the sexually aggressive Chris Hargenson. This opposition is further realized in the relative spaces they occupy at the school prom. Although a narrative necessity, it is significant that Carrie and Tommy stand on the stage and Billy and Chris hide beneath it, the juxtaposition of these two spaces highlighted as the camera alternates between them.

The school prom is, according to Best's survey,[26] the highest of teen ideals, and a space in which 'teens ... solidify their social identities'.[27] It provides an opportunity for Carrie to disavow the humiliation of the shower scene with a masquerade of femininity, and temporarily fulfils her desire to be 'normal' and 'a whole person'. The prom, an archetypically American social ritual, appears here as a feminized space. Best observes how texts concerned with the prom typically show 'the prom ... packaged as a feminized space, wrapped up in contemporary conceptions of heterosexual romance'.[28] She further notes that the prom, as a feminine space, 'is a site where girls are expected to be heavily invested because they can use this space to solidify and display their feminine identities'.[29] Dress is an important part of the construction of feminine identity, since, as Best further observes, 'proms are moments in which girls in particular are on display.'[30] In *Carrie*, the importance of appearance, dress and display are drawn attention to through comments such as, 'where did you buy that dress, I love it,' and Tommy's words to Carrie of 'you look beautiful'.

The feminizing of space is not only discernible in the spectacle of suspended lights and stars, but also in a return to the slow, dreamy camerawork of the opening locker room scenes. These aspects are particularly associated with the dance floor. The prom space in *Carrie* therefore temporarily transforms the gymnasium

into a symbolic heaven in which Carrie attains a briefly coherent status. It therefore has an inherently dual nature, being a site where both physical order and social discipline influence the body. Moreover, the prom becomes further diverse in the minutiae of social meanings constructed within it. Best describes the prom as a heterogeneous space in which 'kids search for and attempt to create makeshift private spaces for themselves within [a] highly public space'.[31] Within the prom scene in *Carrie*, spaces of friendship, romance and display are similarly constructed. Best's survey further reveals that the dance floor is often a space designated for students alone, one where supervision is relinquished and that 'the spatial organization of students' bodies and teachers' bodies seem[s] to suggest an order to the dance floor, through which it came to be defined as a space for and of youth'.[32]

Such spatial organization becomes apparent at the prom where Carrie initially sits at the edge of the dance floor. As the night progresses, she moves further towards its centre, signifying a transition to idealized adolescent femininity. Carrie's development to 'normality' also materializes visually through cinematography and *mise-en-scène*. She not only appears framed in pairs or groups, and positioned in the foreground, but we also see her in long shot, thus avoiding the cinematographic constriction of earlier scenes. Moreover, through low angle cinematography, she increasingly dominates the frame, while towards the end of the film, the camera frames her more centrally, and she is the focus of attention. This is particularly evident in both the dance sequence, when the camera rests solely on her and Tommy, and the prom queen scene, in which she is again at both the centre of other characters' attention and the frame. In both situations, she temporarily achieves a normal adolescent subjectivity. Moreover, during the dance sequence, cinematography and editing become more rapid and chaotic and Carrie's figure behaviour is considerably less constrained.

The prom is a site where social rituals of heterosexuality reach

their apogee in the idealized couple of prom king and queen. When Carrie and Tommy Ross are voted prom king and queen, the site of Carrie's transcendent femininity shifts from the centre of the dance floor to the stage. The scheme of pouring pig's blood over Carrie and Tommy, however, destabilizes the highly feminized space of the prom and renders it a site of humiliation, derision and disgust for them. Hargenson's action results in a disintegration of both spatial coherence and Carrie's feminine identity. The moment during which the blood covers them is extrapolated in slow motion, signalling Carrie's return to grotesque realism. As her masquerade of femininity fails, she again resorts to telekinesis to disavow the anxieties of menstruation that this event reiterates. In the following scenes of chaos, her power escalates and she mostly dominates the frame, while at one point the screen splits to show Carrie and the effects of her telekinesis.

The meaning of the split screen device has attracted much discussion. Some comment on it as a general excessiveness of style,[33] as well as a specific 'distancing and narrowing of interpretation'.[34] I suggest that it represents the disintegrating social space that Carrie has struggled to master and a fracturing of her coherent body image and identity. Although she seems monstrous and violent, her eyes become glassy and fixed, like those of the statue in her prayer cupboard. Arguably, she appears as a saviour, destroying corruption with a righteous anger caused by the relentless abuse inflicted by her classmates and mother. This interpretation also emerges as a possibility in an earlier library scene when she searches for an explanation of her supernatural powers. As she looks in a file entitled 'miracles', the spectator is shown, from her point of view, a reference that says, 'a miracle a day keeps the devil away', explicitly linking her with the miracles of Christ rather than evil. This opposition of and, indeed, ambiguity between good and evil is apparent throughout the film, often through the concepts of heaven and hell. The artifice of

'heaven' manifests in the triteness of the prom, where 'love among the stars' is the theme and the overhead position of the pig's blood marks its ambivalence. Moreover, Margaret White, the epitome of religious fundamentalism, is paradoxically monstrous, while Sue Snell's character remains ambiguous. The home, usually a space of protection, is literally labelled 'hell' and towards the end of the film a low angle shot of the cross that marks the site of the submerged Whites' house looks up towards a blackened sky, further reinforcing this ambivalence.

The blackening effect of the pig's blood on Carrie's pale skin and gown further amplifies the ambiguity of the black/white, evil/good binary. The film deploys ideological connotations of the nature of the pig as disgusting, linking it to Carrie at various points, especially in references to shit and equating pig's blood with menstrual blood. Creed refers to this to support her argument that the menstruating body is abject and monstrous, and evokes references to the low status of the pig in carnival culture.[35] Billy Nolan's comment about 'painted pigs' implies a derogatory parallel between pigs and painted women, suggesting that Chris Hargenson is abject and monstrous. Arguably, killing the pig, depicted as barbaric and horrific, is more horrific than Carrie's telekinesis. Kristeva notes a biblical link between blood and evil, observing that, in the Bible, permission to eat animal flesh 'is accompanied by an acknowledgement of essential evil, and it includes a negative, incriminating connotation with respect to man'.[36] Kristeva further notes that 'blood, as a vital element, also refers to women, fertility, and the assurance of fecundation. It thus becomes a fascinating crossroads, the propitious place for abjection where *death* and *femininity*, *murder* and *procreation*, *cessation of life* and *vitality* [original emphasis] all come together.'[37] Clearly, Kristeva considers that abjection arises not only in relation to the feminine body but also through slaughtering animals.

Furthermore, Carrie's retribution appears justified because everyone seems to have betrayed her. In a trance-like state, she

induces chaos and causes the gymnasium to erupt into flames. Creed's view of Carrie as a witch is supported by her traverse through the burning building and because she causes Hargenson's car to crash and burst into flames. Carrie's figure with her outstretched hands, however, takes on a cruciform shape and she overturns Billy Nolan's car to avoid her own death. Arguably, she is a Christ like figure. Moreover, as she returns home, drenched with blood, Carrie seems more pitiful than monstrous. There are further religious connotations as the Whites' house is transformed into a shrine or sacrificial altar. As Carrie cleanses herself of the blood and make-up, and dresses in a long, plain nightgown, she returns to a child like state. The sacrificial nature of the scene is completed as her mother appears, dressed in white rather than the usual black, and stabs Carrie. Carrie, in self-defence, telekinetically crucifies her mother who assumes the same shape as the figurine in the prayer closet. With the crucifixion of Carrie's mother, the house begins to creak and collapse and Carrie drags her mother into the prayer closet as the house completely subsides. The sinking of the house underground is allied with it as an abject space and, in the closing scenes it is directly labelled 'hell'. However, the ambiguity relating to Carrie's own death means that her liberation from the mother is never fully resolved, while the ritualistic nature of their deaths, which narratively relates to witchcraft, also has links with abjection.

In general, rituals in *Carrie* are synonymous with containing the disgusting body and displaying the clean and proper body. These range from the physical cleansing rituals of bathing and the ritualistic stoning scene to the social rite of the prom and the religious connotations of the final scenes. All are concerned with regulating the body, both physically and socially. The nature of the spaces within which these various rituals occur govern the representation of Carrie's subjectivity and sexuality. Kristeva asserts that rituals of purification help to confront and contain abjection.

She describes how religion, literature and art in particular function in this way:

> The various means of *purifying* [original emphasis] the abject
> – the various catharses – make up the history of religions,
> and end up with that catharsis *par excellence* called art, both
> on the far and near side of religion. Seen from that
> standpoint, the artistic experience, which is rooted in the
> abject it utters and by the same token purifies, appears as
> the essential component of religiosity.[38]

Because Christian fundamentalism underpins both character motivation and narrative, religious ritual appears frequently in the film. The most significant example of this occurs in the final sequence in which Margaret White confesses to the 'sin' of intercourse while Carrie's 'sins' (of femininity and desire) are atoned for by her sacrifice. The numerous candles around the house and the mother's white robes specifically denote its ritualistic nature. Scenes of bodily hygiene, prominent in the opening shower sequence, also occur in the final bathroom scene where physical cleansing not only erases the signifiers of femininity and adult identity, but also implies a washing away of sin. Arguably, *Carrie*'s biblical content is consistent with Kristeva's explanation of abjection. While the film addresses those aspects that are clearly considered abject in *Powers of Horror* (animal slaughter and menstruation), it also positions the maternal and more specifically, the feminine, as abject through proximity to 'sin'. Throughout *Carrie*, the mother frequently recounts the Bible as an attempt to purify both herself and Carrie. Thus, not only is the language of the Bible a means to counter abjection, but it also becomes synonymous with the maternal figure. What is interesting about *Carrie* in the context of Kristeva's theological discourse is that Kristeva notes that 'no attention is paid [within studies of the Bible] to the linguistic subject of the Biblical

utterance, nor by way of consequence, to its addressee. Who is speaking in the Bible? For whom?'[39] In *Carrie*, the ritualized recounting of the Bible by the mother literally positions her as a speaking (and implicitly paternal) subject. Furthermore, through her denial of sex and repression of desire, she represents the Virgin Mary, while in the final scenes she visually becomes a version of Christ. Kristeva[40] argues that the Virgin Mary is essentially a paternal mother and is therefore distinct from the abjection of the sexual, reproductive mother. Furthermore, Kristeva equates the religious purification delineated within Leviticus with that autonomy experienced by the pre-Oedipal subject as it separates from the maternal figure:

> Therefore, it could be said that a biblical text (the Book of Leviticus), which delineates the precise limits of abjection ... has developed a true archaeology of the advent of the subject. Indeed, this book recounts the subject's delicate and painful detachment ... as well as his journey from narcissistic fusion to an autonomy that is never really 'his own', never 'clean', never complete, and never securely guaranteed in the Other.[41]

In short, the mother's mapping of the clean and proper body has parallels with the function of religious ritual in purification of the self. Arguably, the maternal figure of Margaret White is aligned with Christianity and the Bible, as Diane Jonte-Pace suggested: 'In Kristeva's interpretation of Christianity in "Stabat Mater" ... woman and religion are structurally, thematically and logically linked. She [Kristeva] reveals a maternal substratum to the paternal Christian discourse, and hints at an association of motherhood, religion, and death.'[42]

Carrie's inability to separate from her mother therefore relates to an inability to reject religious doctrine. However, when Carrie's

mother confesses to the sin of sexual intercourse, she transforms into an abject, desiring, bleeding maternal figure. In killing the mother, Carrie attempts to reiterate the thetic break, but ultimately retreats to the semiotic space of the maternal world, signified through her immersion in the collapsed abject space of the home. The arm that emerges from the ground in the closing scenes, while commensurate with the horror genre, again suggests Carrie as a Christ-like figure through resurrection.

While rituals within the home generally refer to Carrie's repressed identity, rituals concerned with other spaces, particularly the prom, signal her developing subjectivity. The prom is a significant rite of passage consistent with American tradition. Best describes it as 'an iconic event in American culture' and 'a space in which teens make sense of what it means to be young in culture today, negotiate the process of schooling'.[43] Its ritualistic nature manifests through ceremony, dress and the crowning of the prom king and queen where physical appearance demonstrates social control of the adolescent body.

Exercise, on the other hand, provides a ritualized means to display physical control of the body. It features in the opening scenes and is also a way to punish the girls for their behaviour towards Carrie. A focus on coordination and coherence of body image conforms to conventions of the classical body[44] and is opposed to the grotesquery of the menstruating body. This opposition is mediated through the respective spaces of the gymnasium and the prom.

Generally, the film is relevant to a discussion of abjection since it juxtaposes the themes of purity and pollution that manifest through these various rituals. Aesthetics and beauty closely relate to ideas of the exterior body through artifice (cosmetics and the prom decorations) and physical cleanliness, opposing the invisible, hidden 'dirt' of sin, desire and menstruation. Clearly, while there is a critical focus on the monstrosity caused by

menstruation, exterior 'beauty', signified through the character of Chris Hargenson is also problematic.

In conclusion, *Carrie* is essentially concerned with the suppression and control of the abject body in order to cohere with social and symbolic order, with critical analysis locating the feminized body as a particular source of monstrosity. There are, however, other ways to interpret *Carrie*, and the case is more equivocal than Creed suggests.[45] Fundamentally, the spectator is encouraged to empathize with Carrie's vulnerabilities and Carrie is not inherently evil. Indeed, she consistently appears innocent and naïve, whereas the characters of Chris Hargenson and Billy Nolan are problematic. Their normative heterosexual relationship appears to be unstable and difficult and pivots obsessively around Hargenson's appearance (both cosmetic and sexual). Hargenson, in particular, is malevolent, and represents the threat of the castrating vagina dentata[46] through the visual and narrative emphasis on her mouth. This is suggested in the car scene with Billy Nolan in which she is both seductive and aggressive. She repeatedly and unnecessarily applies her lipstick, and there are frequent close-up shots of her open mouth. At certain points, notably when Carrie is drenched in pig's blood, we see her mouth in extreme close-up, connoting sexuality and threat.

The actions of Carrie's classmates further undermine the notion of Carrie as monstrous, especially in relation to Sue Snell who is responsible for the prom chaos. Although it transpires that Sue Snell and Tommy Ross are innocent, it is their patronizing facilitation of Carrie into normative heterosexuality that catalyses the ensuing violence. As Richard Combs points out, 'the ghoulish prank could not have possibly succeeded without their cooperation.'[47] Her drenching in pig's blood may then also signify Christ's blood, since Carrie is represented as a saviour, her own loss of life being consistent with this. Indeed, there are verbal references to Christ's blood throughout the film. Carrie's actions may therefore reflect her mother's religious conviction and indeed arise primarily

because of her mother's oppressive doctrine. Carrie's apparent misanthropy may thus be concerned with the destruction of corruption in humanity.

Further ambivalence arises in the film's ending as Sue Snell is the sole survivor, suggesting that she is the heroine who is saved because she is innocent. Her long, white gown and the surreal quality of the scene in which she lays flowers at the site of the Whites' house support such an interpretation. However, this is not a rational argument as many other innocent people die, including the gym instructor. Moreover, the hand that emerges from the ashes and grasps Snell's arm threateningly carries the implication that Snell is guilty.

Carrie's inability to sustain a permanently fixed and stable identity relates to the spaces she occupies. Significantly, these spaces are involved in the rituals of establishing a clean or proper body through cleansing, religion or courtship. Carrie repeatedly displaces unsustainable fantasies of femininity with violent and abject realism, and aligns the instability of certain spaces with the improbability of femininity as a coherent adult image. De Palma posits these idealized images of innocence and femininity as unreal through stylized cinematography and *mise-en-scène*, while reality encroaches chaotically and, in the end, apocalyptically. Ultimately, Carrie puts an end to the regime of humiliation and oppression that has inhibited her adult development by destroying the conventionally safe spaces of home and school.

Carol Clover,[48] however, reveals that Stephen King's original narrative, from which the film is adapted, has a feminist underpinning.

> The book [*Carrie* the novel] is, in its more adult implications, an uneasy masculine shrinking from a future of female equality. For me, Carrie White is a sadly misused teenager, an example of the sort of person whose spirit is so often broken

for good in that pit of man- and woman-eaters that is your normal suburban high school. But she's also Woman, feeling her powers for the first time and, like Samson, pulling down the temple on everyone in sight at the end of the book.[49]

Despite this explanation, the film exhibits certain paradoxes in its portrayal of the pubescent female. *Carrie* emerged at the same time as a number of other feminist images that centred on addressing the feminine and maternal body, but which avoided direct objectification of women. De Palma's film however, while similarly confronting aspects of the female reproductive body, not only presents it in monstrous form, but also is replete with images of voyeuristic male fantasy, thus contributing to its ambivalent reception.

A final comment about the film concerns the use of colour. Dominated by the redness of blood, the other noticeable colours are blue and white. Leigh Ehlers links the colours red and blue with the relationship between the mother and Carrie, 'a tension established between these two primary colo[u]rs suggesting an imbalance between the mother's religious mania and the daughter's repressed sexuality'.[50] It is also possible that these reflect the colours of the stars and stripes that are emphasized in the apocalyptic prom scene. While there are no obvious political undertones, the implication is of threat to American culture and family values and, as Sobchack notes,[51] suggests the instabilities of fatherless families (associated with Vietnam) and the threat within the domestic sphere.

Chapter 2
Training the Athletic Body: *Remember the Titans*

Remember the Titans (2000, directed by Boaz Yakin) tells the true story of a team of white American and African American footballers. The film is set in 1971 in the town of Alexandria, Virginia, where racial tensions become immediately apparent through newsreel footage of black protesters. Here, the football team of T. C. Williams High School has a new coach, Herman Boone (Denzel Washington), an African American appointed as part of a political move to integrate blacks and whites. This alarms the all-white original team as well as the team's previous white coach, Bill Yoast (Will Patton). There is blatant racism from the white team players and, while African Americans in the area welcome the black coach, white Americans resent the appointment and the presence of black Americans in their neighbourhood. Thus, they try to establish territorial boundaries within the neighbourhood, extending them to the school and football field. White Americans see African Americans as contaminating and attempt to exclude them through direct intimidation, violence and corruption. In the earlier part of the film the clear divisions of space are expressed socially, culturally and cinematographically. Eventually, under Boone's direction and discipline, the team learns to overcome racial difference and accept each other. The integration of ethnic groups through sport leads not only to harmonious friendships but also to positive and inspirational experiences. In *Remember the Titans* this extends to improved community relations and, in the final frames, to the representation

of black and white Americans as one family. For the spectator, despite an awareness of being manipulated into a sentimental position, the film activates uplifting emotional responses, both through the unity expressed and through resolution of racial difference.

In this chapter I posit racism as a form of abjection, a notion already well grounded in the literature and identified by Kristeva in the writings of Céline and in her own work (*Strangers to Ourselves* and *Nations without Nationalism*).[1] In this film, confrontation with abjection, primarily experienced at the training camp and at the site of Gettysburg, leads to a positive outcome, which contrasts with received connotations of the abject in film studies as articulated principally through the work of Creed.[2] To date, film studies theorists have been mainly concerned with the concept of the abject in relation to horror and science fiction films. The subjects of discussion in such film texts have been the corporeal aspects of the body, including the corpse, the bleeding body and the feminine body. Although not denying these aspects, I shall focus instead on national identity as expressed through sport, language and music. In any case, Kristeva's theory of abjection rests primarily on an analysis of literature and language rather than images of popular culture.

For Kristeva, maternal abjection intimately relates to the acquisition of language. She explains that the state of abjection occurs at the 'thetic break', the point at which the semiotic infant, enveloped in a chaotic, maternal world, begins the process of ego formation.

> We view the thetic phase – the positing of the *imago*, [original emphasis] castration, and the positing of semiotic motility – as the place of the Other, as the precondition for signification, i.e., the precondition for the positing of language. The thetic phase marks a threshold between two heterogeneous realms: the semiotic and the symbolic.[3]

Ego formation also correlates with Jacques Lacan's[4] 'mirror

stage', the moment at which the infant recognizes itself as separate from the mother figure and begins to acquire language. Prior to this, the infant can only indicate its desires through signs, gestures and undeveloped sounds, so occupies the psychical space of the semiotic, or what Kristeva terms 'the semiotic *chora*'.[5] Following its entry into the symbolic, which is the structured paternal world, the child begins to use language to signify. Because the separation from the mother (maternal abjection) is associated with the acquisition of language, Kristeva[6] formulates a link between feelings of loss and language, concluding that language is associated with desire for what has been lost. For Kristeva, therefore, the link between maternal abjection and language is clearly identifiable. However, she describes how the semiotic may persist in the symbolic. In relation to literature, Kristeva suggests that the semiotic is evident in the way we modify language to convey emotion and passion. She explains that this occurs through the use of certain emotive words or intonations, but also through an abandonment of the usual syntax of structured language.

Arguably, Kristeva's[7] concept of a semiotics of language may be used to describe and interpret the cinematography of certain spaces in this film, and thereby similarly infer feelings rather than known facts. In this chapter I shall therefore also consider how the use of language and text within this film represents the symbolic, while the visual poetics of filmmaking achieves a 'feeling' of unity. In addition, I draw on Kristeva's[8] references to the semiotic nature of music to explain how national abjection, which may arise in sport, is contained. In this chapter I further employ Kristeva's[9] concepts of the semiotic and symbolic to interpret physical spaces in the film. A discussion of the thetic phase necessarily involves consideration of the role of the maternal body in the film. In *Remember the Titans*, Boone encourages his team of football players to break away from their parental world, especially their mothers, by taking them away to a training camp to remould them into the 'perfect team'.

Before going to camp, the team players mostly appear with their parents, signifying their infantile status within the family. At the training camp, they come to respect their new 'father' (Boone) and identify with him, thereby marking their entry into the symbolic. Through the rituals of sport and the discipline of training, he thereby retrains them to overcome their racist attitudes.

While the political body rather than the individual is perhaps more salient to discussions of racial discord, it is still appropriate here to consider visceral reactions to the abject, as Kristeva initially postulated. This is relevant to the perceived violation of the individual manifested in this film and in racism discourses. Bodily contamination is certainly suggested in *Remember the Titans*. Thus, I shall examine racism through the transgression of personal and national boundaries in which the 'foreigner' or stranger is seen as abject. I shall consider how this film addresses and renegotiates abjection through sport, music and language, and ultimately demonstrate that the notion of the abject may be positive and inspirational compared with other ideas about compromised subjectivity.

In short, I shall argue that a series of oppositional social/cultural spaces are established, with blacks occupying the space of the other. Within the institution of the training camp, Boone overcomes such opposition by reordering boundaries, in part through instituting physical control over the team on the football field. He also erodes socio-cultural difference using language. Through confronting abjection, both at the training camp and at Gettysburg, the team overcomes and accepts difference. Its members thus develop from a pre-Oedipal state by identifying with the symbolic father, Boone. Boone is consistent with the language of the symbolic, signified through text and speech. As stated earlier, the semiotic may return to accompany the symbolic. In *Remember the Titans*, cinematography visually indicates the persistence of the semiotic, while diegetic music and language allows the group to accommodate abjection without recourse to overt racism.

Remember the Titans is among an increasing number of films to address the issue of racism. Historically, cinema reflects the long-standing societal oppression of the other, in terms of both its signifying practices and of integrating black filmmakers into the canon. Early cinema focused on the black body as a dancing spectacle, exemplified by films such as *The Pickanninies* (1894), which created one of a series of stereotypes that persisted throughout the history of cinema. While there was a resurgence of black independent film-making during the Harlem Renaissance,[10] the incorporation of black Americans into mainstream Hollywood film remained subordinated to derogatory stereotypical roles. While some stereotypes are usefully deployed as cinematic shorthand, Richard Dyer considers that many, however, have a more demeaning function. He suggests that they are used to contain the other, and mark out the meaning of the othered body in exact terms, stating that 'this is the most important function of the stereotype: to maintain sharp boundary definitions, to define clearly where the pale ends and thus who is clearly within and who clearly beyond it.'[11] Stuart Hall's description coincides even more closely with the concept of abjection.

> Stereotyping ... is part of the maintenance of the social and symbolic order. It sets up a symbolic frontier between the 'normal' and the 'pathological', the 'acceptable' and the 'unacceptable', what 'belongs' and what does not or is 'Other', between 'insiders' and 'outsiders', Us and Them. It facilitates the 'binding' or bonding together of all of Us who are 'normal' into one 'imagined community'; and it sends into symbolic exile all of Them – 'the Others'.[12]

Clearly, racially excluded groups fit the category of abjected other. While traces of black stereotypes still persist in contemporary cinema, films such as *Crash* (2004) have deconstructed these practices. Indeed, with increasingly ethnically diverse audiences,

multiracial heroes are becoming more popular, and black American stars and directors alike have a raised profile.[13] Despite this apparent racial egalitarianism, however, white Americans still dominate the Hollywood film industry.

The oppression of minority groups in cinematic representation and the film industry correlates with their subjugation in Western society generally. In relation to black Americans, this oppression resulted in the practice of segregation. Segregation was concerned primarily with delineation of space, where separate facilities existed for blacks and whites. This extended from schools and cinemas to public bathrooms and buses, which remained segregated until changes under civil rights legislation. This oppression, vilification and abjection of the racialized other informs the narrative structure of *Remember the Titans*.

Here, the significance of space through the segregation of whites and blacks is apparent from the outset and manifests literally and cinematographically. The opening sequence cuts from a funeral directly to scenes of black protest against racism and calls for justice. The camera then pans across to a group of white Americans also in violent protest. Both black and white Americans are tightly framed, with whites in one frame and blacks in another. The assembly of whites and blacks causes extreme disorder, with the voiceover of Sheryl Yoast (Hayden Panettiere) describing the city as being 'on the verge of explosion'. The marginalization of black Americans thus leads to scenes of chaos, with whites perceiving blacks as problematic. Indeed, whenever both appear within the frame in the early part of the film, there is a tendency for hostility and disorder. Conversely, racial homogeneity leads to a sense of community and friendship. The concept of contamination by black Americans emerges in many scenes and they are often referred to as 'animals' or 'monkeys'. The use of such racist remarks clearly posits racism as abjection, with Kristeva noting that:

the abject confronts us, on the one hand, with those fragile states where man strays on the territories of *animal* [original emphasis]. Thus, by way of abjection, primitive societies have marked out a precise area of culture in order to remove it from the threatening world of animals or animalism, which were imagined as representatives of sex and murder.[14]

As a white family watch Boone move into the neighbourhood, we too observe the scene from their point of view. When the husband asks his wife, 'are those people the movers?' and she replies, 'no, looks like they're moving in here. How many of them are there?' they are expressing a bigoted opinion about the social status of blacks. Further comments of 'it only takes one and then we're gonna be overrun by them' and 'look there, here comes some more of them', suggest that Boone's family is threatening and polluting.

Although there are similar racial tensions between Boone and Yoast, the team coaches, they eventually learn to respect each other. However, in the early scenes, Yoast refers to the white players as if they were part of a separate family saying, 'I'm worried about my boys.' Boone responds with, 'well I'm not gonna cook 'em and eat 'em,' thereby acknowledging Yoast's racial undertones through reference to primitive cannibalistic practices (eating flesh is in itself an aspect of abjection). The spatial division between whites and blacks emerges in several further scenes, signified through the *mise-en-scène*. In a meeting about the future of the team when Yoast announces that he is 'stepping down' for a season, white Americans, united behind Yoast, occupy a warmly lit scene in the local bar. A parallel scene, but shot out in the street at night, shows black solidarity behind Boone, whom they regard as a saviour. In fact, one supporter, Dr Day (Lou Walker), asks Boone, 'rumour has it that you marched with Dr King, stood toe to toe with the Klan, that you're a race man?' However, when blacks and whites come together there is inevitable disorder. Kristeva's views on abjection

are relevant here. She explains that boundary formation is important in the radical exclusion of the other and helps to consolidate identity (in this case, white national identity).

This spatial distinction is evident in the gymnasium scene where the black players assemble on one side and the white players on the other. Although there is a clear separation of the two groups, one white player, Lewie Lastik (Ethan Suplee), rushes over to join the black group, which regards him rather suspiciously. It is unclear exactly what accounts for Lewie Lastik's lack of prejudice towards the black players other than that he is considerably overweight. While his size clearly marks him out as being different from the rest of his group, he seems to have other reasons for wanting to change sides. He describes himself as 'white trash' and 'not some brainy act like Rev', so clearly he sees himself as polluting and lacking in value. This contrasts with the notion of white purity presented by Gerry Bertier (Ryan Hurst) who, on introducing himself to Boone as 'the only all-American you got on this team', is perhaps alluding to both his sporting status and his 'racial' purity.

Kristeva's principal work on abjection, *Powers of Horror*, could elucidate the rejection of black Americans in *Remember the Titans*. While Kristeva centres on the psychoanalytical aspects of excluding the disgusting, horrific and excremental, she also refers obliquely to the rejection of the foreign body. Her other key focus is on the abjection derived from literature, notably the Bible and the writings of Céline, which she explains, particularly the anti-Semitism in Céline's work, as a way of addressing abjection. However, some of her later works are more politically inflected. For example, in *Strangers to Ourselves* she introduces the text with, 'foreigner: a choked up rage deep down in my throat, a black angel clouding transparency, opaque, unfathomable spur. The image of hatred and of the other, a foreigner is neither the romantic victim of our clannish indolence nor the intruder responsible for all the ills of the polis.'[15]

Kristeva explains this reaction psychoanalytically by suggesting

that 'the foreigner lives within us: he is the hidden face of our identity'.[16] She goes on to show that if we can accept aspects of ourselves (namely the repressed unconscious) we can also accept 'foreigners'. Thus, she alludes to the concept of the abject to demarcate subjectivity through nationalism. She further explores the concept of identity in a national context in *Nations without Nationalism* and is trying to find a way of considering nationalism that does not radically polarize when she asks the following question. 'Is there a way of thinking politically about the "national" that does not degenerate into an exclusory, murderous racism, without at the same time dissolving into an all-encompassing feeling of "SOS Absolute Brotherhood"?'[17]

Kristeva draws on Freud's explanation of narcissism to suggest that national pride might be considered akin to the 'good narcissist image', but she struggles to find a psychoanalytical compromise to the apparent paradox of a non-racist nationalism. Norma Moruzzi finds it problematic that Kristeva, in addressing the horrors associated with maintaining a clear individual subjectivity, should evade issues of national identity. She points out that:

> while Kristeva's recent projects explore the relationships that have always existed between strangers and political or national communities, especially nation-states, she does not particularly address the question of the emotional resistance that often accompanies or disrupts this relationship. Given Kristeva's previous work on the violence of consolidation of psychoanalytical identity, it is odd that she seems to believe in an easily-achieved, generous solution to the problem of national identities.[18]

Moruzzi concludes that, 'in Kristeva's own work, the most relevant concept to be applied to her writings on national identity is her own analysis of abjection.'[19]

Sibley[20] and Derek Hook[21] also consider racism as national abjection. Hook draws direct parallels between the visceral reactions of racism and the physical revulsion associated with the abject. He calls this 'pre-discursive racism', but makes clear that it neither naturalizes nor essentializes racism. Since racism arises from a complex set of historical, social and cultural precedents, using abjection as a tool to define radical nationalism might be limiting. In this book, however, I draw clear parallels between the threat to the self and the threat to national identity, which present in similarly visceral ways. I thus consider abjection as a visceral, corporeal reaction to the threat of national integrity. I also focus on Sibley's notion of abject space, which he considers in *Geographies of Exclusion*. Sibley turns to Kristeva's *Powers of Horror* to explain the exclusion and marginalization of various groups, including gypsies and institutionalized subjects, but also expands his study to encompass discussions of more generalized racism. Further, he applies this geographical broadening of abjection to media imagery and filmic texts such as *Taxi Driver* (1976), where he describes the purification of the spaces of the city that are defiled through prostitution.

While there are parallels between Hook and Sibley's views, in *Remember the Titans* abjection operates at several levels with a return to a semiotic state and a subsequent renegotiation of the abject. In this context, the unification and rituals of sport help overcome the abjection of racism. In this chapter, we see how, through stylized cinematography, *mise-en-scène* and narrative, film can represent a semiotic world. While certain spaces are inherently abject (such as Gettysburg), sport is able to efface the border between racial groups through rituals of discipline and purification. In this way, abjection is represented as socially and culturally liberating rather than discriminatory. While Kristeva asserts that religion and (more recently) art offer ways of confronting and overcoming abjection, I propose that sport has an equivalent ability to foster unity through

ritual and ceremony. Space is significant to discourses of sport and racism because the very process of engaging in sporting activity is a spatializing practice.

Boundaries are significant, not only to national identity but also, and specifically, to individual displays of skill and masculinity. The football field is highly relevant to a discussion of abjection because the game may provoke feelings of extreme nationalism akin to racism. In *Remember the Titans*, the football field is the site of several racist comments and actions, not least the self segregation of the crowd. However, by the final game, the cohesion that the team exhibits overcomes any racist tendencies and unites both team and crowd in the desire for victory. It is at the training camp, however, where abjection is tested, policed and radically redefined and where a coherent adult masculinity subsequently develops.

Racism causes a volatile and unstable world at the training camp, where conflict and disorder are easily provoked. Space features significantly in this conflict and is frequently racially divided. Like the neighbourhoods of the earlier scenes, space is utilized to demarcate the boundaries of racial identity. Boone, however, attempts to redefine these boundaries. In part, he achieves this by homogenizing the group through a regime of training. This regime involves a separation from the maternal world and a renegotiation of abjection through sport and language. The team initially resists desegregation, which consistently provokes anxiety and disorder. Visually, the division of groups within, or by, the frame depicts this resistance. Narratively, it is first exemplified on their arrival at the training camp when Rev places his bag on a bottom bunk bed. Ray immediately claims the bed as his, saying, 'that's my bed'. When Rev moves to the bed above, Ray stops him again. Even at the training camp the space of black Americans is clearly marked as abject and excluded from 'white space'. As in the earlier neighbourhood scenes, the space blacks occupy is subject to constraint. Resistance to such constraint frequently results in

disorder. Racism as abjection is especially evident in the scene where Julius (Wood Harris) hangs a poster on the wall of their shared room, which causes conflict between him and Bertier. The poster refers to the 1968 Olympics when two African American medallists, Tommie Smith and John Carlos, raised their fists in the iconic salute of the Black Panthers during the playing of the American national anthem. Restriction of private space therefore actively promotes tension. The resulting violent outburst indicates that white Americans feel violated by black power. As a result, Boone refers to them as 'fifth grade cissies after a cat fight', thus equating their racism to a lack of masculinity. Boone considers that his role as father is to make the team control themselves and tells them, 'any two-year-old child can throw a fit … it's about control'. He trains the teams to channel their racist feelings into football, saying, 'football is about controlling that anger, harnessing that aggression'. He subsequently defines their masculinity in terms of performance and aligns failure with cowardice.

Boone therefore reorders the boundaries of abjection at the camp through physical control. The space of the training field is often abject because it is where the players confront difference. They ultimately overcome the abjection, however, through a training regime that forces them to move simultaneously and with precision. Boone punishes any deviation from this regime, thus compelling them to be identical and to relinquish racial difference. The film depicts their physical coherence in sequences of medium and long shots that cut back to re-establishing shots in which individual faces are indistinguishable. Boone's system thus transforms the training camp from an abject to a coherent and highly regulated space. To formulate and predict precise movement and strategy he even applies statistical analysis to games. He is therefore concerned with the specificity and sequence of movement, ordering a system of play that is commensurate with the symbolic. Visually, the team members appear as clones through uniform. The film

draws attention to this through *mise-en-scène* and cinematography, with low shots of the players' feet, which appear identical, and tightly framed shots of their similarly helmeted faces. They also chant simultaneously, 'mobile, agile, hostile!' in response to Boone's question, 'what are you?' They therefore become homogenized and regulated through sport, and have to relinquish racial structures that order their social world.

Boone's regime of dismantling racism not only involves the control of the physical body but also demands a psychological adjustment and change in attitude. Boone actually positions himself as a father figure. His comment, 'take a good look at your momma 'cos once you get on the bus, you ain't got no momma no more, you got your brothers and you got your daddy' may be explained with reference to psychoanalysis. Before going to camp, the players are dominated by their parents and appear to be devoted to their mothers, especially Bertier. Even at camp, there are repeated incestuous references to the mother figure. While Kristeva refers to the separation from the mother figure as one aspect of abjection, she rarely discusses the role of the father. In this film, the father figures of Boone and Yoast are significant. It is therefore relevant to discuss the separation from the maternal figure with reference to Freud since the semiotic space they revisit at training camp is devoid of maternal influence. Before they join the team, some players, especially Bertier, seem fixated at an Oedipal stage. Although they are high school adolescents, their parents, especially Bertier's mother, play a prominent role. In the Oedipal scenario Freud describes how

> at a very early age the little boy develops an object-cathexis for his mother, which originally related to the mother's breast …; the boy deals with his father by identifying himself with him. For a time these two relationships proceed side by side, until the boy's sexual wishes in regard to his mother

become more intense and his father is perceived as an obstacle to them. His identification with his father then takes on a more hostile colouring and changes into a wish to get rid of his father in order to take his place with his mother.[22]

Freud's theory is salient here in that, initially, members of the team are reluctant to leave their parents and resent Boone for threatening and punishing them. However, as they pass through the semiotic state that Kristeva associates with infancy, and subsequently unify, they eventually respect Boone and identify with him.

The training camp is therefore a space where the players exist in a pre-symbolic state. In retraining the team, Boone positions himself as the players' 'daddy', repeatedly asking them, 'who is your daddy?' The use of the word 'daddy' rather than 'father' specifically infantilizes them and this is alluded to in other scenes. As in many other institution films, they often appear semi-naked or wearing white underwear. Boone also states, 'I am the Law', establishing himself as the symbolic father and voice of the superego.[23]

The training school thus has parallels with the semiotic *chora*, where cultural and social signifiers of difference recede under Boone's new regime of unity and acceptance. Boone initiates this as the teams board the buses for the training camp. They spontaneously segregate into two separate vehicles according to race but Boone orders them off the buses and redivides them according to their football positions. He then forces them to pair up with a player of the opposite colour and thus initiates the process of their homogenization. He also instructs the team members to talk to each other and learn a fact about each other. This is important in encouraging them to identify narcissistically with each other. Thus, a sense of unity is engendered and they subsequently develop a new collective identity derived from sport rather than culture or race.

This further coheres with Kristeva's view of nationalism: 'by recognizing him [the stranger] within ourselves, we are spared

detesting him in himself.'[24] By forcing them to see similarities in each other, they regress symbolically to Lacan's 'mirror stage' and identify with each other using language. Lacan states that narcissistic identification occurs at the point when a child first recognizes himself or herself in a mirror and initiates the formation of the ego, or self.[25] This 'mirroring' effect is apparent through the multiple pairings of characters such as Sheryl and Nicky, Yoast and Boone, Bertier and Julius, and Blue and Lastik. We often see these characters positioned together in the same frame, initially as opposites, then mirror images of each other, and ultimately as close friends. Sometimes, these characters struggle to identify with each other. Sheryl and Nicky, whose differences are repeatedly emphasized, particularly exemplify this. Ultimately, however, they gain each other's mutual respect. One such pairing, however, fails to unify. Ray is unable to identify with Petey and uses any opportunity to emphasize difference by demeaning Petey. He therefore remains infantilized, suggested by his question, 'what's your daddy's name? Wait, you do have a daddy don't you?' (and his use of the word 'daddy'). Petey pointedly replies, 'I have a father', using language associated with adulthood. At camp, Boone's coercion of the team to socialize thereby begins the process of developing a coherent adult identity.

The significance of language to subjectivity is a central tenet of Kristeva's theory of maternal abjection, for she suggests that people begin to use language when they are subjects in formation. Similarly, in *Remember the Titans*, language signifies development towards subjectivity and an overcoming of abjection. It is prioritized in the first scenes of the film, which feature the text 'unity', 'strength', 'courage', 'brotherhood', 'pride' and 'team' sequentially. Since words reinforce the unifying aspects of narrative and cinematography, the use of this text is significant. Psychoanalytically, the use of language signifies entry into the symbolic world. Using language as a Lacanian 'mirror' to find commonality and likeness, they begin to mimic each other's figures of speech with white

Americans adopting the patois of black Americans. The use of the words 'bro' and 'power' explicate the fraternal bonds that develop, while they also begin to imitate each other's cultural gestures, for example, hand slapping. The team's developing adult masculinity is further embedded in their newfound group identity, suggested by the pre-game chant of, 'everywhere we go, people want to know, who we are, so we tell them, we are the Titans.'

In addition, music contributes to the early stages of their unification. Before the group begins to cohere, its members maintain their respective racial integrity through collective exhibition of cultural or social difference. They express this, in part, through music. Indeed, many of the early extra-diegetic music tracks are of black soul music. However, music as a cultural boundary is eroded, partly through Julius (who disapproves of his fellow team players singing together as he is conscious of inciting racism) and partly through Boone's discipline. Conversely, Lewie Lastik, who consistently aligns himself with black Americans (as other), actively initiates unity through music, especially gospel, soul and blues. There are several scenes when Lewie and Rev (Craig Kirkwood) sing together, encouraging their fellow team members to join in. Lastik's singing is stylized and emulates the black tradition of singing emotionally, perhaps allowing a vent for the excesses of passion Kristeva argues are normally contained within language.[26] Only Ray remains resistant to any fraternal cohesion through music, shaking his head disapprovingly when the rest sing together.

Kristeva considers music significant because it is set aside from language; it is prelinguistic and therefore semiotic. She argues that music is learnt before syntax, asserting that 'children learning a language first learn the intonations indicating syntax structure – that is melody or music – before they assimilate the rules of syntactic formation.'[27] She also suggests that music is assimilated prior to the mirror stage. 'So-called "artistic" practices have always exerted a fascination because they elude this boundary [the thetic break],

owing to which signification – always already in the form of a sentence – comes into being, and they revive the uneasiness that goes with regressing to a time before the mirror stage.[28]

While in the process of defining self and identity, Kristeva refers to the importance of language. Before entering the symbolic, the subject is bound to semiotic forms. Like certain literary texts, in which the syntax of language can signify through energy and rhythm, it is evident that music can operate in a similar way, since it communicates through emotion and tone as well as through words. This becomes apparent on the return from the camp, when the players sing together, unified through both music and sport.

Arguably, sport, like music, has semiotic qualities. While sport and competition fall into Kristeva's categorization of symbolic, given that they involve the measurement of performance, sport, like music, also has emotional meaning. Its power is not solely defined through language or winning times, but through feelings of national unity and the emotional uplift of victory. In *Remember the Titans*, the emotional, semiotic rhythm of winning is conveyed visually through a rapid editing style, with a combination of whip pans, fast tracking shots, slow motion tackles, close-ups and extreme close-ups. In later scenes, these are intercut with long shots of audiences standing and cheering, their arms outstretched. The semiotics of language are therefore translated into a visual form in a process of reforming identity and containing the abject. Frames that include black and white players in close proximity exemplify a new identity dependent on communality and team spirit. Moreover, the players begin to aggregate according to whether they are defensive or offensive players rather than according to skin colour and, in one scene, they eject Ray from the 'defensive' dining table. Although Boone has initiated the process of the team's racial politics, the pivotal point in their unification is at the grave scene at Gettysburg.

Gettysburg is the site of a battle of the American Civil War, which related to calls for the abolition of slavery and the resultant

conflict between the northern and southern states of America. It thus recalls the primary abjection of foreigners as slaves and their treatment as inferior and 'other'. In bringing the team to Gettysburg, Boone again exposes them to abjection, with a view to helping them understand the implications of their racism. While appearing as a peaceful and ordered space, Gettysburg is truly abject. Boone describes it as 'painted red and bubbling with the blood of young boys'. Boone also comments:

> Take a lesson from the dead. If we don't come together right now on this hallowed ground, we too will be destroyed, just like they were. I don't care if you like each other but you will respect each other and … maybe you can learn to play this game like men.

He thus equates masculinity and manhood with a rejection of racist beliefs, suggesting that the process of training is essentially concerned with retraining them to become men. Even though fraternity is closely linked with 'mirroring' each other, it is the scene at Gettysburg that affects them most profoundly, leading to positive effects.

In the game that follows the scene at Gettysburg, they begin to criticize each other for failing to play well, irrespective of skin colour. Further, the bond between Julius and Bertier becomes stronger, which is evident in several exchanges in which they verbally ritualize their common goal of victory. Multiple close-ups of players as they chant communally emphasize the cohesion of the group visually, aurally and narratively. The camera circles inwards with the inward swirl of bodies, again visually conveying the unity of the team. Their development to coherent adult masculinity is evident from the increased formation of heterosexual relationships on their return from camp and a detachment from parental figures, with the mother resuming her proper place. In addition, Lewie Lastik passes his exams and, while earlier describing himself as

'white trash', now declares to Boone, 'I'm eligible'. He therefore achieves a sense of adult identity because he proves his ability to communicate through language as well as music.

While at the training camp, however, the team's sexuality is sometimes ambiguous and largely undifferentiated. At times, this is reflected in gender representation. It is curiously evident in the almost balletic dance routine the team members perform before the game, and which becomes their signature mantra for victory. The scene is puzzling in the paradox of the hyper-masculinized costume they wear and the feminizing spectacle of their dance routine. This performance of 'otherness' is perhaps used to destabilize the opposition. Occasionally, however, the fraternal bonding that develops within the team borders on the homoerotic, with girls marginalized and sport taking the place of the mother. The homoerotic tendencies of some of the team become apparent in the locker room scene. In one scene, Ronnie 'Sunshine' Bass (Kip Pardue) suddenly kisses Bertier, saying to him, 'I think you know what I want.' The players, especially Bertier, react with disbelief and literally recoil. One player comments that, 'there's too much male bonding going on here for me.' But, despite Bertier's angry reaction, Julius dismisses the event as amusing and insignificant. It seems that the threat of homosexuality is trivial in comparison with the racism that has dominated their lives. In fact, the group rarely refers to it again and it is ultimately deemed irrelevant as Ronnie 'Sunshine' Bass becomes heroic by the end of film. Even Lewie Lastik's comments to the group that he has noticed that 'Blue wears leopard spotted bikini style underwear' seem inconsequential. In short, the team overcomes the marginalization of homosexuality as well as race.

The ambivalent sexuality existing at the training camp, especially in the locker room scenes, is consistent with Freud's views on infantile sexual development. As outlined earlier, Freud[29] states that infantile sexuality goes through oral, anal and genital stages. His theory of childhood sexuality explains that, in the normal process

of psychosexual development, a child passes through these stages to identify eventually with the parent of the same sex, though fixation at, or return to, the anal stage of sexuality may signal homosexual tendencies. Normally, however, the male child relinquishes his desire for his mother, which is replaced with a desire for another female. A resolution of the Oedipal complex is seen when the team leaves the camp; having overcome their feelings of abjection the players begin to develop a coherent adult subjectivity.

This development is thwarted, however, because they return to a world of racial politics that is still resistant to desegregation, especially at the school, where the mothers protest against it. The fathers also ask each other, 'what'd they do out there, brainwash them?' The families not only exclude the racial other, but also marginalize Sunshine because of his homosexuality, saying to him, 'we don't want you here either, hippy boy,' and Emma (Kate Bosworth), Bertier's girlfriend, refuses to shake hands with Julius when he is introduced to her. Moreover, during the Titans' early games, though the players on the field are united, the crowds remain segregated. Boone confronts the problem, commenting, 'we've got Hayfield tonight. They're all white – they don't have to worry about race, we do. We're better for it.' In this way, he suggests that embracing 'foreignness' makes them the stronger team.

However, after winning the match, Petey, Sunshine and Blue are turned away from a bar because Blue and Petey are black and Sunshine is homosexual. Their exclusion from 'white, heterosexual' spaces compromises their newly formed identity and, as a result, they begin to resegregate. Their newfound status is eroded not only by the surrounding bigotry but also by the power of the maternal figure. Bertier's mother refuses to accept Julius as his friend and insists that Bertier accompanies her to church. This suggests the reluctance of the mother to relinquish the child and, as in *Carrie*, implicates religion as a way of containing abjection.

Because the community's resistance to integration threatens to

destabilize the integrity of the whole team, Blue and Lastik arrange a meeting to resolve some of the issues. Their approach involves using religion and music to reunite the group and control its disintegration. The ritual and spiritual aspects of this scene are suggested by their handclapping and ritualistic dancing, and further emphasized visually by the shafts of light that emanate from the midst of the group as they spiral in together. Most of them participate in this ritual, though Ray remains resistant. Several close-up and medium close-up shots show him increasingly isolated and detached from the group. He is unable to find commonality with anyone in the team; he resents Boone (whom he refers to as 'Coach Coon') and cannot overcome his racism. While the rest of the team reunite, Ray remains an outsider, signified by his disappearance into darkness when Bertier drops him from the team for cheating.

Eventually, the external community begins to accept one another's colour and, after the Titans win their final game, whites and blacks are completely unified. Blackness is no longer radically excluded, but is signified, albeit sentimentally, as something positive and jubilant. This is indicated in the scene when a police car stops Julius and the police officer congratulates him on the Titans' success, thus challenging the audience's expectations. The acceptance of the black community is further evident in the news coverage of the Titans' successes, which is similarly celebratory. The news footage appears as a montage triptych rather than a structured narrative, the synchronization of the televised images again generating a visual rhythm that energizes and uplifts the spectator. The Titans' success makes Boone a hero to both black and white Americans and both sets of neighbours cheer him on his success. After winning the final game, the opposing team's coach rushes up to shake his hand without any sign of discrimination, indicating that, through sport, the marginalization of black Americans has finally been overcome. (The film is based on a true

story of the success of the Titans football team, which brought together the community of Alexandria.)

That sport in America, particularly American football, engenders almost religious fervour is indicated by the voiceover of Sheryl Yoast, who says, 'in Virginia, high school football is a way of life. It's bigger than Christmas Day.' While ritual is commonplace in all types of sport, it has a particular focus in this film, which supports a Kristevan view of addressing the abject. Ritual in sport, especially American football, often centres on spectacle and displays of team unity as a way of intimidating the opposition. This cohesion necessarily involves relinquishing individuality to the collective identity and often focuses on displays of aggression as a way of signifying masculinity. The game has inherent religious qualities, for black Americans regard Boone as a saviour and there are frequent biblical allusions throughout the film. Furthermore, there are specific references in *Remember the Titans* to religion playing a role in resolving racial difference and, as mentioned earlier, Lastik and Rev combine song and religion to unite the group.

Any sport, but especially American football, is ritualistic and has a religious dimension in the way it attracts a following. It also invokes certain ritualistic patterns, such as singing and clapping hands, which are analogous to religious observances and induce feelings of bonding and unity. Indeed, Varda Burstyn states that in sport 'these dimensions of feeling and identification approximate the experience of religion more than any other form of human cultural practice.'[30] This unity extends beyond individuals to whole nations and Burstyn goes on to suggest that 'Brazil's football culture is a form of national religion in itself.'[31] Burstyn says that there are two levels of religious experience in sport, namely the feelings of the individual involved in the sport and the collective identification of the larger audience with that individual's achievements. An example of this is the extensive coverage of David Beckham's foot injury in 2002. One newspaper headline read, 'World Waits on Beckham's Broken Bone. From No

10 to the Pub Pundit, from Leading Surgeons to Big Business, Everybody has an Opinion about the England Captain's Foot'.[32] There was almost a worldwide reaction to it, which perfectly illustrates Burstyn's point,

> When moments of primal physical intensity are socially shared through the performance of physical ritual, the athlete's intrinsic pleasure of bodily performance and his sacrificial pain, if pain has been involved, are crowned and embellished by a sense of belonging. The crowd feels a similar pleasure and pain and, if victory is achieved, a feeling of representation and affirmation.[33]

Similarly, the unifying aspect of sport is exemplified and magnified by *Remember the Titans*, both in its focus on scenes of ceremony and harmony towards the end, and also in its deployment of various cinematographic techniques. There are frequent close-ups of black and white players embracing, while long shots of scenes such as the final championship show an ethnically integrated crowd. Even Sheryl and Nicky, who have previously been unable to find any common ground, hug each other momentarily.

Clearly, the religious nature of sporting ritual enables the team to contain their differences and overcome them. This is particularly evident in the scene prior to the final game when they pray together. The religious and purifying context of the football field is further confirmed by Boone's comment that 'this is my sanctuary, right here. All that hatred and turmoil swirling round, but this is always right.' It implies that sport and its institutions are sites where difference may be resolved, thus offering ways to unify rather than divide.

Conclusion

Remember the Titans demonstrates how Kristeva's theory of abjection may be interpreted differently. While Creed links abjection to the

feminine body as a negative phenomenon, the way in which this film overcomes abjection by demarginalizing the other is inspirational and positive. Moreover, *Remember the Titans* is associated largely with the male body and is devoid of scenes of disgust or bloody horror, though these are alluded to at Gettysburg. By confronting abjection with discipline and sport, and at the graves at Gettysburg, the boundary between the different groups recedes. While Creed[34] argues that difference gives rise to images of horror in which a perverse pleasure is derived, this film suggests that the resolution of difference may also be represented in ways that generate pleasure through inspiration and unity through renegotiating abjection. This pleasure emerges partly in distinctive editing and cinematography. It is analogous to the semiotics of language that Kristeva describes, whose meaning derives from rhythm and emotion rather than words and text. Even though Kristeva signals the archaic spaces of the abject to be inconsistent with individuality and a place where identities barely exist, this film shows how a return to a semiotic state encourages a group identity to develop founded on sport rather than ethnicity or race. Rituals of sport allow confrontation with the other but also embrace nationalism without racism. This process, however, involves working through abjection so that individual identities do not remain suppressed. Instead, the semiotic persists and accompanies development to the symbolic, as suggested by Kristeva in her analysis of literature.

Discrete quantities of energy move through the body of the subject who is not yet constituted as such and, in the course of his development, they are arranged according to the various constraints imposed on this body – they are already involved in a semiotic process – by family and social structures. In this way drives, which are 'energy' charges as well as 'psychical' marks, articulate what we call a *chora* [original emphasis]: a nonexpressive totality formed by the

drives and their stases in a motility that is as full of movement as it is regulated.[35]

One way of interpreting this semiotic world is to use frequent intra- and extra-diegetic musical scores, which are synchronized with cinematography and editing and thus tend to dictate the 'syntax' of the film's visual style. The focus is on the feelings and emotions that success and unity generated rather than on empirical signification.

Arguably, in *Remember the Titans* music and sport replace the loss of the maternal figure as the team identifies with Boone and enters the symbolic. Like the opening scenes, the final frames show black and white Americans intermingling as a group to emphasize their unity. In the closing frames, a close-up of Mrs Bertier (Marion Guyot) with her white hand holding Julius's black hand, offering a clichéd symbol of unity, signifies racial acceptance and equality. The final image of Yoast and Boone standing side by side reinforces this harmony.

In *Remember the Titans* abject spaces, especially the training camp and football field, encourage a reappraisal of values affirming morality, honesty and collective effort, and impugning cheating and corruption. This concurs with Kristeva's views on abjection as racism, as she concludes in *Strangers to Ourselves*.

A paradoxical community is emerging, made up of foreigners, who are reconciled to themselves to the extent that they recognize themselves as foreigners. The multinational society would thus be the consequence of an extreme individualism, but conscious of its discontents and limits, knowing only indomitable people ready-to-help-themselves in their weakness, whose other name is our radical strangeness.[36]

While there is perhaps an argument that sport potentially volatizes racial discord, Moruzzi also recognizes optimism in Kristeva's dis-

cussion of the return of the abject. She refers to the following passage in *The Powers of Horror*.

> The abject is the violence of mourning for an 'object' that has always already been lost. The abject shatters the wall of repression and its judgements. It takes the ego back to its source on the abominable limits from which, in order to be, the ego has broken away – it assigns it a source in the non-ego, drive and death. Abjection is a resurrection that has gone through death (of the ego). It is an alchemy that transforms [the] death drive into a start of life, of new significance.[37]

Moruzzi uses this quote to define and substantiate an underpinning optimism in Kristeva's discussion of national identity, arguing that, 'given this perspective, we would assume that the disintegration and degeneration of the fixed identity of the nation-state, or the national, need not mean the end of political identity or participation, though it may transform national identity, both individual and collective, as we know it.'[38]

Adopting Moruzzi's reading of Kristeva we can therefore interpret the unity and integration expressed in the film *Remember the Titans* as an overcoming of the abject and a revitalization of nationalism. While Kristeva describes how literature and art have replaced religion as ways of confronting and containing abjection, I suggest, in interpreting *Remember the Titans*, that sport and music are also significant. At the individual level, the film shows how Bertier ultimately overcomes the personal trauma of physical injury through sport. At the collective level, this true story shows how the institution of sport, in its proximity to religion, can instil self-belief, inspiration and team spirit. Through the semiotics of cinematography, editing, *mise-en-scène* and narrative, *Remember the Titans* demonstrates that such qualities can simultaneously both promote national identity and overwhelm barriers of difference.

Chapter 3

Ordering the Military Body: *Full Metal Jacket*

Full Metal Jacket (1987, directed by Stanley Kubrick) charts the transformation of young American males into fighting machines at a military boot camp Sergeant Hartman (Lee Ermey) supervises. Hartman imposes a relentlessly abusive and cruel regime on the recruits, which represses their individuality by infantilizing and emasculating them. Hartman assigns each recruit a new name, thereby erasing their previous identity, while their new identities, as soldiers, are forged through their abilities to kill. Any deviation from this is seen as a weakness that the film consistently aligns with the infantile, homosexual or feminine body. One recruit in particular becomes the object of Hartman's abuse and ridicule – Gomer Pyle (Vincent D'Onofrio), as Hartman names him, who appears overtly infantilized.

While Private Pyle eventually attains the 'born again hard' masculinity that Hartman inculcates in the recruits, his repressed feelings towards the drill sergeant eventually lead him to shoot Hartman and then himself. This scene, which dissects the narrative, is climactic in its breakdown of the highly ordered regime that characterizes the first half of the film. Space is especially important to the narrative since it is in the meticulously ordered 'head' (the communal toilet) that Hartman's killing occurs. The head is significant since its function demands an exacting repression of the abject within the cadets. Paradoxically, while it is a site of intense control, it is where abjection emerges.

Hartman's killing serves visually as a trigger to the disorder that characterizes the second half of the film. This moves from the boot camp on Parris Island to Vietnam, where, in the final scene, the other key protagonist, Private Joker (Matthew Modine), kills a female Vietnamese sniper. There has been much discussion of Kubrick's depiction of the racialized[1] or sexualized other[2] and equation of both as dangerous and contaminating. I suggest that although Pyle is feminized and dangerous, equating with the female Vietnamese sniper at the film's end, it is the development of infantilized yet 'born again hard' masculinity that proves to be monstrous. While several authors consider that Joker's killing of the sniper initiates him to manhood, I argue that abjection, arising in the toilet scene and in the killings in Vietnam, consolidates Joker's morality. Further, in his killing of the sniper, he shows a compassionate and coherent version of 'new' masculinity as described by Susan Jeffords.[3] This again resituates Creed's notion of the abject as predominantly associated with the feminine body. Instead, I suggest that the male body, through the processes of boot camp and warfare, transforms into a subverted version of sadistic masculinity that closely aligns with Freud's sadistic-anal stage of psychosexual development.[4] Therefore, while the men are masculinized, they remain paradoxically infantilized. It is a contradiction that the film never fully resolves since towards the end of the film, even as fully-fledged soldiers, they appear to remain mired in infantilism. Because the soldiers are persistently exposed to abjection, they are inured to aspects of the horrific, notably those associated with the Vietnam War.

The erasure of the new recruits' individuality begins in the opening scenes when they have their heads shaved. The removal of their long and distinctive hairstyles immediately makes them uniform and initiates their infantilization. This scene also perhaps evokes popular myths that describe how shaving a man's hair depletes his strength and masculinity,[5] while Gresham Sykes[6] suggests that it is a form of degradation. The repetitive editing of

the hair-shaving sequence renders it almost ceremonial, forming one of a series of rites and rituals that insistently structure the first section of the film and that serve to mark and sanctify the film's abject aspects. Subsequently, various marching, physical training and rifle drills achieve the cadets' conformity and removal of adult identity. Hartman's barrage of abuse further contributes to their loss of masculinity. Comments such as 'I will unscrew your head and shit down your neck,' and 'I will definitely fuck you up,' both humiliate and feminize the cadets by suggesting them to be penetrated and passive receptacles. According to Elizabeth Grosz, the potential of a body to be a 'passive receptacle' rather than an 'active agent' in the transmission of bodily fluids arouses anxiety in men. While she refers to the fluidity and seepage associated with the feminine body, she asserts that, 'perhaps it is not after all flow in itself that a certain phallicized masculinity abhors but the idea that flow moves in two-way or indeterminable directions that elicits horror, the possibility of being not only an active agent in the transmission of flow but also a passive receptacle.'[7] Hartman's abuse not only focuses on the recruits as 'passive receptacles' but also addresses the cadets as 'ladies', 'sweethearts' or 'queers'.

The cadets subsequently perform as a single body (often referred to as the corps or Mother Green) with uniformity sustained through precisely synchronized movement. They also chant ritual-istically as one voice, 'I love working for Uncle Sam, lets me know just who I am.' As in *Remember the Titans*, the boot camp erases their former identities and reconstructs them as killing clones. The boot camp scenes are generally extremely highly ordered, with any aberration subjected to Hartman's disciplinary action. He defines any deviation as feminizing, thus instilling in the cadets a hatred and repression of the feminine, both in themselves and in women in general.

Hartman links femininity and homosexuality to contamination and impurity with references to the cadets as 'pukes', 'maggots',

'filthy sewers' and 'shit'. James Naremore[8] asserts that this focus on lower bodily strata is consistent with the grotesque,[9] for shit is a constant feature throughout the film. For example, Hartman says to one recruit: 'looks to me like the best part of you ran down the crack of your mama's ass and ended up as a brown stain on the mattress.' Hartman also refers to them as 'unorganized, amphibian shit' and asks one cadet, 'how tall are you, private?' When the cadet responds 'five feet nine', Hartman's riposte is 'I didn't know they stacked shit that high.' I argue, however, that since the boot camp centres on repressing the cadets' identity and attempts to return them to an infantile state, such aspects emerge in the broader context of abjection. In one barracks scene, Hartman physically inspects the cadets' hands and feet as if they were children. He also informs the cadets that they will no longer have sexual relationships with women, for 'your days of finger banging old Mary Jane Rottencrotch are over.' While this denies them an adult sexual identity, it also suggests, as Paul Williams implies, that they will have to resort to other sources of sexual pleasure since 'the possibility of an emotional tie to a woman is replaced by the intimacy of the phallus, the rifle given girls' names by the marines. They must rely on themselves for pleasure.'[10]

At the same time Hartman instils in them the need to eliminate compassion or hesitation in killing the enemy. 'If your killer instincts are not clean and strong you will hesitate at the moment of proof – you will not kill, you will become dead marines and then you will be in a world of shit.' Compassion implies femininity, and to be men they need to develop their ruthlessness and suppress any sympathy for the enemy. This is particularly evident in the second half of the film in that the soldiers harbour no sense of immorality about killing women, children and innocent civilians. Indeed, they rejoice in their slaughter. As Joker and Rafter Man (Kevyn Major Howard) approach the front by helicopter, a gunnery soldier is shooting civilians. Indicating his compassion and sense of

humanity, Joker asks him, 'how can you shoot women and children?' To this the laughing soldier replies, 'easy, you just don't lead them so much.'

Freud delineated this denial and reversal of adult sexuality, together with a propensity for cruelty without pity, as one of the stages in the development of infantile sexuality. As he wrote, 'it may be assumed that the impulse of cruelty arises from the instinct for mastery and appears at a period of sexual life at which the genitals have not yet taken over their later role.'[11] Freud established that the relationship between sexuality and violence occurs at the child's anal stage of development when the anus functions as an erotogenic zone. Mastery of the bowels affords the child a certain power and Freud held that this power can manifest as cruelty in the pregenital phase.

> A second pregenital phase is that of the sadistic-anal organiz-ation. Here the opposition between two currents, which runs through all sexual life, is already developed: they cannot yet, however, be described as masculine and feminine, but only as 'active' and 'passive'. The *activity* [original emphasis] is put into operation by the instinct for mastery through the agency of the somatic musculature.[12]

Freud also describes a tendency to scopophilia as an alternative to sadism at the sadistic-anal stage. While Mulvey extrapolated this theory in her explanation of visual pleasure and narrative cinema,[13] I argue that in this film Freud's theory is directly relevant to the representation of the cadets. The cadets' sexuality is repressed to a similar pregenital sadistic-anal phase, implied by the film's focus on anality, and its many references to anal penetration, homosexual sex and shit. This approach also explains a propensity to cruelty, par-ticularly without pity or conscience, and the relationship that manifests between sex and violence. The cadets' marching chant of

'I don't want no teenage queen, I just want my M-14' explicitly articulates the sex-violence analogy. Violence thus satisfies a sexual desire unavailable through normal adult relationships. Freud's theory may explain why characters such as the innocent, blond haired Rafter Man do not engage in this cruelty. It is interesting that Joker's task is to look after him, establishing Joker in a parental role for a second time. Rafter Man, who is repelled by the killing of innocent civilians (he vomits as the gunnery soldier shoots civilians) 'shoots' instead with his camera and is therefore scopophilic through his photography. The camera as an alternative to the rifle is made explicit in the attack on Hue when Rafter Man carries his camera in the same way as the others carry their rifles. Scenes of the soldiers shooting at the Vietnamese intercut with Rafter Man photographing them.

Animal Mother also suggests scopophilia as an alternative to killing when he asks Joker if he has 'seen much combat', with the emphasis on the word 'seen'. The theme of scopophilia further emerges through the deployment of a camera crew. Although there is an emphasis on anality, there is little evidence of an earlier pregenital sexuality, the oral phase; in fact, apart from Pyle's jelly doughnut, there are no scenes of eating or drinking in the film.

Adult masculinity, usually in part associated with the development of reasoning and a conscience,[14] is instead measured by the ability to kill[15] and is articulated through the cadets' use of their rifles. The cadets, who assign girls' names to their rifles, perform their rifle drill while lying on their beds. The equation between sex and violence is consolidated by their marching chant of 'this is my rifle, this is my gun, this is for firing, and this (as they hold their crotches) is for fun' (see Figure 2). This has particular resonance for Private Pyle and for the sexualizing of the bathroom scene.

Private Pyle appears overtly emasculated from the outset as Hartman refers to him as 'a disgusting fat body', and then makes him perform a masochistic self-choking. Cinematography, espe-

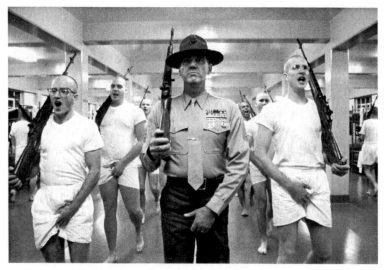

Figure 2 *Full Metal Jacket* (Stanley Kubrick, 1987) © Warner Bros. Inc.

cially the use of the close-up, repeatedly emphasizes his fatness, an aspect of representation that Antony Easthope suggests is feminizing.[16] Masculinity on the other hand, he asserts, is bound to musculature.

> For the masculine ego the body can be used to draw a defensive line between inside and outside. So long as there is very little fat, tensed muscle and tight sinew can give a hard clear outline to the body. Flesh and bone can pass itself off as a kind of armour.[17]

Films made in the immediate post-Vietnam era were particularly associated with such displays of musculature. *Full Metal Jacket* (1987) emerged at the same time as a series of what Yvonne Tasker refers to as 'muscular movies', which defined their heroes through the muscular male body. Tasker describes how 'films such as *Indiana Jones and the Temple of Doom*, *Commando*, *Die Hard* and *Predator*

paraded the bodies of their male heroes in advanced stages of both muscular development and undress,'[18] which she asserts were 'potentially parodic'. A more sensitive, caring and fatherly masculinity displaced these muscular heroes during the late 1980s. Jeffords describes this new masculinity as evident in films of the Reagan era, including *Three Men and a Baby* (1987), *Look Who's Talking* (1989) and *Regarding Henry* (1991). She suggests that, 'the vehicle for that transformation is fathering, the link for men to "discover" their "new" internalized selves.'[19] The evolution of this 'new man' imagery is countered, Jonathan Rutherford[20] argues, by another representation of masculinity, that of 'retributive man', which resists feminized male identities and re-establishes a classic macho masculinity.

While the development of these polarized versions of masculinity materialize in the latter half of the film (in the characters of Joker and Animal Mother respectively, which I discuss later), initially all the cadets are infantilized, particularly Pyle. Hartman derides him not only for his fatness but also for his inability to perform physically on the obstacle course, and then emasculates him further by renaming him 'Gomer Pyle'. The name is taken from an American television show entitled *Gomer Pyle USMC* (1964–69) featuring Jim Nabors who was allegedly homosexual. The unremitting psychological trauma Pyle experiences from the series of humiliating measures to which Hartman subjects him finally culminates in Pyle killing Hartman and then himself in the communal toilet.

While the corps functions as a maternal entity (in that it is often referred to as Mother Green), Hartman, who on several occasions speaks of 'his beloved corps', is a father figure. Even though his physical stature is not overtly muscular and he rarely engages in physical activity, he dominates through displays of brutality towards the cadets. His masculinity also derives from the control he exerts through using abusive language. A significant part of the cadets'

humiliation arises from his constant stream of verbal abuse, which is one of the most noticeable aspects of his character. As discussed earlier, the use of language, according to Kristeva, is associated with the symbolic world of the father. Hartman also dominates through surveillance. Like Boone in *Remember the Titans,* he watches the cadets' performance closely during rifle drills and physical assault courses, continuously on the look-out for aberration. Indeed, Hartman dominates the first half of the film.

The first section takes place at the boot camp on Parris Island, the second half in Vietnam. The visual discontinuity of the two halves has provoked some criticism,[21] with the first half often seen as being stronger.[22] The reasons for this may include its faster pace of editing and dialogue, and overall purposefulness. One criticism of the second part is its apparent lack of direction, much like the activities of the newly fledged marines. The difference in the two halves may also be explained using abjection as an approach to the film's interpretation.

The first section of the film is highly ordered, with Hartman suppressing all aspects of the recruits' individuality, especially their sexuality. Humour frequently relieves the harshness of the recruits' indoctrination, shown, for example, through Pyle's compulsory self-choking. As Kristeva notes, 'laughing is a way of placing or displacing abjection'.[23] The high degree of order also stems from a number of rituals and repetitive events that stabilize visual and narrative structure. The cadets' extreme oppression, however, predictably gives way to short bursts of explosive disorder, exemplified through the night attack on Pyle, the killing of Hartman and Pyle's suicide. The spectator experiences similar tensions as the characters, with the cathartic scenes of disorder providing both narrative and aesthetic pleasure. For example, the scenes of the night attack are stylized through lighting, while slow motion cinematography exaggerates the bloody spectacle of Hartman and Pyle's deaths.

In the film's second half, set in Vietnam, the oppression experi-

enced in the boot camp leads to the formation of an exaggerated but subverted masculinity, which makes the marines mostly impervious to the horrors of war. These scenes represent a more unstructured, semiotic world, signified through fluid, tracking cinematography that lacks the symmetrical framing of the first half. This immersion in the abject aspects of war is also devoid of any form of ritual, though other visual spectacles take their place. These range from aesthetic images of warfare to the frequent sights of death and decay in the devastated city of Hue. The second part of the film therefore lacks the humour and cohesion of the first part.

The world of the boot camp comprises the obstacle training course, the drill range and the barracks. The orchestration of movement through the spaces of the obstacle course is less regimented than in other spaces but still requires control of the physical body. Men have to prove their masculinity through repetitive displays of strength and endurance. The open spaces afforded by the obstacle course allow for such performance. Private Pyle, however, cannot perform physically and is unable to complete one pull up or climb over a single obstacle. Cinematography and framing emphasize his rounded physique visually, especially his abdomen, which is frequently visible.

Pyle also fails to prove himself on the drill range where the cadets' movements have to be precise and orderly. As they perform the drill, Hartman specifies to Pyle, 'four inches from your chest, Pyle, four inches!' The ritualistic and orderly movements of the drills serve to sanctify the use of their rifles and the subsequent acts of killing. It is one way of confronting and containing the abjection associated with warfare. Because Pyle fails to complete the rifle drill correctly, Hartman makes him walk a distance behind the rest of the recruits with his trousers around his ankles, sucking his thumb. He thus appears overtly infantile and 'other'. Hartman even says to him, 'you want to be different, Pyle!' Joker, who is appointed as squad leader, is given the task of 'training' Pyle in the practices of

everyday life, which, in effect, are those of adult life. Hartman tells Pyle, 'you will bunk with him! He [Joker] will teach you everything. He'll teach you how to pee.' This places Joker as a nurturing parental figure, fulfilling Jeffords[24] description of a 'new' masculinity founded on fathering roles. Joker teaches Pyle how to load his gun, lace his boots and make his bed. He also trains him to complete the obstacle course and perform the rifle drill correctly. In these scenes, Pyle watches Joker intently and looks up to him with an expression of awe and love, as if Joker were his father. Indeed, Joker potentially occupies the role of both parents as Pyle sinks irretrievably into infantilism. At one point, he even dresses Pyle. This scene shows Joker and Pyle standing very close together and again suggests the homoerotic tendencies of the film as Joker asks Pyle to 'tuck his shirt in'. The relevant scenes show the slow and painful progress that Pyle makes, with Joker encouraging him in a parental role, saying, 'atta boy', again consolidating Pyle's infantilism.

In the barracks, Pyle is further marked as different and outside the group. This transpires through events that break with the otherwise extremely ordered nature of the barracks. Cinematography and framing accentuate orderliness through a focus on both the symmetry and geometry of the *mise-en-scène*. The camera often occupies a central position and camera shots tend to be protracted and fixed. In one sequence, the cadets stand at the foot of their uniformly arranged beds wearing only their white underwear (which suggests their infantilism), when one of several disruptive events occurs. The first arises when Hartman discovers a jelly doughnut in Pyle's foot locker. Psychoanalytically, we can interpret this as indicating Pyle's fixation at an (early) oral stage of psychosexual development, as Freud described.[25] Hartman humiliates Pyle by forcing him to eat the doughnut while the other cadets perform press-ups as a punishment for Pyle's aberrant behaviour. Later, the barracks again becomes disorderly through the release of the marines' repressed resentment for Pyle's lax self-discipline. While Pyle is asleep, his

vest pulled up, exposing his soft, fat belly, the cadets tie him down and hit him in turn. Although Joker is reluctant to strike Pyle and initially resists, he too eventually joins in. Pyle cries as they beat him, confirming his infantile state. In this world of shit, where violence equates with sex, Pyle's beating perhaps represents a form of (homo) sexual abuse and anticipates the cadets' sadistic pleasure in the killings in Vietnam. Only Joker sustains any sign of conscience or guilt as he covers his ears to Pyle's cries.

The third and most significant episode of disorder arises in relation to Pyle's relationship with his rifle, which leads to Hartman's murder. A later barracks scene finds the cadets crouching down astride their foot lockers, polishing their rifles, which are an obvious phallic symbol. As they obsessively polish them (the action appears masturbatory, though the communal nature rather suggests homo-sex), Pyle pays excessive attention to his rifle and Joker notices, with apparent concern, that he is talking to it. Pyle, fondling his rifle, says, 'so that it slides perfect, nice ... everything cleaned ... oiled ... so that your action is beautiful ... smooth Charlene.' The obsessive and ritualistic cleaning that pervades the film therefore extends to the rifle where its possibilities as both symbolic homosexual penis and killing machine are contained. It also marks Pyle's transition from the oral stage to the sadistic-anal stage of psychosexual development.

The compulsive rifle-cleaning ritual spills over into the following two scenes in which the cadets are first framed mopping the barracks. There is then a rapid cut to Joker and Cowboy cleaning the 'head'. As if both to substantiate and to negate the possibilities of homo-sex implicit in the rifle cleaning scenes, Joker comments that 'I want to slip my tube steak into your sister. What do you take in trade?' to which Cowboy responds, 'what ya got?'

The 'head' is an ambivalent space and it provides the setting for the climactic scene of the film. It is arguably the most repressed space of the film and, in a place normally associated with 'letting

go', there has to be careful control. The possibility of the penis on display and the homoerotic connotations of the anus threaten hetero-normative masculinity. Ultimately, any propensity to linger in a space aligned with seepage and fluidity suggests a body out of control. Such proximity to the abject is potentially feminizing and a threat to the cadets' budding masculinity. As a space of potential disorder, the 'head' in *Full Metal Jacket* has much in common with other toilet scenes in mainstream American film. While narratively a significant space, visually it becomes an abject one, the men's toilet having a fundamental meaning that extends beyond *Full Metal Jacket*.[26]

While Ruth Barcan[27] suggests that men's toilets tend to be 'dirty spaces', in *Full Metal Jacket*, the 'head' is the site of excessive and meticulous cleaning rituals and is almost considered a shrine. Indeed, Hartman orders Joker to clean it, with the instruction, 'I want that head so sanitary that the Virgin Mary herself would be proud to go in there and take a dump.' While the 'head' is a potentially abject space, its design makes it especially so, particularly within the confines of an all-male community. The need to contain potential abjection explains the ritualistic and excessive nature of its cleaning.

A key scene relevant to a discussion of abject spaces begins with Private Joker checking the dormitory at night. He opens the bathroom door and shines his torch around to rest on Private Pyle who is sitting on a toilet. The toilet is pristine and one of a regimented row of communal toilets, lidless and completely devoid of privacy. The stalls and urinals that usually characterize the male toilet are absent. Barcan suggests that men's toilets are where 'heteronormative masculinity is defined, tested and policed'[28] and that they are designed to disavow the homoerotic connotations of the anus. In this scene, however, it is impossible to conceal bodily orifices. Kubrick's deliberate insertion of the toilet scene – in Gustav Hasford's original novel, *The Short Timers*, Hartman's mur-

der took place in the barracks[29] – suggests that its narrative function and design are significant. The open, lidless design not only means that bodies are on display but also that the process of excretion is public. Easthope[30] asserts that men need to keep tight control of bodily orifices, not only because of the possibility of homosexual penetration but also because the abject inner body detracts from masculinity. The extreme cleanliness of the communal toilets is therefore significant because it seems to deny a relation to the abject body.

For Kristeva, as discussed earlier, the abject inner body has links to the feminine body through childbirth and menstruation. Clearly, she considers the female body closer to abjection than the male one in that 'polluting objects fall schematically into two types: excremental and menstrual. Neither tears nor sperm, for instance, although they belong to the borders of the body, have any polluting value.'[31] Grosz explains Kristeva's views by stating that 'seminal fluid is understood primarily as what it makes, what is achieves, a causal agent and thus a thing, a solid,'[32] but she disputes Kristeva's emphasis on the abject female body by suggesting that semen is also polluting. In this film, Hartman's words to Pyle, 'I'm going to wring your balls off so you can't contaminate the rest of the world,' specifically suggest the contaminating effects of semen. While this might imply that disease and abjection relate to seminal fluid, in the light of Hartman's tirade against Pyle, it may also mean that Pyle is contaminating in the same way as a woman. Arguably, men's toilets carry the threat of feminization because of this fluidity, particularly since the penis is used for both urine and seminal fluid and because of the potential for homoerotic penetration. Thus, the communal toilet depicted in *Full Metal Jacket* is particularly susceptible because of its open design. Further, it denies certain socio-cultural aspects of adulthood associated with the privatizing of such bodily functions. For both reasons, the toilet scene brings men closer to abjection.

The cinematography and *mise-en-scène* of the toilet scene in *Full*

Metal Jacket enforce these potentially emasculating effects. Pyle sits on the toilet with a rifle magazine between his legs, his body feminized by its softness and infantilized by his white underwear. The rifle, an obvious phallic symbol, stands for the fully-fledged masculinity he desires if he is to escape the 'shit' in which he exists. As he begins to load the magazine with live rounds, Joker asks him, 'are those live rounds?' Pyle replies, 'seven six two millimetres, full metal jacket', indicating that his rifle is fully loaded and primed. Joker attempts to reason with him by saying, 'if Hartman comes in here, we'll both be in a world of shit.' Pyle, whose rolling eyes, gaping mouth and half-lit face suggest mounting derangement, replies, 'I am in a world of shit,' and then starts to practise the rifle drill that defines the sexual nature of the relationship with his rifle. At that point Hartman, wearing only his hat and underwear, enters the bathroom. A long shot, which makes him seem much smaller in the frame than Pyle, emphasizes his comic appearance. Conversely, Pyle, whose weapon is loaded, attempts a final grasp at adult masculinity by shooting Hartman. The framing shows Pyle in profile with the gun held at hip height, which reinforces the rifle as a phallic symbol and the act as sexual. As blood ejaculates from the drill instructor's chest in slow motion and Pyle emits a sigh as he shoots Hartman, the order of the toilet is disrupted. Violence between men clearly equates with sex, as either a male rape or homosexual act. (This theme is reiterated throughout the rest of the film in which extreme violence against women is associated with rape.) In a final loss of control, Pyle slumps back on the toilet seat, places the rifle in his mouth and shoots himself through the head – his blood splatters the whiteness of the tiles. While the act is in itself shocking, the aesthetic, bloody spectacle distracts the spectator from its homoerotic connotations.

Arguably, Pyle killing Hartman, the father figure, is Oedipal and motivated by hatred and an inability to identify with him. Alternatively, the scene suggests repressed homosexual desire. Given the

87

humiliation to which Hartman has subjected Pyle and the repressed sexuality the cadets endure, it more likely represents a homosexual rape, symbolizing the sadistic-anal tendencies Freud[33] describes. Pyle's suicide arguably comes from his hatred of the feminine in himself, signified by his decision to place the rifle in his mouth.

Pyle's feminization in relation to the toilet scene is significant in that it dissects the narrative. The second half of the film, which directly follows the toilet scene, moves to Vietnam and ends with the death of a female sniper. Several authors[34] note the homology of these scenes and the representation of the other in each of the two segments as dangerous. Pyle is infantilized and dangerous, and his actions parallel those of both the prostitutes and the woman sniper who kills the other soldiers towards the end of the film. Therefore, while the 'head' scene is narratively significant in its dissection and repetition of storylines, it functions to indicate that Pyle's masculinity is precarious and ultimately unattainable.

The second half of *Full Metal Jacket* shifts from one 'world of shit' to another. While the first half visually orchestrates uniformity and regulation of movement through its precise framing and *mise-en-scène*, the second half is disordered, chaotic and dirty. Everything is contaminating, especially the Vietnamese women who are often depicted as prostitutes. We see this through an abrupt cut from Pyle's bloody death to the swaying movements of a Vietnamese prostitute as she walks across the screen. In contrast to the boot camp, where all movement is precise, the prostitute symbolizes the unpredictability and confusion of Vietnam, which is marked as feminized and 'other'. While the boot camp aims to infantilize the cadets and ultimately trains them to repress aspects of the disgusting body, the second half constitutes an unequivocally abject world. In Vietnam, the soldiers fail to recognize the horror of their actions, and the distinction between morality and immorality disappears. Like the infant who fails to recognize its own excrement as contaminating, there is, in several scenes, a joyous

wallowing in the abject. Kristeva notes how 'one does not know it [abjection], one does not desire it, one joys in it. Violently and painfully. A passion. ... One thus understands why so many victims of the abject are its fascinated victims – if not its submissive and willing ones.'[35]

This is evident in the scene when Joker meets Cowboy's platoon. Sitting next to Crazy Earl (Kieron Jecchinis) is a soldier with his face covered by a hat, as if asleep. Crazy Earl removes the hat to reveal that the Vietnamese soldier is dead. The sight of the dead soldier is shocking to the spectator, but the marines appear indifferent or amused, and display neither physical revulsion nor moral repugnance. Kristeva notes that the corpse would normally induce horror, stating 'as in true theater, without make-up or masks, refuse and corpses show me what I permanently thrust aside in order to live.'[36] In a separate incident Joker, in his role as combat correspondent, reports on a Vietnamese civilian mass grave. While Joker's face shows revulsion, another marine is more concerned about his appearance for Rafter Man's camera and appears indifferent to the deaths. The only other display of compassion is Animal Mother's reaction to the protracted, bloody deaths of his two fellow marines, Eightball (Dorian Harewood) and Doc (Jon Stafford). As they writhe in agony, each round of gunfire causing blood to spray in slow motion, in one of the film's rare examples of humanity or bravery Animal Mother tries to save them.

Vietnam appears as a world still largely governed by the maternal (army) and a place where many aspects of masculine subjectivity remain suppressed. Apart from Animal Mother hiring a prostitute, the only evidence of sexual activity is Hand Job's (Marcus D'Amico) purported overzealous masturbation, for which he is being psychiatrically assessed. While this could indicate a shift from the sadistic-anal phase of autoeroticism to the genital stage, as described by Freud,[37] Hand Job is clearly fixated at this level and is unable to progress to adult sexuality.

On numerous occasions, the cadets refer to Vietnam, specifically the war zone, as 'being in the shit' and there are repeated references to homosexuality and anality. The newspaper editor of *Stars and Stripes* describes the situation in Vietnam as, 'one huge shit sandwich' and comments that his duties keep him 'in the rear with the gear', and on 'rear echelon paranoia'. However, although the *mise-en-scène* depicts the war zone as a burnt-out wasteland, this 'world of shit' is seductive to the bored soldiers. Even Joker and Rafter Man, the innocent, blond haired photographer, express a desire to 'be in the shit', suggesting the intrinsic attraction of the abject. There is a similar fascination for the viewer, which partly lies in the aesthetic depiction of the war zone and the use of saturated colour, deep focus and stylized framing. Given the film's preoccupation with anality and shit, it is possible to interpret these often circular framing devices as anal orifices. Exemplar scenes include the framing of the two dead soldiers in a round grave and the circular framing of Animal Mother, Cowboy, Joker and Rafter Man in an entrance portal. The sniper also shoots Cowboy and some of the other recruits through shell holes in buildings and, significantly, we see the sniper's point of view through one of these holes. Another source of fascination for the viewer is, perhaps, the apparent borderline madness of the recruits and their disregard for human life. The scenes of Vietnam therefore alternate visually and narratively between fascination and disgust, with persistent reference to lower body strata.

The latter part of *Full Metal Jacket* therefore lacks the aesthetic and narrative coherence of the boot camp. Indeed, the first half of the film's narrative structure depends almost entirely on collective rituals, including rifle drills, ritualized manoeuvres, chants and prayers. Even before going to sleep, Hartman orders the recruits to perform a rifle drill, shouting, 'you will give your rifle a girl's name. This is the only pussy you people are going to get. You're married to this piece, this weapon of wood and steel and you will be

faithful.' Hartman's instruction to the cadets to 'prepare to mount!' has obvious sexual connotations, while the rifle drill, which they perform lying down, culminates in a prayer to their rifle. A number of other rites invoke religious iconography and celebration: the cleaning of the head is associated with the Virgin Mary and, at Christmas, Hartman makes them sing 'Happy birthday to Jesus'. He consolidates a link between sex, violence and religion with his statement that 'the free world will conquer communism with the aid of God and a few marines. God has a hard-on for marines because we kill everything we see.' The cadets' attack on Pyle is another literal form of ritual cleansing. Using bars of soap wrapped in towels to beat him, they attempt to punish and 'purify' his infantilized abject body. While Paula Willoquet-Maricondi[38] sees these rituals as rites of passage to manhood, I suggest they function to contain the abjection of killing, while the purification of abject spaces such as the 'head' through ritualized cleaning absolves its association with the disgusting or homosexual body.

Willoquet-Maricondi notes that the fear of homosexuality was prevalent during the years of the Vietnam War and suggests that, in *Full Metal Jacket*, 'the recruit training is one of purification from such homosexual contamination.'[39] She proposes that this contamination is aligned with Vietnamese women, both as prostitutes and killers – '*Full Metal Jacket* exposes the process of dominance of the feminine within by defining this feminine as the enemy, by exteriorizing it so that it can be attacked and eliminating it.'[40] While there can be no doubt that the military's fear of homosexuality is reflected as an underpinning narrative strategy in *Full Metal Jacket*, I suggest that the key transgression is not expressed through the female sniper and the prostitutes but by the immoral and sadistic masculinity cultivated within the corps.

In explaining the process of masculinization in *Full Metal Jacket*, Willoquet-Maricondi suggests that the cadets must sever their link with the mother (Mother Green) and that the brotherhood of

marines, the corps, replaces the lost mother.[41] I propose, however, that 'Mother Green' remains a surrogate from which the cadets must ultimately separate if they are to attain true rational and moral subjectivity. Incestuous unity with the 'mother', through Vietnam, perpetuates the semiotic, institutionalized self and represses compassion and individuality. The film suggests that processes of warfare engender such qualities. Indeed, Willoquet-Maricondi comments that the final scene 'represents a return to childhood that puts into question the process of maturation and masculinization we have just witnessed'.[42] I suggest that the marines do not achieve maturation since they display a child-like sadistic cruelty and indifference to suffering. Furthermore, their performance as marines is in question since they lose their way, are ill disciplined, panic when under fire and fail to execute their mission. Figures of authority are successively executed and Cowboy is unable to control the group successfully. The final scenes of singing the Mickey Mouse Club anthem further validate this argument.

There are also problems with Jeffords's interpretation. On comparing the translation of the novel with the film, she concludes that Kubrick's version shows a 'clarified rejection of the feminine and restitution of the masculine'.[43] She asserts that the film 'rewrites the novel as a story of a gendered opposition between masculine and feminine, a battle that the masculine must win in order to survive the war'.[44] Jeffords bases her interpretation on the two main scenes in the film (three in the novel), one of which is the crucial sniper one. The sniper who kills the men one by one is revealed as a woman. When Rafter Man wounds her, Joker agonizes about leaving her 'for the rats' as Animal Mother suggests. Instead, he shoots her, but simultaneously relieves her of a slow and agonizing death. Although he kills a woman, an act he has previously condemned, it is out of humanity rather than ruthless slaughter and Joker, through his humanity implied by his 'feminine' side, is morally redeemed. This is also suggested by the lighting during this sequence, which

emphasizes the peace button, though this temporarily disappears from view as he shoots the sniper. While Jeffords claims that 'the war [Vietnam] and its representations have been successfully employed as vehicles for a renewed sense of American masculinity, one that has, as popular opinion would declare, altered its role and character',[45] I suggest that *Full Metal Jacket* undermines masculinity as constructed through images of Vietnam.

Jeffords's reading suggests that a polarization of gender in which the feminine is posited as dangerous and contaminating replaces Hasford's gender ambivalence of *The Short Timers*. Joker's killing of the sniper, however, needs to be interpreted in the light of his previous condemnation of killing women. Williams also notes an ambiguity in Joker killing the sniper and the fact that he acted compassionately: 'this ambiguity, like that behind Pyle's death, suggests the impossibility of the coherence of white masculine identity.'[46] Others see Joker's killing of the sniper as ultimately nihilistic and negative. For example, William Palmer comments that 'the world of the Vietnam War is a negative one and the final acts of the protagonists of both *Platoon* and *Full Metal Jacket* are the most negative of human acts, murders … these are not mercy killings.'[47] Willoquet-Maricondi also points to the regressive nature of the recruits' masculinity when she asserts that:

> rather than endorsing the dominant patriarchal ideology that turns boys into men through a display of bravery in the face of death, Kubrick criticizes the whole process of masculin- ization by showing that it fundamentally not only involves defeat of an 'other' (female or otherwise) but, more funda- mentally, the defeat of the very self.[48]

While the remark 'hardcore, man', spoken by the other characters in the sniper killing scene, enforces the link between sex and violence,[49] the feminized form of a new masculinity, which

Joker exemplifies, is otherwise portrayed positively. The 'Born to Kill' slogan on Joker's helmet and the peace button on his jacket, while perhaps indicating his moral ambiguity, may equate with the masculine and feminine sides of his character. We have already seen his caring side in the way he 'trained' and encouraged Pyle and in his fatherly treatment of Rafter Man. He is bespectacled, cultured (he watches action films and frequently imitates John Wayne) and is clever with words (he is a combat correspondent). Although strong, he is slight and physically does not measure up to the typically muscular ideal of the 1980s masculinized hero Tasker described. Rather, Joker is the caring, compassionate 'new man' that Rutherford[50] and Jeffords[51] describe as a contrast to the muscular, subverted masculinity of Animal Mother. When Animal Mother asks Joker if he has 'seen' much combat, the implication is clearly that Joker has 'seen', but not engaged in, combat. Animal Mother, by contrast, with his body draped in hundreds of rounds of ammunition and his sleeveless shirt fully displaying his muscular arms, is a killing machine. Framing emphasizes the width of his biceps and, unlike Joker with his camera, he carries a rifle. Animal Mother threatens to 'tear [Joker] a new arsehole', reiterating the homo-sexualizing threats that originated in the first half of the film and further compounding the film's well-established relationship between sex and violence. This binary opposition of 'new' versus 'muscular' masculinities thus displaces notions of a clearly defined feminine and masculine, as Jeffords posited.

That the soldiers' development to fully-fledged subjectivity remains equivocal is suggested by the film's ending, which does not leave Vietnam or provide any narrative resolution. The soldiers are never contextualized in relation to their families or homes; the film instead emphasizes the dehumanizing process they have undergone. The final scenes focus on a perpetuation of male homo-sociality, with the team of marines shown in profile and singing in unison, as they did in the boot camp. The burning buildings that surround

them seem to confirm an earlier line of 'ain't war hell?' Thus, as they are unable to escape the abject morass of Vietnam, their social identities remain fixated and undifferentiated. Only Joker displays a progression towards a coherent adult male subjectivity. While his voiceover describes his 'great homecoming fuck-fantasy' about Mary Jane Rottencrotch, his final line of 'I'm in a world of shit, but I'm alive' is perhaps significant. In defining the abject world of Vietnam, he is able to differentiate self from other, for, as Kristeva points out, 'we may call it a border; abjection is above all ambiguity. Because, while releasing a hold, it does not radically cut off the subject from what threatens it — on the contrary, abjection acknowledges it to be in perpetual danger.'[52]

Thus while Jeffords reads the singing of the Mickey Mouse Club anthem as nothing more than a 'celebratory tune of American childhood',[53] I argue that it demonstrates soldiers fixated at the sadistic-anal stage. Their relationship to the abject has been consistent throughout the film, with Hartman frequently referring to the cadets as 'maggots' and 'shit', suggesting the disgust of a world that later engulfs them. Initially, they can contain the abject inner self (their killer instinct and homoeroticism) by cleaning and purification rituals. In Vietnam, the marines descend into a semiotic morass. Ultimately, devoid of any significant father figure with which to identify, they are unable to achieve a true adult masculinity. Rather, they develop a subverted masculinity that closely intersects with a sadistic, anally fixated infantilism.

The spaces of these two parts are thus distinctly different, the first displaying meticulous order and bodies performing in a coherent, uniform manner. The second half has a looser structure, with bodies behaving in incoherent ways. Typical examples include the swaying movements of the Vietnamese prostitute, the sniper killings, in which bodies writhe randomly, and the lost wanderings of the cadets. The two halves of the narrative, distinctively articulated by space, therefore materialize in the characters and their

actions. The disciplined body represents the symbolic world associated with Hartman, while the disordered body represents the semiotic abject world of Vietnam. The boot camp trains the cadets for this unstable primal world of Vietnam by erasing their identities and breaking down social and moral boundaries. It strips them of compassion and trains them to be ruthless killers, compelling them to relinquish the emotions and desires of adulthood, particularly those relating to sexual identity. They regress into a semiotic state and develop sadistic-anal tendencies. The corps as a version of the archaic mother is further suggested by the notion that the men are immortalized as marines – Hartman informs them, 'the Marine Corps lives forever. And that means you live forever.'

Sources of abjection in the first part of this film (which Hartman equates with the feminine, homosexual, infantile or communist body) are under constant surveillance and undergo a number of purification rituals. Potentially abject spaces, such as the head and the barracks, are therefore subject to extreme cleanliness and frequent washing and Hartman strives to maintain a high degree of order here. The bathroom, however, as frequently seen in contemporary American films, is a site of masculine vulnerability. In *Full Metal Jacket*, this vulnerability and risk of being penetrated results in violence. It is in the 'head' where extreme repression, particularly in relation to the homoerotic body, is required to control abject aspects of the male body. However, it is here that a homoerotic act, signified through Hartman's killing, takes place. Pyle's emasculation and representation as dangerous may link to the sniper's actions towards the end of the film.

Several authors[54] advocate a gendered reading of the film, in which the feminine (consisting of Pyle, the prostitutes and the sniper) is represented as threatening and contaminating. In many respects, however, the film explores the ambiguity of gender, symbolized through both Joker and Pyle. Uncertain gender is also implied by the cadets' rifles, which are given girls' names but are

otherwise equated with phallic symbols,[55] sex and rape. It is further evident in the name of 'Animal Mother', the character who is paradoxically hyper-masculinized. The outcome of the film suggests that the feminized compassion shown by Joker is morally good and that the excessive masculinity as inculcated through the boot camp is morally repugnant.

Jeffords[56] proposes that the muscle-bound heroes of the 1980s gave way to a gentler more compassionate man. *Full Metal Jacket* anticipates this shift through Joker, who writes rather than fights, and is a talker (it is his voiceover the spectator hears and he is clever with words) rather than a walker (which Animal Mother notes in his confrontational meeting with Joker when he says 'you talk the talk, but do you walk the walk?') Indeed, there is an exaggerated focus on being 'hard', with the parallel again made between sex and violence; the two versions of mother, as represented through Mother Green and Animal Mother are particularly ruthless and cruel. To attain this 'born again hardness' the cadets must, apart from tests of physical endurance, undergo a systematic repression of their subjectivity in the boot camp and a return to the infantile world of the maternal. The numerous references to being 'in the shit' substantiate this.

While this abjection sustains a fascination for the viewer, mediated through aesthetic images of warfare and death, most of the marines become indifferent to it. However, it serves to consolidate Joker's moral development to a fully constituted adult subjectivity. While the rest of the marines remain mired in infantilism, Joker, in shooting the sniper as an act of compassion, shows progression towards a coherent subjectivity. In *Full Metal Jacket*, abjection is most closely associated with the aberrant macho masculinity that warfare engenders rather than, as others have suggested,[57] with the feminine, homosexual or Oriental body. A dangerous, sadistic masculinity emerges when certain aspects of adulthood are repressed. Joker's feminine side means that he is the

only cadet to realize that he is 'in the shit' and so retain his humanity. Rather than straightforwardly opposing masculine and feminine, or Occidental and Oriental, *Full Metal Jacket* explores the gradients between these groups and seems to suggest that traditional masculinities are under threat.

The threat that stems from the 'other' in *Full Metal Jacket* probably reflects not only the military's anxieties about homosexuality but also masculinity's threat from feminism. The film further tempers these threats with those that the political and institutional doctrines of the military impose. Ultimately, however, Kubrick denigrates the military's castigation of homosexuality and relentless institutionalization that drives a recruit to madness and murder. The film, in the end, is critical of American involvement in Vietnam and shows it as a war of words in which media misinformation is widespread. By drawing attention to the processes that indoctrinate cadets with sadistic cruelty and complete disregard for human life, the film shows the Vietnam War as futile and regressive.

PART II

MAINTAINING SELF: SPACES OF DISCIPLINE

In the end, no matter what, being locked in a cell changes a human permanently.

(Nick Yarris, former death row prisoner, 26 February 2008)

On-screen prisons provide many opportunities to study abjection because challenges to subjectivity abound in carceral spaces. Analysis of *The Shawshank Redemption*, *Lock Up* and *The Last Castle* reveals how fictional prisons strive to repress or remould their inmates' identities. Generally, this involves inflicting intense physical and psychological hardship on the prisoner, which is a prominent feature of the three films examined here. In general, the genre displays clearly recognizable plot formations and characters, as well as a distinct iconography of prison bars, tall gates and high perimeter fencing. Indeed, unlike other typical 'male' genres, such as action films or westerns, where the male body generally performs against spectacular backdrops, the prison film is set in mundane, restricted spaces. As a result, the prisoners' (usually male) activities also tend to be limited. Prison narratives work in predictable ways, with a common theme of escape and often a focus on penal labour, confinement and social deprivation of the body. Increasingly, prison films comment on the death penalty. The genre's key stereotypes include the evil warder and the heroic inmate who is wrongfully imprisoned or suffers

inhumane treatment. The relationship between these two characters often provides the central tension of the film, while inmate solidarity is a frequent finding. The development of conflict between warder and inmate creates disorder within the narrative, culminating in chaos or escape.

Despite the centrality of space to the prison genre, there has been little academic study of this aspect, which is surprising given that prison films often overplay the visual features of confinement in relation to sentence duration. This is likely because it is easier to represent space than time and for a genre devoid of spectacular settings, high perimeter walls, solitary confinement and other spatial restrictions provide greater visual interest than a focus on protracted sentences. Therefore, space tends to dominate the typical prison film and even where the sentences are very long, as in *Papillon* (1973) and *In the Name of the Father* (1993), its spatial features remain prominent.

Notwithstanding the importance of space, the critical attention increasingly paid to prison narratives in the last decade only marginally addresses this issue. In one study, Mason[1] alludes to the nature of prison space when he posits the prison as a machine, both in its *mise-en-scène* and in its processing of prisoners. The prison as maternal body has been identified in literary texts,[2] while both Fiddler and Jarvis[3] provide filmic accounts of the prison as a uterine space. Because the latter models relate to the prison as maternal space and are relevant to this book, I shall discuss them in detail later.

Mike Nellis and Christopher Hale's study[4] of the prison film, essentially a chronological survey, also refers to space. Nellis suggests that horror films set in institutions such as castles and asylums resemble prison films, because 'they express in pure and undiluted form our deep ambivalence towards enclosed spaces, inspiring both fears of being locked in and fears of being locked out, the threat of entombment and the denial of sanctuary.'[5] According to Nellis, the distorted sexuality, sadism and treachery that pervade the prison

film are characteristics derived from film noir. He further asserts that part of the attraction of prison films is that they mark out boundaries 'between freedom and constraint, between good and evil, and in extremis, between the living and the dead'.[6] Indeed, in *Escape from Alcatraz* (1979), Hale identifies a '"shadow" prison of pipes, shafts, secret spaces and hidden processes. A different anatomy, another body that is opposed to the regulated machine of cells, landings, and wings'.[7] Nellis and Hale's study therefore acknowledges the presence of 'other' spaces without fully exploring their significance.

The importance of space to the genre is also briefly mentioned by Steve Neale, who notes that in film genres where locations are restricted, as in prison films, 'space, the control of space, and the ability to move through space or from one space to another are always important'.[8] He identifies narrative patterns in relation to open and closed spaces, commenting that the hero is vulnerable to attack in closed spaces, whereas open spaces such as the natural landscape offer safety or victory, suggesting links between open spaces and 'the geography of adventure'.[9] For Nicole Rafter, one of the stock themes of the prison film is that of control in relation to masculinity.[10] She argues that films work to recuperate control and therefore reclaim masculinity. While Rafter briefly discusses the significance of space in relation to the theme of control and release, this again remains peripheral to her account.

Although these studies do not fully explore the spatial dimension of the prison genre, they do, however, indicate a common recognition of vulnerability, dehumanization and loss of power related to spatial confinement. Such challenges to identity, as within other institutions discussed in this book, manifest through uniformity of appearance and regulation of the body by various means. These may range from intensive surveillance to extreme forms of physical punishment, with both tending to occur in prison films. Surveillance may include gendered ways of looking as well as more

impartial controlling observation. Gendered looking is usually associated with feminist film theory, and is central to the work of Laura Mulvey.[11] Her theory of a 'male gaze', while not always seemingly relevant to a largely 'male' genre, is one implicated in the homoerotic desires commonly expressed in the prison film. Such a gaze, directed from the warders, also points to the potential emasculation of male prisoners.

More commonly ascribed to the prison genre is Foucault's (1991) account of the disciplinary gaze. Foucault's version describes a pervasive and impassive surveillance that induces a degree of self-regulation in prisoners and that erodes or negates privacy altogether. Foucault's articulation of discipline also considers space, time and rehabilitation in relation to physical labour. He connects space to punishment through the generalized loss of liberty (personal space) and through time spent in prison. For Foucault, the punishment regime becomes more intense when a prison sentence is uninterrupted, and has 'internal mechanisms of repression and punishment'.[12] He highlights a third aspect of control that relates to an intimate knowledge of the inmate, though his critics point to, among other things, a lack of consideration of gender,[13] the requirements of coercion,[14] and the role of the state in the maintenance of control.[15]

Other sociologists support Foucault's later assertion that power is not a singular force exerted by one individual but exists in equilibrium within a group,[16] which is important to our understanding of how film narratives work. According to sociological theory, space in prison is significant in terms of maintaining a balance of power. Indeed, the utilization of time and space is intrinsic to regimes of punishment and the more extreme the crime, in general, the more tightly controlled is the accompanying carceral space. Such extremes of spatial control feature prominently in fictional prisons, usually as isolation cells or maximum-security prisons.

Spatial restriction within real prisons may induce compensatory

or resistant behaviour in inmates that contributes to the balance of control. These modes of resistance frequently involve a reclaiming of space. Alternatively, excessive control may precipitate suicide, riots or other disturbances. Prisoner isolation, in which social space is absent, is particularly conducive to suicide,[17] while at the other end of the spectrum 'a riot will typically involve the attempt to capture and control space.'[18] Roger Matthews concludes that 'the fact that riots in prisons involve the objective of controlling certain spaces and redefining their use underlines the fact that spatial control is critical to the exercise of power.'[19] Therefore, in real prisons, the maintenance of order and its breakdown are not simple oppositions but represent a complex interplay of authority and resistance to it by various means.

This pattern of control and resistance in real prisons is clearly recognizable in their fictional counterparts. In prison narratives, control also operates through surveillance, marshalling the body in space and time, and confining the prisoner. Resistance to control is manifested through reclamation of private space, inmate solidarity, escape, or rioting and taking over prison space. The three prison films discussed in this book each demonstrate various forms of control, and the resistance or disorder that results from excessive regimes. In *The Shawshank Redemption*, control is exerted predominantly through incentives of space and rehabilitation; in *The Last Castle* it is exercised through the gaze and in *Lock Up* through brutality. Common to all three films, however, is the prolonged restriction of space or extreme control of bodies within space.

The resultant narrative disorder relates to abjection in that escape is usually through the tunnels or the inner workings of the prison, especially the prison sewer. The very nature of these spaces, particularly in *The Shawshank Redemption* and *Lock Up*, implies a feminine body consisting of secret passageways, shafts and holes. The desire to break away from a controlling force that orchestrates a parental role in its mapping of hygiene and order also replays the

infant's separation from the abject maternal body. As a result, the internal spaces of the prison are frequently sources of horror and disgust, but at the same time they offer liberation. Alternatively, prisoners take over space through riot and conflict. In both scenarios, there is a reclaiming of autonomy and escape from excessive and cruel regimes.

These abject, unstructured spaces are often located in the subterranean levels of the prison. Conversely, spaces that are orderly and highly controlling tend to be in elevated positions and include observation points and towers. The exercise yard, library and dining room are generally spaces of low restraint while those like the gas chamber, electric chair, or solitary confinement involve severe threats to subjectivity and consequently lead to high degrees of resistance. In this part I shall show how excessive regimes of control linked to these spaces culminate in scenes of abjection. Indeed, the spaces that directly lead to narrative disorder are the solitary confinement scenes of *Lock Up* and *The Shawshank Redemption*.

In general, then, space is crucial to a consideration of the prison narrative for several reasons; first, prison entails a redefining of personal space insofar as it is restricted in relation to the severity of the crime and the level of discipline. Second, space is significant because, according to film theorists such as Neale,[20] it provides a stage on which men can articulate their masculinity through either conflict or heroic display. Space also provides landscapes that distract from the potential instabilities generated by looking at the male body. According to Mulvey,[21] the constriction of space in the framing of a woman focuses attention on her appearance rather than her activities. Space size therefore has gender implications, with open spaces generally masculinizing and enclosed small spaces potentially feminizing. Masculinity is an important issue in both real and fictional prisons. In the films studied, the more enclosed the space, the greater the threat to masculinity. The specific threat in *The Shawshank Redemption* is one of rape, while in *Lock Up* it is

violent abuse. In *The Last Castle*, which features less claustrophobic spaces, there is a resistance to emasculation, with a performance of masculinity through military operations and conflict. The first two films therefore differ from the third. In the former, incarceration of the inmates is castrating, for it strips them of their masculine identity. While this emasculation surfaces periodically, both films show a processing of inmates that begins symbolically as they cross the threshold of the prison. This processing involves a negation of their individuality, initiated by the removal of their clothing and the allocation of prison uniform. In *The Last Castle*, the character of Irwin is resistant to emasculation and is ultimately heroic, moral and self-sacrificing.

A common factor in these three films is the way they use conventional modes of identification to engage the spectator's sympathies for the criminal. In *The Shawshank Redemption* Red's voiceover encourages the spectator to engage with him. In *The Last Castle*, there is an emphasis on Irwin's personal circumstances, his history and sense of achievement. In *Lock Up*, we see Leone's suffering through close-ups of his brutal treatment, and details of his personal life. Conversely, prison staff members are invariably cruel, avaricious, mentally unstable or corrupt, perhaps a reflection of filmmakers' intentions to criticize prison systems, particularly those concerned with the death penalty.

Cinematically, identification with inmates encourages the viewer to be both transgressive and masochistic without threat. This allows a proximity to the corporeal aspects of fictional confinement, with its focus on homoerotic desire, bodily function and extreme violence. At the same time, the prisoner's escape from the prison offers redemption and hope. Thus, audience pleasure not only derives from experiencing the harshness of imprisonment but also from progressive male fantasies that celebrate heroism and salvation in the face of adversity.

Chapter 4

Staying Clean and Proper:
The Shawshank Redemption

The Shawshank Redemption (1994, directed by Frank Darabont) tells the story of an innocent man, Andy Dufresne (Tim Robbins), wrongly convicted for murder. Based on Steven King's novella *Rita Hayworth and Shawshank Redemption*,[1] the film fared poorly at the box office, achieving $18,000,000 on its initial release,[2] but subsequently rising to top film popularity ratings.[3]

The enduring success of *The Shawshank Redemption* is probably a measure of the film's feel-good factor, arising from the fact that justice is finally served and Andy Dufresne, the main protagonist, escapes from prison. While its focus is a theme of hope, and the friendship between two men, it otherwise features many aspects of excessive control that are common to the prison genre. Such control typically manifests through suppression of masculinity, displays of brutality and restrictions of space. Prisoners react to this control by systems of resistance (termed mushfaking) that include inmate solidarity and exchange of contraband. Another way they maintain autonomy involves the sexual victimization of other prisoners. Alternatively, resistance leads to the creation or reclamation of private space and, like many prison narratives, eventual escape. To effect his escape and overcome the repressions of imprisonment, Andy Dufresne crawls through a sewer of what Red (Morgan Freeman) describes as '500 yards of shit-smelling foulness I can't begin to imagine'. The production of abject space therefore lies predominantly in Andy's separation from the institution as maternal

body and in the expression of the *mise-en-scène* that forms his escape route. The final stages of his escape are traumatic but triumphant, while the image of his first moment of freedom has become iconic. In this chapter I therefore posit the prison as a maternal body, with Andy's escape from it consistent with rebirth, thus likening his escape tunnel to the feminine reproductive body. Many other aspects of *The Shawshank Redemption* cohere with the notion of the prison as a semiotic, maternal world, particularly in its foregrounding of shit and anality, and bodies that are variously infantilized, homogenized and emasculated.

The homogenization of the prisoners begins in the opening scenes. A circling crane shot of the prison, which highlights its Gothic architecture, shows the prisoners streaming towards the gates. From this camera position, they appear minute in the frame, with their identities transiently effaced. As the camera moves in closer, the details of a group of new prisoners shackled together become visible. Sequential shots of their arrival show, in close-up, first one prisoner's plump and juvenile face (Fat Ass played by Frank Medrano), then, in long-shot, a thin and almost fragile looking Andy Dufresne. Control is implicit in the depiction of the physical structure of the prison, with bars, grilles and geometric architecture dominating the *mise-en-scène*. Constricting male authority manifests mostly through the guard Hadley (Clancy Brown) and Warder Norton (Bob Gunton) and, while the prison is supposedly rehabilitative, control inevitably features excessive brutality, highly regimented regimes and intensive control of the prisoners' space. The prisoners therefore have little privacy, being subject to regular scrutiny when the guards 'toss the cells' for contraband. Although there are scenes in which surveillance is a mode of control, regulation generally occurs through access to space, which is utilized as either punishment or incentive.

From the outset, Andy Dufresne's masculinity is in question because his conviction for murder rests on the fact that his wife

was adulterous. Uncertainties about his masculinity recur through-out the early prison scenes and, in part, relate to his elevated social status on the 'outside'. One of the spectator's first views of Andy shows, in close-up, his white shirtsleeves under a pinstripe suit. Later, in the scene when the prisoners arrive shackled together, he appears taller and slimmer than the rest. His smart attire, lack of overt musculature and tall stature thus mark him out as different, while Red's comment, 'looks like a stiff breeze would blow him over', immediately allies his social status to weakness. Therefore, while Andy held a position of financial power as vice-president of a bank on the outside, inside prison these social values make him vulnerable, and his physique and mild demeanour mean that he becomes easy prey to other inmates. Indeed, taking bets on which newcomer will succumb to the rigours of the system first, Red opts for Andy, describing him, in a remark that compounds class and anality, as 'that tall drink of water with a silver spoon up his arse'.

As the new inmates enter the prison, the cinematography frames them tightly, while a *mise-en-scène* of prison bars, meshed fencing and an overall sense of confinement invariably materializes from their point of view. The guards, on the other hand, occupy open and occa-sionally elevated positions so they can easily observe the prisoners. Andy Dufresne's point of view appears as an extreme low-angle shot of the entrance portal that emphasizes the overwhelming nature of his confinement and an acute loss of freedom. This low-angle shot fades briefly to black, symbolizing the end of his life on the 'outside'. The following scene further amplifies the feeling of claustrophobia. Here, high contrast lighting creates deep shadow against the back-drop of Gothic prison architecture. Another cut to a low-angle shot of the prisoners' shackled feet draws attention to their restriction and symbolic castration. As the new prisoners shuffle inside the prison, their coercion to an infantile state is further suggested by Hadley, captain of the guards, who tells them 'you eat when we say you eat, you shit when we say you shit and you piss when we say you piss.'

From the outset, there is an emphasis on discipline, particularly with respect to space and bodily function. Kristeva notes that 'maternal authority is the trustee of that mapping of the self's clean and proper body'.[4] The reference to regulation of bodily function thus begins to implicate the prison as a maternal entity.

The infantilization of new arrivals is further demonstrable in the subsequent scenes when the guards hose them down and delouse them. The white delousing powder, which gives them the appearance of newborn infants, renders them at once virginal, infantile and stripped of individuality and sexuality. Red's voiceover saying 'they march you in naked as the day you were born' confirms this. The prison staff are paradoxically masculinized through a number of phallic devices, including the hosepipe used to hose down the prisoners and various weapons such as Hadley's baton with which he beats Fat Ass to death. Wearing prison uniform further diminishes any sense of individuality, while ultimately it is their assignment to the cells that signals the end of freedom and eventually, for some, a sense of self. Red comments, 'when they put you in that cell and those bars slam home, that's when you know it's for real.' He continues, 'most new fish come close to madness that first night.' In Andy's cell a close-up of the naked light bulb in its own protective cage, while indicating a propensity for suicide under such oppressive conditions, is a metaphor for his enclosure. While perhaps signifying his fragility, its burning light also suggests the optimism that sustains him to his eventual escape.

As in many institution films, infantilization of the prisoners leads to conflict and resistance while their loss of power, together with the brutality they endure, has parallels with Freud's explanation of the castrating mother. Freud describes how the male child perceives the first sight of his mother's genitals as lack or loss, and thus fears that his own genitals will also be removed.[5] While literal castration does not occur in the film, there are many scenes where it is meta-phorically represented through depletion of masculinity. This

invariably arises through spatial restriction but for some prisoners, including Andy and potentially Fat Ass, it materializes as anal rape.

Masculinity is therefore under constant threat in *The Shawshank Redemption*, not only from the prison system but also from other prisoners. Numerous studies indicate that, in real prisons, typical targets for anal rape tend to have feminine characteristics, often suggested by qualities of submission, passivity and physical softness. As discussed earlier, fictional films also signify femininity with physical softness, while the display of orifices and other openings may render the male body susceptible to attack. Clearly, both the rounded Fat Ass and the slim, tall Andy Dufresne are vulnerable. One inmate, Heywood (William Sadler), expounds on the link between softness and femininity, addressing the rounded Fat Ass with, 'I know a couple of big bull queers who'd love to make your acquaintance, especially that big white mushy butt of yours.' Fat Ass breaks down in tears, and his cries of 'I want my mother,' confirm his childlike status. In response, Hadley the guard threatens him by saying, 'you'll shut the fuck up or I'll sing you a lullaby.' Hadley's comment further compounds Fat Ass's infantilism and means that Heywood wins his bet on which prisoner will break down first. Heywood makes further anal and homosexual references, for example, saying, 'smell my ass' as he is handed his 'winnings' (cigarettes), and 'I believe I owe that boy a great big sloppy kiss when I see him.'

Indeed, references to excrement and anality permeate the film. Together with persistent allusions to the prisoners as emasculated and infantile, they serve to reinforce the position of the prison as a maternal figure. As Hadley violently kicks Fat Ass, he says, 'take that tub of shit down to the infirmary,' thereby conflating the abject with the emasculated and infantilized body. During Fat Ass's beating, the camera positions the viewer at floor level in a stationary, straight-on shot, encouraging sympathy for the prisoner and emphasizing the violence of the scene. Fat Ass dies as a result of Hadley's assault, demonstrating brutality and physical violence as another

mode of domination. As if to justify his actions after beating Fat Ass to death, Hadley proclaims, 'I swear by God and sonny Jesus.' This use of biblical references as a way of assuaging violence recurs repeatedly throughout the film, while Hadley's sadism serves to shore up his masculinity, particularly in the use of his phallic baton.

By far the most usual method of control in this film, as in others of the prison genre, involves the management of space. Prisoners are rewarded with freedom of space and punished with its constriction. The cell is the most obvious example of spatial control. Its open barred frontage allows prison guards easy observation and claustrophobic framing is often used to emphasize its small dimensions. Figure behaviour may also draw attention to its size, shown, for example, as Andy stoops his head on entering his cell. As in *Girl, Interrupted* (1999), washing facilities are com-munal and the toilet is in full view of the prison guards. In Andy's case, we see the system of incentives and rewards of space in oper-ation by his transfer from laundry duty to the library, while punishments include his extended solitary confinement. Since solitary confinement prevents social interaction, limits privacy and leads to mental confusion, particularly in relation to identity, it is especially salient to the relationship between subjectivity and abjection. The prisoner's typical assumption of a foetal position signifies its potentially dehumanizing and infantilizing effects.

The general lack of space afforded to prisoners both limits the socializing aspects of adult behaviour and compromises perform-ances of masculinity. As outlined at the beginning of this section, on-screen masculinity manifests not only through musculature and physical integrity but also through the activity of the male body. Neale[6] draws attention to the relationship between space and masculinity in cinematic representation. Referring to Mulvey's work,[7] he outlines how this relationship implicates the sexually subordinating gaze as a mode of potential feminization. Drawing on Paul Willemen's[8] study of Anthony Mann's films, Neale asserts

that, in film, large open spaces allow for performances of typically masculinizing activities.[9] Men may therefore evade a potentially feminizing spectator gaze that is instead directed either at the space (such as a vast landscape), or the spectacle of combat or violence.[10] Conversely, constrictions of space tend to restrict displays of masculinity. Logically, therefore, restricted space must render male characters vulnerable to a contemplative or erotic gaze by other characters (as well as by the spectator). Neale contends that such a gaze is destabilizing to heterosexual and patriarchal values and that 'the male body cannot be marked explicitly as the erotic object of another male look: that look must be motivated in some other way, its erotic component repressed.'[11] Clearly, Neale's argument is salient to the prison film, where space is likewise restricted.

In this film, the contemplative gaze at the male body, more so when potentially erotic, is often coupled with a *mise-en-scène* of constricted space. Examples include not only the feminized Fat Ass's beating, but also Dufresne's rape in the laundry and the projection room. Such constriction of space and its coterminous effects of emasculation tend to induce disorder and abjection. Conversely, stable situations, in which prisoners may recoup their masculinity, generally occur in more open, well-lit, sunny situations, such as the roof-top scene in which both physical labour and beer drinking are 'masculinizing' activities. In fact, Andy states, 'I think a man working outdoors feels more like a man if he can have a bottle of suds.'

While restricted space is fundamental to prison narratives, the length of sentence also has some import. In *The Shawshank Redemption*, there is vagueness about the length of the prisoners' sentences, and particularly about the function of parole. Narratively, it seems to be an arbitrary procedure, for with no apparent good reason to do so the parole board rejects Red's application for release. These scenes, however, serve to reveal the inadequacies of the prison's rehabilitative programme. Red is asked repeatedly if he has been rehabilitated, when it is clear, exemplified

by Brooks Hatlen's suicide, that the prison has failed in this respect. At his final parole hearing, Red therefore abandons his pretence of being a reformed character and challenges the board on the real meaning of 'rehabilitation'. The parole scene recurs almost identically three times throughout the entire film, punctuating the narrative at ten-year intervals. Like the system of 'checks' in *Girl, Interrupted*, its inclusion, while related to control, also indicates the passage of time. The indeterminate length of their sentence is referred to several times, Andy commenting to Red, 'I was in the path of a tornado; I just didn't expect the storm would last as long as it has.' For the inmates, parole is more an indifferent gesture to Andy's seemingly idealized perspective of 'hope' than a real possibility. This is apparent in a discussion between Red and another prisoner about his parole. Red says, 'same old shit, different day' and another prisoner replies, 'yep, I know how you feel, I'm up for rejection next week.' The inevitability of rejection thus conveys its meaningless and ritualized nature.

These systems of control in Shawshank prison meet various mechanisms of resistance within the prisoner network. While such resistance commonly materializes through the reclamation of small pockets of private space, its other, more insidious, manifestation is through sexual victimization. This reflects an aspect of real prisons, where prisoners are unable to form heterosexual relationships, and the reassertion of their masculinity often takes the form of rape.

That Andy is a target for this form of prisoner control first emerges in the communal shower scene when Bogs (Mark Rolston), the prison rapist, approaches him. As Andy turns down his advances, Bogs says, 'hard to get, I like that,' thereby feminizing Andy, though his later approaches become more violent. As I outlined earlier, Freud's[12] description of infantile psychosexual development explains why violence is readily interchangeable with rape. Freud asserts that at the anal stage of development, the anus as erotogenic zone coincides with a mastery of the bowels that is also linked to

cruelty. He states that 'it may be assumed that the impulse of cruelty arises from the instinct for mastery and appears at a period of sexual life at which the genitals have not taken over their later role.'[13] Freud continues that, 'the absence of the barrier of pity brings with it a danger that the connection between the cruel and the erotogenic instincts, thus established in childhood, may prove unbreakable in later life.'[14]

The interchangeability of sadism and anal stimulation that Freud describes is a theme that appears in certain types of institution films, tending to emerge in all-male institutions where repression of sexuality and hyper-masculinity coexist. It becomes evident in many of the scenes in which Bogs and the Sisters (the prison rapists) rape Andy. Indeed, Mark Kermode[15] identifies the principal threat to Andy as being of a predatory sexual nature. The threat of anal rape persistently surfaces through comments about anality or excrement. The ready adoption of anality and excrement as social norms, suggested by frequent verbal references to them, also has relevance to the prison as a maternal semiotic world. On initially befriending Andy, Red makes explicit anal references, saying to him, 'rumour has it you're a real cold fish … think your shit smells sweeter than most.' Even the warder states, 'put your trust in the Lord, your ass belongs to me.' It is possible to interpret these references to shit as signifiers of solidity and masculinity, as suggested through various socio-psychoanalytical studies.[16] However, in the context of the institution as maternal body, it is more relevant to consider such comments as an indication of a regressed, infantile world. It is a world in which the maternal is closely linked to excrement and blood, and the infant displays a fascination with its bodily orifices that sometimes extends to sadistic-anal fixation.

Subsequent to the shower scene, the Sisters and Bogs observe Andy in the yard, projecting a sexually desiring gaze that feminizes him (though it is interesting to note that this is directed from Red's point of view who also casts admiring looks at Andy). In the open

space of the yard, this gaze does not carry much threat. Andy asks Red, 'I don't suppose it would help any if I explained to them I'm not homosexual?' to which Red responds, 'neither are they – they have to be human first, they don't qualify. Bull queers take by force – that's all they want or understand.' In his discussion of cinematic representations of anal sex, Joe Wlodarz[17] argues that in *The Shawshank Redemption*, as in many other films, anal sex can only be represented as rape, though he notes that in Red's comment, there is 'lip service to tolerance [of homosexuality]'.[18] Even though Andy Dufresne explicitly states his sexuality, he occupies a position of femininity by the fact that the Sisters routinely rape him. This occurs in enclosed spaces such as the laundry and the projection room where the sexual repression that prison life inflicts finds outlet. These spaces, however, while routinely places of fear and humiliation for Andy, prove to be a catalyst for his subsequent escape from the prison.

In her study of real prisons, Sasha Gear claims that being sexually penetrated confirms 'womanhood', but that physical weakness, an unwillingness to use violence, youth and physical softness are likely to be perceived as vulnerabilities.[19] Andy possesses many of these qualities. The scene in which Red obtains a rock hammer for him amplifies his feminization, for it turns out to be a tiny hand tool that establishes his non-aggressive character and negates any potential phallic signification. Andy's feminization is suggested in other ways – he is close friends with Red, he is non-violent and he 'strolls' around the yard. Red notes this difference, stating, 'Andy had a quiet way about him, a walk and a talk that just wasn't normal around here.'

According to several studies of real prisons,[20] high social status increases the likelihood of victimization. Here, Andy's elevated social standing is signified in various ways. He pays close attention to dress (his shirt top is neatly buttoned) and shows servitude to the prison guards. Further, he is manipulative and seen as a negotiator.

He also appears cultured, plays Mozart and his wife has committed adultery. Moreover, Andy appears to adhere and submit to the carceral process though it later becomes clear that he is 'performing' this femininity to effect an escape. Red's further comment of, 'I think it would be fair to say that I liked Andy from the start, like none of the other inmates,' also carries implications of homoeroticism, particularly as the film culminates in their eventual reunion.

The pattern of Andy's rape and the reasons for his sexual victimization are therefore consistent with those found in real prisons, especially through his apparent feminization at the beginning of the film. The narrative, however, continuously works to reclaim his heterosexuality and masculinity, initially through images of feminine desirability (the posters in his cell). Andy also displays renewed resistance to Bogs and when the latter instructs him to 'swallow what I give you to swallow', Andy responds with aggression, threatening, 'anything you put in my mouth you're gonna lose.' Although Bogs threatens to 'put all eight inches of steel' in Andy's ear and is clearly established as a penetrating male, Andy becomes equally dangerous and castrating. This scene ironically occurs in the projection room during a screening of the film *Gilda* (1946). The sexual ambiguity displayed in the scene in *Gilda*, in which the relationship between the characters of Ballin Mundson and Johnny Farrell appears homosexual or bisexual, parallels that of *The Shawshank Redemption*; when Andy rejects Bogs's advances, Ballin Mundson (George Macready) informs Johnny Farrell (Glenn Ford) that he is married to Gilda (Rita Hayworth).

For the rest of the prisoners, the screening of *Gilda*, together with other images of feminine desirability such as 'playing cards with naked ladies on them', sustain their heterosexual fantasies in less insidious ways. There is further intertextuality here since the implied homosexual relationship between Ballin and Johnny in *Gilda* is neutralized by the character of Gilda herself. Within the context of Shawshank prison, she performs a similar function, reaf-

firming the prisoners' heterosexual identity and displacing looks between men with those at a woman. Her image provides an object for the voyeuristic male gaze, thereby both substantiating their heterosexuality and disavowing latent homosexuality. This is suggested as the inmates cheer when Gilda throws back her hair. Such a communal display of heterosexuality, as well as stabilizing masculinity, also demonstrates inmate solidarity.

Solidarity between inmates, distinct from homoeroticism, emerges in various ways and represents another form of resistance, as well as a way of reclaiming autonomy. In real prisons, a code of conduct between inmates partly achieves this and, because it helps to stabilize the prison environment, it is often conducive to order,[21] although disturbances and riots are obvious examples of solidarity, as well as ways to reclaim space. *The Shawshank Redemption* instead tends to display solidarity by 'mushfaking', particularly the trafficking of contraband.

'Mushfaking' is a prison argot term for behaviour that represents a compensatory response from prisoners to their various deprivations.[22] Such behaviour functions as a form of informal power or resistance in inmates in relation to the formal discipline of the prison. 'Mushfaking' may be physical such as the production of articles or obtaining contraband, or psychological, which includes daydreaming, use of drugs or alcohol, or meditation to escape the realities of prison. It may also assume a sociological form whereby inmates construct prison 'families', which not only allows a regulation of homosexuality but also provides for substitute social roles that the prison system denies.[23]

These versions of resistance are evident in *The Shawshank Redemption* and include, for example, Andy sculpting chess pieces, the unauthorized playing of *The Marriage of Figaro* (when, as Red put it, 'for the briefest of moments every last man in Shawshank felt free') and the relationships forged between the inmates. The various forms of 'mushfaking' mostly involve the transgression of spatial boundaries or the creation of networks of hidden space that

allow masculinizing activities to continue. In one sequence, the spectator learns that a secret chain within the system of laundry and blanket distribution facilitates a black market. This black market depends on a series of hidden micro-spaces that shadow the formal, visible aspects of prison life, with cigarettes forming an important part of an underground economy. Robert Eberwein, in his study of combat films, also notes the significance of cigarettes, commenting that, 'the sharing and exchange of cigarettes serves as a significant way of demonstrating bonding among men in combat films.'[24] The exchange of contraband occurs in spaces such as between blankets, at the side of the books Brooks distributes, or the carved out place inside the Bible where Andy hides his rock hammer. In another sequence, under cover of darkness, we see Andy in close-up chiselling and carving chessmen from stones the other inmates had collected. Creating a network of secret spaces allows prisoners to maintain some autonomy and, indeed, these opposing 'other' spaces and the agency of the characters they encourage, sustain much of the film's narrative.

The Shawshank Redemption shows how the prisoners, and even some officers, are complicit in forming a network of secret spaces, with the hammer Andy requests passing through the laundry and the book distribution system. The posters in Andy's cell are another example of this. Norton comments negatively on them – 'can't say I approve of this' – yet accepts them in exchange for Andy's tax advice. Implicitly, therefore, power is finely balanced between prisoners and warders, rather than belonging to one group or the other.

While the posters thus exemplify the control-resistance interface between warders and prisoners, they also serve to remind and reassure the spectator of Andy's heterosexuality. More significantly, they function as a narrative cue, for it is behind each of the posters that he excavates his escape route. It seems, therefore, that Andy's apparent heterosexual interest in the posters may be merely a cover for his escape route.

Andy's masculinity is further restored through the progressive relaxation of spatial boundaries. This first materializes in an opportunity to work outdoors, resulting from Red's bribes to the officers. While working on the roof, Andy overhears Hadley discussing his financial concerns with another officer and then trades on his banking expertise by offering the warder tax advice. As a result, he exchanges his knowledge for beers for the other inmates, commenting that 'beer makes you feel more like a man.' In this scene, the prisoners are therefore masculinized, despite Hadley's remark of 'drink up while it's cold, ladies.' Red remarks that he thinks Andy 'did it just to feel normal again', suggesting that resuming his banking skills helped reinstate his 'outside' identity.

Andy's tax assistance, which Red called 'a regular cottage industry' ('cottaging' being a colloquial term for homosexuality) is perhaps so described because Andy appears to submit to the prison system. It results in his reassignment from the feminized work of the laundry to the less constricted domain of the library. The spaces he occupies become increasingly relaxed and noticeably lighter as the threats to him, particularly of rape, recede. He even begins to take over space. In one scene, he locks the guard in the toilet (another reference to anality and bodily function) and plays Mozart's *The Marriage of Figaro* over the prison PA system, despite Norton's orders to the contrary.

While working in the library, Andy's character appears to gain agency. He writes letters to procure books and funds for the library, teaches others to read and write, and deals with the officers' financial affairs. In the expanded space afforded him, he is therefore more active and authoritative. He even appears to resume his previous role on the 'inside', for he has his own desk and assistant. He achieves some control over the warder and officers and has access to Norton's office. Andy remains feminized, however, in relation to the warder; in one scene Norton straightens his tie, then asks Andy 'how do I look?' a question that might be

more appropriately asked of his wife. Norton also expects Andy to deal with his laundry and polish his shoes.

Andy's manipulation of the officers functions as a form of resistance to the carceral system. Moreover, the other prisoners experience a change as they gain access, previously denied, to books, music and leisure, which allows them to develop culturally. With increased space, Andy's status changes from being infantilized and feminized to becoming a father figure, especially to a new inmate, Tommy, whom he teaches to read, write and speak properly. This father–son relationship fulfils one of the social roles that constitute 'mushfaking', while signifying a shift for Andy from a semiotic to a symbolic world. His development of an adult identity is therefore clearly expedited through the increased spatial capacity afforded him. However, Jarvis's account of *The Shawshank Redemption* suggests that the process is reversed. As he puts it, 'Andy's flight to freedom is depicted as a passage from the symbolic to the semiotic (tunnelling behind pin-up posters, the "two Italian ladies" singing a duet from *The Marriage of Figaro* and finally the ocean).'[25]

As noted previously, Kristeva's account of the subject in process describes the semiotic as a period before the acquisition of language in which communication is through gestures and signs. For Kristeva, the semiotic world is that of the maternal, while the symbolic, paternal world is conversely concerned with language and empiricism. Jarvis's argument is therefore inconsistent with the fact that Andy failed to speak for a month following his arrival at the prison. In earlier scenes, he is both emasculated and infantilized. Moreover, his progression to adult masculinity is corroborated by a new role that pivots around facts, figures, words and language. On escaping from Shawshank prison, he claims a new identity, and freedom from the constraints of the maternal prison. Jarvis's assertion that Andy regresses from the symbolic to semiotic therefore seems incongruous, especially since the repressed, infantilized world of prison

is recognizable through persistent references to shit and anality and a readiness to accept abjection.

Among many possible examples is the scene when the prisoners dig for rocks for Andy's 'homecoming' from his hospitalization and Heywood picks up a piece of petrified horse manure, mistaking it for a rock. In another, Brooks says, 'I nearly soiled myself.' These scenes repeatedly serve to authenticate the institution as a semiotic space and its inmates as infantilized. A recurrent pattern emerging from the films examined thus far suggests that while there are various coping strategies for spatial restriction, these have limitations. When oppression becomes too severe, rupture occurs, leading to the production of abject space. The most potent signifier of abject space in *The Shawshank Redemption* is the tunnel that Andy excavates and through which he escapes. The precipitation of his escape includes several incidents, namely his spell in 'the hole' and the murder of Tommy.

Andy's solitary confinement arises out of him directly questioning Norton's authority. Even though Andy's knowledge of the warder's corrupt activities puts him in a position of strength, the threat of feminization at the hands of Norton still exists. When Andy intimates his power to him, the warder responds by saying:

> You will do the hardest time there is. I'll pull you out of that one bunk Hilton and cast you down with the sodomites – you'll think you've been fucked by a train and the library … gone … sealed off brick by brick. We'll have us a little book barbecue in the yard. They'll see the flames for miles and we'll dance like wild Indians.

Norton's threat is made more potent by its referral to the Nazi book burnings in their 'purification' of German culture, thereby drawing analogies between prison authority and the Nazi regime. Moreover, Norton resurrects the threat of sexual victimization.

Andy's ego is therefore at risk, both through the potential loss of the library space, which has been crucial to the consolidation of his adult identity, and through the threat of anal rape. In some ways, however, the prolonged solitary confinement Andy subsequently endures proves cathartic for him. Afterwards, he talks to Red for the first time about his personal life, in which both his sense of loss and his repression of it materialize. Solitary confinement allows him to address this loss and relive the trauma of his wife's death, for which he has previously shown no grief. He also reveals to Red his guilt for the way he treated her.

Nellis and Hale suggest that the proximity of the prison genre to the horror genre carries with it Romantic overtures of redemption through suffering, and that 'scenes of noble suffering, agonized redemption and the joy of self-discovery have occurred many times and they can be predicated on the same Romantic notion that confinement can be a regenerative and enlightening experience'.[26] In a similar way, after his prolonged spell in the 'hole', Andy concludes that he is indirectly responsible for his wife's death. His acute restriction of space also precipitates his escape, suggested by his comment to Red, 'either get busy living, or get busy dying,' and his description of Mexico as 'an idyllic place with no memory'. Red dismisses Andy's fantasy as 'shitty pipe dreams', again reiterating the film's theme of anality. Although Red construes Andy's morose state as potentially suicidal, solitary confinement and the murder of Tommy are the final factors that trigger Andy's escape from Shawshank. The opportunity for his escape arises partly from having access to Norton's office. It allows him, over the years, to construct and eventually claim a new identity, while at the same time, excavate his escape route.

He subsequently escapes through the tunnel he constructed behind the poster of Raquel Welch and, undergoing a traumatic re-entry to the world through the prison sewers, is figuratively reborn. The possible meaning of the tunnel has attracted much debate.

Wlodarz[27] comments that it is metaphoric for the anality that pervades the film (see Figure 3), and Kermode refers to it as 'the arsehole of the world'.[28] Kermode does not elaborate further on the significance of the escape route, though he suggests Dufresne's emergence as a rebirth, 'literally bursting out of Shawshank's rectum to be reborn again in the cleansing waters of a new world'.[29] Fiddler's reading of *The Shawshank Redemption* also interprets Andy's cell as 'an intra-uterine space'[30] and his subsequent escape as a rebirth. The implication of rebirth clearly suggests the tunnel as the abject feminine body, especially as it arises in the image of a female. Furthermore, as Fiddler notes,[31] the explicitness of the prison as maternal body is suggested by the word 'mother', chiselled out and first seen over the poster of Rita Hayworth, a point Kermode[32] observes and to which he attaches religious connotations. Kermode also comments on the film's intertextual references to *Frankenstein*. Referring to the lightning crashes and 'Andy's ... look of wild-eyed madness',[33] Kermode notes that, 'Darabont nods his head toward the iconography of James Whale's *Frankenstein*'.[34] Clearly, this reference to creation relates to Andy's new start. Therefore, while this scene is literally abject in its proximity to excrement, it symbolizes the prison as abject maternal body and Andy's separation from it as a rebirth.

As discussed earlier, Jarvis also adopts a psychoanalytical reading of the prison film but interprets *The Shawshank Redemption* differently. Within the prison genre generally, he suggests three alternative explanations. First, he considers the relationship between the warder and the prisoner as an 'Oedipal allegory'[35] in which the prisoner son desires the mother and resents the father. Jarvis suggests that liberty, in this scenario, is the maternal figure.

Second, he considers that the prison may also function as a 'maternal vessel'[36] in a negative Oedipal scenario in which the prisoner desires the father. Third, he offers a Deleuzean perspective, in which the prison and warder together embody the castrating pre-Oedipal mother.

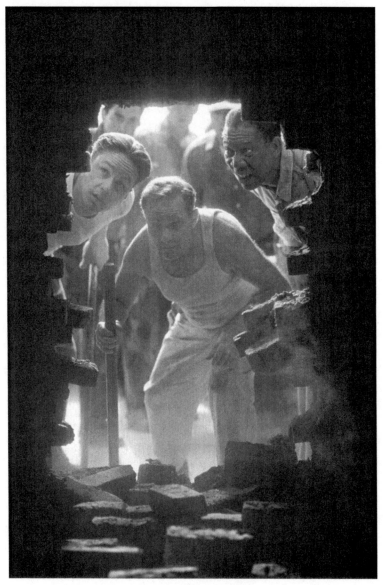

Figure 3, *The Shawshank Redemption* (Frank Darabont, 1994) © Castle Rock
Entertainment. All Rights Reserved.

In his explanation of the prison as maternal body, Jarvis describes its various spaces as uterine, whereby 'the prisoner-son experiences claustrophobic confinement in a concrete womb (the cell, the hole, the box), [and] is returned to uterine darkness and a pre-language of grunts and groans in a maternal space that provides no succour'.[37] He relates certain spaces such as 'the hole' with 'not only grave and womb, but also the rectum'.[38] Jarvis therefore identifies constrictions of space, but does not further correlate space with subjectivity or consider its implications within institutions generally.

In relation to the tunnel scene in *The Shawshank Redemption*, Jarvis discusses both birth imagery and excrement, noting that 'Andy escapes through a sewer, a river of shit, and then leads the authorities to a river of dirty money.'[39] He therefore gravitates towards a Freudian interpretation of shit as money. Given the birth imagery and frequent uterine metaphors, the maternal body as prison seems a more logical analogy. Jarvis further suggests that the posters represent, in his positive Oedipal analysis, a gendering of liberty. His reading of liberty as the maternal underpins his interpretation of Andy's passage as a flight from the symbolic back to the semiotic (the beach scene). While the final beach scene is ambiguous, Jarvis's account of the open space as semiotic is inconsistent with the semiotic infantilized world. It is more congruent with regaining identity and masculinity in line with Neale's[40] discussion of masculinity.

The prison in *The Shawshank Redemption* is represented as the maternal castrating mother and the passage to the outside world is a scene that must surely equate to his rebirth, given his assumption of a completely new identity. Liberty, in any case, is literally gendered through the construction of male identity (Randall Stevens). In the bank as he collects the money, Andy Dufresne is much taller than anyone else, groomed, well spoken, fully controlled and articulate. His reclaiming of adult subjectivity is therefore complete. This

clearly defined identity (visually marshalled by a close-up of various documents bearing the name Randall Stevens), and the collection of the money does not really fit Jarvis's explanation of a return to the semiotic. Andy's desire to go back to 'a warm place with no memory' is undeniably suggestive of a desire to return to a uterine existence. Zihuatanejo, the Mexican town to which Andy escapes, is possibly the material manifestation of this desire, though Kermode alternatively considers it as a 'Nietzschean state of guiltlessness',[41] or as 'a state of 'hope".[42] The maternal metaphors that Jarvis extends to the confined spaces within the prison do not, however, correlate with the open expanse of beach and ocean in the final scene. The unrestricted vistas that occur towards the end of the film and the increasing light and intensified colour of the *mise-en-scène* reflect freedom from, rather than enclosure within, uterine space. It is a place in which to forget about the trauma of prison. It represents a state of hope and, more significantly, freedom, functioning as purification for Andy after the filth of the prison. It likely therefore functions in the context of religion, especially considering the theological theme that underpins the narrative, and the film's title. Its visual equation to a spiritual place therefore suggests Kermode's interpretation is more credible.

Furthermore, a consideration of the prison as abject maternal body explains the effects of institutionalization that make it difficult for prisoners to cope with the outside world. Interpreting imprisonment as the maternal semiotic world both explains the process of wanting to break out (abjection) of the institution and accounts for the desire to remain (incestuously) immersed in it.[43] Abjection therefore offers a reading of Red's explanation of institutionalization. He describes how, 'these walls are funny. First you hate them, then you get used to them. Enough time passes you get so you depend on them.' This is true for Brooks Hatlen; abjection is difficult for him and he does not want to leave the security of the prison. This is suggested by the fact that outside he remains

vulnerable and infantilized, shown, in part, through camera angles that emphasize his small stature. He holds onto the bus rail with both hands, as if a small child, and almost runs into the path of a car. He even tries to commit a further crime in order to remain in a repressive but secure environment. Red, on the other hand, though equivocating between the desire for the order of prison and his desire for freedom, finally evades institutionalization. Even though he considers himself 'an institutional man' and outside prison is unable to 'take a piss without say so', he subsequently transgresses the carceral system by breaking parole. Part of the effect of institutionalization therefore arises through a dependence on the order and ritual that structure prison life.

The rituals present in this film are largely characteristic of the prison genre and, indeed, form part of the iconography of the institution film. They range from the rituals of dehumanization on arrival at the prison to the daily cycle of prison life. This includes opening cells as the prisoners ('roll out'), locking them as they 'roll in' and the routine of 'tossing the cells'. The repetition of these actions lends visual emphasis to the drudgery and boredom experienced in prisons, while narratively it mediates a semblance of order. While such rituals serve to order the criminal body and repress signs of abjection, they invariably conceal transgressive practice because Andy manages to excavate his escape tunnel and the channelling of contraband occurs easily and almost incessantly. This partly reflects the interface of power in real life prisons but it also underpins narrative causal logic in the institution film in which space is integrally bound to character agency.

Prisoners also contrive their own rituals to maintain their autonomy or position in the hierarchy of competing masculinities. Attention is drawn to one such ritual at the outset of the film, that of the arrival of new prisoners, namely 'fresh fish'. The function of the 'fresh fish' ritual appears to be partly an expression of solidarity, which is important for maintaining hierarchies of prisoner control.

It also directly intimidates the new inmates so that the weakest succumb – in this way it reinforces the relative masculinity of the other prisoners. Its ritualistic nature is stated by Red who says, 'the boys always go fishing with first timers and they don't quit 'til they reel someone in.'

For Kristeva, ritual and religion are related in containing abjection. Most noticeable about *The Shawshank Redemption* are the frequent references to the Bible, from which the warder often quotes. These quotes or references are usually coterminous with, or precede, acts of violence. One such example occurs during the early scenes when Norton states, 'I believe in two things, discipline and the Bible. Here, you'll receive both. Put your trust in the Lord, your ass belongs to me.' The verbal reference to discipline and religion immediately precedes Hadley's violent response to a prisoner's enquiry. References to the Bible therefore seem to be a means to assuage violence, one of the ways in which the prison 'castrates' the prisoners and impacts on their masculine identities.

Loss of masculinity further emerges through suggestions of homosexuality and anal rape. These references manifest via the *mise-en-scène*, especially the prison's secret passageways, while the actual prison is depicted as a feminine, semiotic world allied to excrement and bodily function. Moreover, space clearly relates to subjectivity, with prolonged restrictions leading in some cases to institutionalization. More usually, the creation of a network of hidden spaces sustains autonomy and to some extent masculinity. Indeed, Andy's character is wholly concerned with the preservation and creation of private spaces, which range from the library and the escape tunnel to the box he leaves for Red. When deprived of physical space he resorts to psychical space for consolation. This is shown, for example, by the scene when he spends two weeks in the 'hole' for playing Mozart and later comments, 'easiest time I ever did'. Extreme spatial restriction, however, leads to disorder. This arises through Andy's prolonged solitary confinement, which makes

him reassess certain aspects of his life, including his wife's death, and precipitates his escape.

Andy's escape tunnel is analogous to the inner body in its proximity to abjection and its parallels with birth. Although abject space is a product of suffering and incarceration, it ultimately brings about the redundancy of a cruel and brutal regime. While the *mise-en-scène* of the escape tunnel resonates with Creed's description of 'womb-like imagery'[44] in *Alien*, its function here allows for a positive interpretation of abject space. *The Shawshank Redemption* therefore shows that space is abject not only through physical allusion but also through the process of Andy's separation from the prison.

While Shawshank prison is concerned with stripping autonomy and remoulding the inmate, the film suggests that the rehabilitative aspects of prison are limited. This is demonstrated by the suicide of Brooks Hatlen and highlighted in Red's final parole hearing in which he questions the real meaning of rehabilitation. It fails to rehabilitate both because the inmates become institutionalized and because the chances of criminality are actually increased, suggested by Andy's words of, 'I was an honest man, straight as an arrow. I had to come to prison to be a crook.' Fundamentally, *The Shawshank Redemption*, like many other prison films, questions the usefulness of incarceration.

Moreover, the warder's manner of public address about rehabilitation, which he uses as a cover for taking bribes, suggests undertones of corrupt institutional politics. In these public talks, he describes the 'inside-out' programme in which inmates work outside prison. In *Shawshank: The Redeeming Feature*,[45] John Patterson refers to Norton in this scene as 'explicitly Nixonian', thus drawing parallels between the corrupt Nixon presidency and Shawshank prison. Kermode further equates Norton's corruption with the Watergate conspiracy, describing his exclamation upon finding Andy's disappearance as, 'a final flourish of ironically Nixonian

dialogue ("this is a conspiracy ... and everyone's in on it ... including her!")'.[46] David Wilson and Sean O'Sullivan also see the faults of Shawshank prison as a reflection of American political failure.[47] *The Shawshank Redemption* therefore contributes towards a trend developing in this book of questioning individual institutions while simultaneously commenting on larger ones.

Chapter 5

Performing Masculinity: *Lock Up*

Lock Up (1989, directed by John Flynn) bears similarities to *The Shawshank Redemption* in both its *mise-en-scène* and narrative trajectory. It follows the transfer of a model prisoner, Frank Leone (Sylvester Stallone), from a minimum to a maximum security prison and eventually to freedom. However, while *The Shawshank Redemption* is concerned thematically with rehabilitation, and narratively with the friendship between two men, *Lock Up* focuses on the relationship between the sadistic warder, Drumgoole (Donald Sutherland) and Leone. Drumgoole has a personal vendetta against Leone and subjects him to severe brutality and extremes of confinement. *Lock Up* therefore centres on the symbolically castrating effects of Leone's incarceration. Attempts to humiliate and emasculate him include beatings by the guards and threats of violence from other prisoners. However, one of the main means of symbolic castration is exercised by the acute restriction of space, which threatens to affect Leone's sense of self. The film leads the spectator through a number of these enclosed and highly oppressive spaces that include an execution cell, a delousing chamber, Leone's cell and the 'hole'. While much of the film is concerned with spaces of extreme control, the final scenes shift to the tunnels and sewers that underlie the prison. These are subject to less control, are structurally more labyrinthine, and visually abject. They allow reprieve from the oppression of extreme confinement and violence and, finally, escape from the prison.

While images of feminine desirability signal Andy Dufresne's sexuality and masculine identity in *The Shawshank Redemption*, in *Lock*

Up Frank Leone is physically and narratively masculinized. This is evident in the opening sequences and constantly reiterated through the film by an emphasis on his muscular physique, as well as his physical and psychological endurance. Therefore, despite being targeted by the sadistic Drumgoole and constrained physically, a focus on Leone's masculinity visually offsets his symbolic feminization.

Tasker observes that 'images of extreme violence in *Lock Up* serve as metonymic representations of castration, marking the limits within which the hero must operate'.[1] Offering an alternative view of prison narratives, Jarvis[2] sees the warder's sadistic brutality and the prison as embodying a Deleuzian version of the castrating maternal figure,[3] though it is an explanation that does not account for certain visual and narrative aspects of this film. Instead, abjection, in its relationship to subjectivity explains the clear correlation that exists between space and identity, a relationship that Drumgoole exploits by attempting to erase Leone's identity through solitary confinement. Indeed, threats to Leone's autonomy arise mostly through deprivation of private space and the frustrations of its inaccessibility, particularly in relation to his personal life. Moreover, while a Deleuzian approach has some relevance to this particular film, the ambivalence of maternal abjection explains the processes of institutionalization found, for example, in *The Shawshank Redemption* and *One Flew Over the Cuckoo's Nest*. Furthermore, a focus on the relationship between subjectivity and space as a way of interpreting prison narratives explains how deprivation of space inevitably leads to disorder in prison films as well as having relevance to real-life prisons.[4] Such disorder commonly involves efforts to reclaim space in both. Therefore, while Jarvis focuses on Deleuzian aspects of sadomasochism as one means of interpreting prison narratives, spatial abjection is clearly more appropriate, especially since restriction of space is intrinsic to prison films.

There is an emphasis on the internal architecture of *Lock Up*, particularly its claustrophobic and highly controlling spaces. The

cinematography and narrative repeatedly draw attention to these often abject, almost fetishized spaces. References to excrement and blood frequently equate these with the interior body and there is a general preoccupation with the corporeal body. In *Lock Up*, as with most of the films examined in this book, extremes of spatial confinement are followed by attempts to reclaim space to maintain or recover a coherent adult identity. In Leone's case, heterosexual masculinity primarily defines this identity.

The interior architecture of *Lock Up* displays a pronounced manifestation of the noir influence to which Nellis and Hale refer. It is distinct in the *mise-en-scène* of labyrinthine corridors and chiaroscuro lighting, and in the sadism and 'distorted sexuality' of Drumgoole and the other prison guards.[5] In the typical film noir, however, a dangerous and castrating woman, the *femme fatale*, represents the main threat to masculinity. While many of the noir traits that Nellis and Hale associate with the prison film are conspicuous in *Lock Up*, the *femme fatale* is absent or perhaps manifests differently, as I suggest later. This noir aesthetic is most evident at times of profound abjection, notably in the gymnasium scene and the sewer scene. *Lock Up* therefore represents extremes of abject space, which are accompanied by a distinctive repertoire of visual and cinematographic effects.

As in *The Shawshank Redemption*, Leone eventually escapes through this system of underground passageways and sewers before overpowering the warder and threatening him with death. Suffused with red lighting, the passageways and tunnels appear slimy and dark. They resemble the passageways of *Alien* and are highly suggestive of the visceral inner workings of the body. *Lock Up* is therefore similar to *The Shawshank Redemption* in its proximity to shit and abjection, but differs in that it offers a more austere version of incarceration as well as a more masculinized hero.

The choice of Stallone as Frank Leone implicitly defines the masculinity of the character since his star persona is mostly

associated with his roles in *Rambo* (1982) and *Rocky* (1976), both concerned with displays of strength, aggression and sufferance. The *mise-en-scène* of the opening sequence further mediates Leone's masculinity. While a slow pan from his point of view across a number of old photographs suggests a close relationship with his father, it also reveals that he is a car mechanic. Indeed, the opening scene is set in a garage. In addition, he plays football with a group of young boys and his heterosexuality is apparent through emphasis on the relationship with his girlfriend, Melissa (Darlanne Fluegel). These activities, together with his physical stature and star image, therefore define him as a typically masculinized and family-oriented man. A certain sensitivity, however, established in the opening scenes through displays of love and emotion and channelled through the romantic, high-noted extra-diegetic music, nuances Stallone's usual tough-guy representation.

In Norwood prison, Leone's cell is a bright, clean space individualized with photographs of his wife and family and other personal paraphernalia. Jocularity and open exchanges of contraband suggest camaraderie and solidarity between the inmates. The transition from extra-diegetic music to the sounds of electronic barriers and prison gates opening and closing, and a change from natural lighting to low-key artificial light, mark the distinction between 'outside' and 'inside'. The *mise-en-scène* of the prison is characteristically geometric and austere. Visually, Norwood, where Leone is initially detained, is significantly different from Gateway, to where he is subsequently transferred. The transfer occurs at night and, as in *The Shawshank Redemption*, is marked by Leone's absence of clothing. In one way, this draws attention to his musculature and hence masculinity, while concurrently signifying the onset of his incarceration in a maximum-security prison.

Partly through the use of chiaroscuro lighting, Gateway prison is represented as a more violent and threatening place than Norwood. A huge spotlight pans around and rests on Leone as he arrives, and

136

there is emphasis on the guards' weaponry, with sequential close-ups of the rifles as they are primed for action. Cinematography is rapid, with a number of whip pans from Leone's point of view to signify his confusion and the fast pace of events. The high imposing walls and barbed wire fencing at the entrance to the prison are significant, for they suggest claustrophobia.

As in *The Shawshank Redemption*, crossing the threshold is significant, rendered as an extreme low angle shot of a huge pair of gates opening. This marks the boundary of Leone's descent into a dark world of brutality and suggests the impossibility of ever escaping. The internal *mise-en-scène* of the prison contains the usual elements of the genre, namely barbed wire fencing, prison bars and high barriers, as well as a series of dimly lit, labyrinthine passageways through which Leone is taken. Moreover, in later scenes, Drumgoole forces Leone into a series of spaces that relate to execution or extreme constriction. These highly controlled spaces tend to be under close observation and the prisoner's agency is correspondingly inhibited. As in *The Shawshank Redemption*, maternal control of the prisoner is implied through reference to bodily function, particularly anality. Indeed, within the first few minutes of the film, Meissner (John Amos) informs Leone that, if he misplaces his toilet paper, he 'will be wiping [his] ass with [his] shirt'. Drumgoole himself refers to Gateway as 'the worst shit-hole in the system'.

Leone's 'tour' of Gateway leads the spectator sequentially through its various spaces, which mostly serve as sites of torture for him. A lack of daylight suggests that these are located in the basement of the prison, the first being the execution chamber in which Leone is locked. Here, Drumgoole tells Leone, 'you have no rights unless I give them to you; you feel no pleasure unless I tell you you can.' Drumgoole fetishistically describes the chamber as 'beautiful', and tells Leone that 'when I came to Gateway, it was falling apart so I had it restored, put back into perfect working

order.' Although Leone is not subjected to any physical torture at this point, Drumgoole's intention seems explicit.

The structure of the chamber allows visibility from all sides, emphaizing the notion of death as spectacle and recalling Foucault's[6] description of medieval torture. Drumgoole saying 'in the old days, the warder would have come down that private passageway from his office to this execution chamber to witness the putting to death of a criminal' reinforces the point. The term 'private passageway' aligns secret spaces with horror and has undertones of anality, a recurrent theme of the film. Red filtered lighting is distinctive and accentuates Drumgoole's evil character, partly veiling his face as he says, 'this is hell and I'm going to give you the guided tour.'

The theme of observing cruelty is apparent throughout the film and sadism is persistently linked to the gaze. There are several shots of Drumgoole secretly observing Leone through windows, closed circuit television (CCTV) and binoculars. In almost every incidence of Leone's suffering, Drumgoole emerges out of the shadows to watch him. While in *The Shawshank Redemption* sadism is linked to sexual violence, here it manifests as scopophilia. Although Drumgoole never seems to engage in actual violence against Leone, he takes pleasure in watching it. His gaze clearly defines a power relation that has sadistic, sexualized intentions. Moreover, while Foucault's articulation of control derives from an internalized disciplinary practice arising from surveillance (as discussed earlier), violence and deprivation also actively repress Leone.

In *A Case of Hysteria, Three Essays on Sexuality and Other Works*, Freud explains that scopophilia becomes a perversion 'if instead of being preparatory to the normal sexual aim, it supplants it'.[7] He describes how 'in scopophilia ... the eye corresponds to an erotogenic zone.'[8] Mulvey[9] exploited the theory that sadism and a desire to watch surreptitiously are linked. In *Lock Up*, a similar coupling depicts the perverted sadistic Drumgoole as fixated at a stage

coterminous with anality (hence the sadistic anal stage). Meissner states that he is actually mentally ill at the end of the film, to which Drumgoole replies, 'I'll have your ass for this Meissner, I'll have your ass' (seeming to confirm his fixation). As in *The Shawshank Redemption*, the gaze is therefore significant, though the implication of its accompanying violence is what carries the threat.

A balding, fat prison guard called Manly (Jordan Lund) is also aggressive towards Leone. He uses sadistic violence to compensate for his emasculated appearance and his soft paunchy body is especially feminized in relation to Leone's muscular stature. Dallas (Tom Sizemore) even refers to him as a 'fat tub of shit', which is an identical expression to that used in *The Shawshank Redemption*, again in the context of the emasculated male body (Fat Ass). Manly thus exercises violence to assert his masculinity and in one scene he warns Leone, 'you'd better not eyeball me boy,' implying that to return the gaze will result in violence. Leone consequently averts his gaze, in one sense fulfilling the masochistic, feminized position Jarvis[10] envisions in his account of the Deleuzian maternal prison.

In her analysis of *Lock Up*, Tasker shows masculinity constructed as emotional reticence; 'the rules of prison life involve not betraying emotion, looking away – refusing, for the sake of survival, the challenge that a look proposes.'[11] This ostensibly feminized, masochistic position equates to a masculine display of endurance and control.[12] Leone appears to submit to the carceral process and 'performs' femininity to avoid conflict so he can 'just do [his] time'; his averted gaze indicates a control of self rather than submission.

Leone's symbolic feminization involves the guards physically examining his bodily orifices. Such examinations bear obvious allusions to homosexual penetration. While peering into Leone's mouth, one guard, in an attempt to emasculate Leone further and to negate the (homosexual) implications of such close proximity to another man, asks if he is 'trying to kiss' him. Leone is then confined to the delousing chamber, which, like the execution

139

chamber, entails total control. He is naked except for his underwear and is directed to stand with his legs apart and arms outstretched. As the guard turns on the insecticidal gas, he is unable to breathe or speak. This scene clearly represents an extreme version of Foucault's concept of bodily discipline. The transient inability to speak or offer resistance represents a stripping of autonomy and signifies repression to a pre-Oedipal state. The delousing ritual also brings to mind Kristeva's[13] notion of purification of the abject (criminal) body. Moreover, the *mise-en-scène* of a dimly lit, steamy, enclosed space suggests the interior body. The combination of Leone's lack of clothing, inability to breathe or speak, together with his sweating body and the steamy atmosphere again connotes the prison as maternal body.

Although Leone symbolically returns to a uterine state, attention nevertheless remains focused on his muscular body. As noted previously, the lack of space for typically masculinizing activity imposes one limitation on displays of masculinity within the prison genre. Opportunities for a prolonged and controlling gaze are therefore readily available. The excessive suffering Leone experiences in the chamber might also contribute to the instabilities of masculinity inherent in such a gaze.[14] However, a succession of rapid edits between Leone, Drumgoole and Braden (William Allen Young), as well as pronounced and agitated activity by Leone himself, offset any questioning of Leone's masculinity. Cinematography thereby serves to increase tension and, arguably, to legitimize male-to-male gazing by both the spectator and other characters. An emphasis on musculature and physical activity mitigates the feminization of the potentially castrated body.

Extreme control of bodies and space characterizes *Lock Up*, which depicts a brutal prison regime in a maximum-security prison. The narrative centres on Drumgoole's attempts to break Leone while at the same time showing Leone resist this treatment and succeed in retaining his masculine identity. As in *The Shawshank*

Redemption, the degree of threat to Leone correlates with spatial restriction. Confined space places limitations on physical activity but Leone refuses to succumb to the brutal regime and continuously attempts, with excessive activity, to displace his objectification (through the sadistic gaze) and associated feminization. He is therefore always 'doing' something and is rarely passive. Only in one scene is he seen lying down in his cell and then, when he realizes that Drumgoole is secretly watching him, he declares 'you won't break me.' Even when mopping the floor, a potentially feminizing task,[15] he employs large, vigorous actions. Although at times he appears to submit to the carceral process, in most scenes of acute oppression he does not surrender to the system. While, for Leone, abject spaces tend to be sites of suffering and deprivation, they also serve to demonstrate his physical resilience and autonomy and, ultimately, they allow him to overthrow a regime of cruelty and subjugation, and this leads to his eventual freedom.

The most distinct example of control occurs during Leone's six weeks of solitary confinement when he is stripped to his underwear and subjected to unremitting camera observation. The cell has rough concrete walls and floor (close-ups show a drain in the latter) and without either a bed or toilet facilities, he is deprived of even basic needs. In any case, as extreme camera angles highlight, the cell is too small to accommodate a bed or toilet. Even in the face of the punishing combination of spatial constriction and deliberate sleep deprivation, with Leone repeatedly ordered to recite his name and prison number, the authorities fail to erase his identity and he continues to resist by performing a series of exercises to maintain his physical fitness.

Leone's musculature signifies masculinity and a refusal to give in to physical and psychological torture. When food deprivation restricts his physical activity he turns his attention to daydreaming when shots of him in the cell are intercut with images of Melissa. His fantasies about Melissa serve as a form of resistance (described

earlier as 'mushfaking') and partially neutralize the horror of solitary confinement. He evokes thoughts of normality, particularly heterosexuality, to stave off disorientation. Sleep deprivation, however, eventually causes him to break down and he is temporarily unable to recall his name or prison number. The guards use this as an excuse to beat him violently. A shot of one guard forcing him into a cold shower intercuts with another of a damaged car outside in the rain. Earlier in the film, the restoration of the car was the focus of sustained masculine activity, but it now functions as a metaphor for his depleted masculinity and identity. These scenes thus portray the prison in *Lock Up* as an extreme example of a total institution in which attempts are made to erase Leone's identity.

Showing resistance is crucial to Leone's autonomy and ego. There is a sustained focus on his physique, which is usually accessible to view. He wears sleeveless vests that reveal his muscular arms and he often engages in activity that promotes a display and flexing of his muscles. Frequent low-key lighting allows a visual sculpting of his body and emphasizes the glisten of sweat, which is also a signifier of masculinity. Pat Kirkham and Janet Thumim suggest that evidence of exertion or suffering, such as bulging muscles and sweat, points to both power and vulnerability, a bead of sweat being 'the visual mark of the male's power in marshalling and controlling his bodily resources'.[16] Indeed, Leone is usually associated with the 'innards' of the prison, particularly the engineering section, where there is an emphasis on bodily fluids, steam, sweat and oil. He likes to be close to the inner workings of things and enjoys a proximity to dirt; his clothing is often stained with sweat and oil. His attraction to certain abject spaces therefore emerges persistently throughout the film, perhaps because they allow freedom from surveillance and control.

Attention to his muscular body and persistent references to his heterosexual status offset the threat to Leone's masculinity; by

transgressing boundaries and reclaiming space he redresses the threat further. Certain spaces, however, especially the exercise yard, remain potentially dangerous for him. While usually functioning as a social area in prison films, the yard in *Lock Up* lacks the camaraderie of *The Shawshank Redemption* and carries the threat of displays of excessive masculinity through violence, especially by the use of penetrating weapons. Indeed, there are overt displays of masculinity, seen through men lifting weights and by threatening looks and actions. Masculinity is mobilized not only through performance but also through claims on territory, indicated by Weber's (Sonny Landham) comment to Leone of, 'move it, that's my spot.' Despite their aggression towards each other – Weber tries to kill Leone – there is evidence of inmate solidarity, for Leone covers for him by telling the warder 'you've got your rules, we['ve] got ours.'

The threat to Leone's masculinity recedes in the ensuing garage scene in which he discusses the restoration of a car with Eclipse (Frank McRae). This scene is important in reclaiming his ego, since the workshop affords a degree of personal control. He runs his hands over 'Mabelline' (the car) and comments on her 'good bodywork' to which Eclipse responds, 'a couple of guys tried to get her going but couldn't. I'm a body man myself.' There is thus a sexualizing of the car and re-establishment of masculinity, especially Leone's, who had been injured in a football game, which a number of close-ups of Leone's muscles, and a focus on tools emphasize. Sexualizing the car legitimates the men's contact with each other and the garage, as a male-defined space for mechanics, sustains a reclaiming of masculinity. It perhaps disavows potential homoeroticism, which is suggested as Leone sprays water over his young companion, First Base (Larry Romano), and in the way the men frequently touch and hug each other. The homoerotic undertone of the car scene is also evident in the playful way in which the men spray red paint over each other and is suggested by the extra-diegetic music, which plays 'I love you, I need you'. It is alluded to further

when First Base asks Leone if he is married. The implication of Leone's response of, 'are you proposing to me?' compounds their breathless exchanges as Leone pushes the car around the garage. Thus, their heterosexuality is sometimes in question. However, while First Base discusses his failed relationships, Leone's mention of Melissa serves to remind viewers of his heterosexuality.

Leone teaching First Base how to drive the car further counters the scene's sexual ambivalence. At the same time, Leone encourages First Base to fantasize, particularly about the formation of heterosexual relationships, which in the male-defined area of car mechanics inculcates in him a sense of adult masculinity. To prove his budding masculinity, however, First Base crashes through the garage wall and into the sports field. There is therefore an association established between masculine prowess and the reclamation of space. As a result, in a display of power suggestive of Leone's symbolic rape, Drumgoole destroys the car. Moreover, Drumgoole throws Leone into the 'hole' for six weeks, tortures him with bright lights, and deprives him of food and sleep.

Several authors have discussed the homoerotic implications of the car restoration scene. Tasker[17] comments on the closeness between male buddies and asserts that a rapidly edited montage sequence, rather than direct interaction, facilitates the intensity of this scene in which First Base and Leone touch each other. Chris Holmlund[18] also comments on its potentially homoerotic aspects. She interprets *Lock Up*, and this scene in particular, as a 'masquerade of masculinity' that disguises homoeroticism and homosexuality. Asserting that First Base is a 'Stallone clone' and that the relationship between them is homosexual, Holmlund suggests that First Base is a younger version of Leone. She notes that 'their hair colour and cuts, speech patterns and movements are identical'[19] and that rapid editing and their close relationship further reinforce their bond. For Holmlund, the *mise-en-scène* implies a sexually charged relationship, for 'constant explosions and grunts create a super-

charged and definitely male sonic atmosphere, while shadowy blue tunnels and steamy rooms set the stage for heated half-lit passion.'[20] She asserts that *Lock Up* attempts to contain any homoeroticism by establishing an apparent father–son relationship in which First Base is the more effeminate.

Holmlund's suggestion of a father–son relationship between First Base and Leone has some validity in that Leone teaches First Base not only how to drive a car but also how to survive in the prison world. It is Dallas rather than First Base, however, who is feminized and more closely associated with anality, for it is he who signals to Leone the attraction of the secret passageways under-neath the prison. In another scene Dallas deliberately bends over and says to the guard, 'lost my watch. Why don't you give me a hand looking for it?' Moreover, the father–son relationship Holm-lund describes, especially one in which the son dies or commits suicide, is apparent in other institution films. Sociologically, such a relationship may be explained by reference to patterns of 'mushfaking'[21] that occur in real prisons. As described previously, one scenario entails prisoners' attempts to synthesize their own 'families' within the prison caste.

An alternative explanation may lie in changing attitudes to mas-culinity and resultant shifts in representational practice. As dis-cussed previously, Jeffords[22] identifies the father–son relationship in the context of 'new masculinities' arising out of the Reagan era. Therefore, rather than being a clone of Stallone, and thus unique to Stallone films, First Base represents his son in a relationship that is typical of the institution genre. In the three prison films examined in this book, the main male protagonists have protégés whom they nurture. These protégés look up to their father figures as ego ideals and all are killed, including Aguilar in *The Last Castle*, First Base in *Lock Up* and Tommy in *The Shawshank Redemption*. It is interesting to note that Aguilar has problems with speech, Tommy cannot read or write and First Base is sexually naïve, sug-

gesting that these characters are therefore associated with Kristeva's semiotic *chora*.

Moreover, this motif is also evident in *One Flew Over the Cuckoo's Nest*, *Full Metal Jacket* and, arguably, *Remember the Titans*, further suggesting that the father–son relationship forms part of the generic iconography of the institution film. Indeed, the death of the 'son' is often a narrative strategy to remobilize the masculinities of their mentors, and cause them to break away from the castrating, maternal institution. This provides predictable narrative closure in escape or death. Perhaps the father figure of the positive Oedipal scenario that Jarvis[23] envisions in the prison warder is to be found in the older and more experienced prisoner. Evidence found here in the narratives of at least five films supports such a hypothesis. Psychoanalytically, the most obvious interpretation would therefore be of a relationship in which the son not only desires the father but also identifies with him as an ego ideal. It is possible that such relationships not only serve as narrative strategies to effect 'masculine' action of the father figure, but also help to restore his adult identity.

This places Drumgoole, the prison warder, in a somewhat ambivalent and unstable position. Characterized by his fetishization of certain spaces, which perhaps function to conceal sexual inadequacy, and fixated as a scopophilic sadist, Leone reveals him as a coward in the 'execution' scene. Invariably physically inactive within the narrative, he therefore embodies both the Freudian castrated maternal and castrating paternal figure. His own shackling at the end of the film tends to confirm this. He thus potentially epitomizes the Freudian sadomasochist that Jarvis excludes from his account of prison narratives, since, according to Freud, the perversions of sadism and masochism are likely to coexist within the same individual.[24] Alternatively, he may represent the dangerous and castrating *femme fatale* of Nellis and Hale's[25] noir scenario.

While noir characteristics and labyrinthine *mise-en-scène* generally characterize abject spaces in *Lock Up*, this is not inevitably the

case. Proximity to bodily fluids is symbolically suggested in the football game and the mud in which the prisoners roll around equates visually to excrement.

Being an unconfined space, and typically a male domain, it also allows for masculinizing activity and at the same time alleviates pent-up aggression and repressed desire. The football field therefore integrally relates to reclaiming the ego and becomes disorderly through competing masculinities when violence negates its potential socializing aspects. It allows an assertion of masculinity by Weber, who is trying to bait Leone into fighting. He goads Leone by saying to First Base, 'when you gonna paint your nails, answer the name bitch.'

In the construction of hierarchies of masculinity, First Base is here therefore evidently feminized. Leone participates in the ball game to mitigate the threat to First Base, but since he is almost at the end of his sentence, and wants to complete it with minimum disruption, he is keen to maintain a distance from potential conflict.

A rapid sequence of close-ups, whip pans and fast tracking shots suggest conflict and disorder in the violence that Weber precipitates. The sound of guttural groans and grunts, which signify a return to a prelingual, semiotic state as well as the unrestrained violence of the id, highlight abjection further. Frequent close-up shots of the mud, emphasizing its similarity to excrement, signal the intersection of macho masculinity with the maternal world of the prison. Again, extreme violence negates the potential homoeroticism of male bodies in close proximity. As in the exercise yard and garage, which are relatively uncontrolled compared with other spaces, it allows a reclaiming of ego, though injury and threat mitigate this for Leone. He refuses, however, to submit to Weber who threatens him with, 'next time I want … you give,' indicating that he expects Leone to submit masochistically to his punishment.

The subsequent scene shows the inmates racing cockroaches, which suggests infantilism and regression. The reference to cockroaches also alludes to dirt and decay, especially as the inmates appear to be in the basement. While Leone's bug is called 'Dirt Creature', it is interesting to note that First Base's bug is called 'Rear Entry'. Leone's comment of 'that figures' perhaps confirms Holmlund's suggestion of a homoerotic relationship. First Base puts his bug in Leone's care as he is summoned to the gym. The gym and particularly the boxing ring are usually spaces where the male body is legitimately a site of both spectacle and action, and where careful and strategic positioning of the body occurs. Here, however, the gym has a significant noir aesthetic, cohering closely to those qualities previously related to abjection. Moreover, as Weber again addresses First Base as 'little bitch' and crushes his chest, the male body becomes a feminized spectacle. While comedy or action commonly alleviate the spectacle of the male body, it is, as Tasker argues, also 'displaced through ... the deployment of images of torture or suffering'[26] and in this scene torture reinforces the male body as a feminized spectacle. Leone retaliates by holding a heavy weight over Weber, but does not drop it. While this action could be interpreted as masochistic and feminizing, it is also a sign of Leone's control and refusal to be manipulated. The other inmates, however, take his lack of aggression as weakness and attack him. A muffled sound signifies Leone's loss of consciousness as he slumps to the floor and his muscular armour is penetrated. Tasker holds that, 'such [breaches] can be interpreted in relation to images of castration.'[27] Leone therefore oscillates between masculinity (defined by his muscular body) and femininity (defined by his suppressed aggression and wounds), his 'Achilles' heel' being First Base and Melissa.

With Leone refusing to be manipulated, pressure is put on his 'feminized' partners (who are physically and psychologically weaker). While First Base is killed, the guards prevent Melissa's access to the prison. She is, however, periodically reintroduced to

the film both visually (through photographs and letters) as a diversion from Leone's damaged body and narratively to re-establish his heterosexuality. She is eventually allowed to visit Leone in the infirmary, but Manly, the prison guard, deliberately cuts short her visit. Subsequently, another disguised prison guard reveals to Leone that he intends to rape Melissa, thus further compounding Leone's impotence. Melissa's reappearance and First Base's murder narratively provoke his escape through the sewers, for he has to escape the castrating effects of the prison to reclaim his heterosexual identity. Threats to subjectivity again prompt the production of the abject space of the prison. While in *The Shawshank Redemption* this resulted partly from extreme confinement, in *Lock Up* it also stems from attempts to negate Leone's heterosexual masculinity.

Leone's escape route through the tunnels distinctly echoes the *mise-en-scène* of *The Shawshank Redemption*. As in *Alien*, there is a reddening of the wet tunnels, suggesting the sewer as a corporeal space. A revolving fan, through which shafts of light permeate, contributes to the noir aesthetic that tends to define the film's abject spaces. Moreover, there is a direct reference to abjection when Manly pushes Dallas into the sewer water saying, 'see, shit does float.' While the steamy, reddened tunnels may be interpreted as the inner body, Leone's and the officers' grunts and groans further suggest this is a primitive, archaic space commensurate with Kristeva's semiotic *chora*. The intrinsically abject nature of the sewer is heightened as Dallas, who is bleeding, electrocutes first Manly and then himself. Dallas, though feminized throughout the film, is ultimately masochistic, but in this context his self-sacrifice is a sign of heroism rather than passive submission.

Observed closely by Drumgoole on CCTV, Leone crawls through the hidden spaces of the prison before returning to Drumgoole's office and the execution chamber. Leone then straps Drumgoole into the execution chair and strips him of his power by exposing him to the fear of electrocution. Drumgoole's display of

fear and submission finally allows Leone to re-establish control and a stable adult identity as the male hero. Leone binds his hand to the upright, phallic handle of the electrocution equipment, thus transposing himself to a position of sadistic masculine power and Drumgoole to one of masochistic femininity. This inversion of power restores Leone's masculinity, which has been continually at risk from the outset of his incarceration.

His adherence to certain self-imposed rituals is important in warding off threats to subjectivity. Rituals help the symbolic subject sustain the borders that prevent him sinking irretrievably into the abject maternal prison world. These are manifested in the ritualized exercises and physical activity in which Leone engages, especially during the scenes of his solitary confinement. He maintains a self-disciplining of the physical body not only to keep fit but also to show endurance and keep the feminized or abject body at bay. Leone even says, 'as long as you keep moving you don't become a part of this place.' Ego thus closely relates to ritual, with persistent efforts to consolidate identity and maintain detachment from the prison. In Leone's case, however, psychical space also often helps him endure his situation rather than the system of physical spaces that serves to sustain the inmates of Shawshank prison.

In *Lock Up*, the prison as a site of sadomasochistic fantasy manifests in the overtly sadistic Drumgoole and in the torture and suffering that Leone endures. Leone's suffering is largely related to spatial restriction, while unrestrained spaces enhance his narrative agency. In spaces of total control, such as the delousing cell, he is symbolically returned to an infantile state, with the narrative correspondingly slowing down. In spaces of lesser control, he is physically more active and the narrative therefore tends to progress more quickly. During periods of acute restriction, Leone's body is also potentially a site of spectacle. This is averted, however, by a focus on displays of his resistance, suffering and activity. At times, spaces of extreme repression, especially solitary confinement,

induce transient loss of identity and ego. Alternatively, Leone appears to submit masochistically to the process of imprisonment and performs femininity as a form of control.

The electrocution chamber, which is unequivocally abject in both its purpose and structural analogy with the feminine body, is a particular site of trauma. It functions in the early scenes as a place of acute and total control over Leone. Drumgoole relinquishes this control during Leone's confrontation with him, however, and Leone's phallic power is restored. The inner, abject spaces of the prison are therefore shown to be liberating and allow Leone to overcome a regime of sadistic cruelty. As a result, Leone's ego and masculine identity are restored and he is able to separate himself from the maternal prison.

While the *mise-en-scène* of *Lock Up* does not entail specific images of birth or other unequivocal signs of the reproductive body, it is distinctly corporeal. Moreover, the prison as institution functions like the castrating maternal body in its attempts to infantilize and emasculate the inmates, though they strongly resist this through displays of overt masculinity. *Lock Up* also correlates with other institution films in its *mise-en-scène* of dark labyrinthine tunnels as places of both abjection and liberation. A number of enclosed spaces constrict the inmates, with loss of basic facilities causing oppression and, consequently, leading to abjection. While transient reclaiming of space and hence, masculinity, occurs, an acute lack of personal space eventually leads to attempted escape. *Lock Up* demonstrates extremes of punishment and perhaps comments on the harsh conditions of maximum-security prisons.

Chapter 6

Resisting the Gaze:
The Last Castle

Perhaps more than any other film discussed in this book, *The Last Castle* (2001, directed by Rod Lurie) comes closest to Foucault's[1] account of control through surveillance and knowledge. *The Last Castle* is set in a military prison in which discipline is mediated through almost constant observation of certain spaces, with the yard being the focal point. While the film refers to space and time, it also questions surveillance as an effective means of control, for the yard becomes a site of conflict and disorder in the final scenes under the direction of its central protagonist, Eugene Irwin (Robert Redford). Irwin is a high-ranking military officer who is in prison for disobeying an order, which resulted in the loss of life. Despite this failing, both the prisoners and prison guards, and initially also the warder, Colonel Winter (James Gandolfini), regard him with awe. Within a short time it becomes apparent to Irwin that Winter's disciplinary regime depends not only on surveillance but also on physical cruelty, even murder. Irwin therefore aims to overthrow the prison regime through a strategic transgression of its boundaries, and to fly the prison flag upside down (as a sign of distress).

Irwin's voiceover at the beginning of the film describes the prison as a type of castle: 'the only difference between this castle [the prison] and all the rest is that they were built to keep people out – this castle was built to keep people in.' The concept of the boundary and the division of space is therefore established in the opening scenes. The film essentially suggests that the separation

153

of good and evil is not always clear and is a motif that is repeated throughout. While the boundary, a central tenet of Kristeva's[2] theory of abjection, is pivotal to the film's narrative, *The Last Castle* lacks a focus on some of the more corporeal aspects of abjection, such as bodily fluids, uterine metaphors and anality. Furthermore, the noir aesthetic that typifies *Lock Up*, and to a lesser extent *The Shawshank Redemption*, is confined to the cellblocks and visitor spaces. *The Last Castle* also differs from these films in that it departs from scenes of enclosed spaces to focus instead on the open space of the yard. The visual iconography therefore exists at the opposite extreme of abjection to *Lock Up*. As an institution film, however, the main signifiers of abjection and repression are still evident, but channelled primarily through the concept of the boundary.

The border in both its physical and psychical manifestations is a key concept in Kristeva's theory of abjection. Psychically, it is mostly relevant to the bounding of the self in the development of subjectivity, and to its disintegration in the return of the repressed. Kristeva also refers to the physical border, usually in relation to the body and its transgression. In this film the border, as a way of marking subjectivity, is represented in quite a literal sense, namely in the stones and mortar of the prison itself. As noted earlier, the border is explicitly remarked upon in Irwin's opening voiceover, while its transgression produces abject space in the closing scenes. The prisoners' identities also symbolically manifest as a wall built within the yard. In this chapter I focus therefore on the physical border as relevant to subjectivity and masculine adult identity rather than on the specifics of abjection. The prisoners also articulate subjectivity through the exercise of precise, strategic movement. Identity is thus further consolidated through control of the physical self, in which a spatial ordering of the body is achieved.

While abject space is normally occupied by the other, in this case it is produced through efforts to exclude the other (Winter). It is

nonetheless synonymous with the transgression of spatial boundaries, especially in those spaces where control is excessive, such as the yard, where reclamation of space escalates into a full-scale battle. It leads ultimately to the overthrow of a cruel and corrupt prison official (Winter) who orchestrates a regime of excessive control. Although abjection proves liberating for the prison inmates in that Winter is finally removed from his position of power, it also results in Irwin's death. Irwin is therefore not only a hero but also, narratively and visually, a Christ-like figure, with his death at the flag-head analogous to a crucifixion.

Although abjection in *The Last Castle* is associated with open spaces rather than the enclosures and labyrinthine architecture that usually characterize prison films, there is still evidence of the emasculating practices that typify the fictional institution. In Irwin, however, *The Last Castle* features a character who is markedly resistant to such practices. The film therefore focuses on efforts to erode his masculinity, not only by restricting his personal space but also by attempting to discredit his military ability and physical strength. Winter likewise tries to humiliate other prisoners by referring to their military failures. Thus, while a significant feature of *The Last Castle* is its focus on a surveillant gaze that entails violence as a mode of discipline, the warder also believes that knowledge further contributes to prisoner control. Although it becomes clear that the prisoners, who are aware that they are under constant scrutiny, modify their behaviour to some extent, surveillance emerges as an ineffective mode of control. This destabilizes Foucault's ideas about the mechanisms that underpin his accounts of disciplinary practices.

The focal point of Winter's surveillant gaze, the yard, is depicted in the opening scenes as a site of general disorder. This is represented through a succession of rapidly edited and disorientating shots, the extra-diegetic sound of rap music, and displays of aggression and masculinity. Conflict between various ethnic groups seems particularly linked to this disorder. The association between

different ethnicities and disorder perhaps references abjection through racial and national identity, as Kristeva[3] and other scholars have suggested.

The subsequent cut to Winter's office offers an antithetical world of classical music and polished military memorabilia. As well as being a space of order and culture, a sense of nationalism is evident. An image of Abraham Lincoln is visible in the background and a reflection of the Stars and Stripes flag overlies Winter's rounded face as he observes the yard. In short, the scene implies that order and justice directly relate to white American nationality and identity. Several close-ups show Winter fetishistically polishing his military collection, particularly his buckles and sword. Then, rather inappropriately dressed in combat fatigues, he obsessively polishes the cabinet itself. The paradox of this scene is repeatedly addressed throughout the film. As he discusses the impending arrival of Lieutenant General Irwin with Captain Peretz (Steve Burton), the sound of Winter's breathing becomes more apparent, suggesting emotion in relation to this event. Winter's comment that 'they should be naming a base after him' further indicates that Irwin is a significant prisoner.

As in the opening scenes of *The Shawshank Redemption*, a crane shot circling over the prison shows Irwin's arrival and the prisoners in the yard swarming towards the gates. The generically characteristic scene of the prison gates opening is also present. From the outset of the film, the space of the yard is significant in that it affords Winter a clear and constant view of the prisoners from the apparent security and relative comfort of his suite. Rather atypically for the prison genre, the setting for Irwin's arrival shows a sunny day with blue skies.

Within the prison walls, the conventional *mise-en-scène* of the prison genre is evident, with geometric pylons and meshed fencing set against the angularity of the rear buildings. These characteristic prison features are reflected onto the windscreen of the bus as it

arrives with Irwin inside. The construction of such *mise-en-scène*, consistent across the prison films examined, suggests the imminent constriction of Irwin's space, and marks the onset of his incarceration. On his arrival, the other prisoners take immediate bets on the likelihood of his suicide, as they did in *The Shawshank Redemption*. Unlike Andy Dufresne, however, Irwin, shown in medium close-up, stands proud and upright and wears full military uniform. Not until he comes into long shot do we see that his hands and feet are shackled, visually marking his loss of liberty and potential castration. The following scene, in which a female prison warder goes through his personal effects, heightens the threat to his masculine identity. In an awkward exchange, exacerbated by the warder's gender and physical attractiveness, she removes the vestiges of his military prowess; not only is Irwin predictably stripped to his underwear, but his military stars, shown in close-up for emphasis, are also taken from him.

Despite the removal of his personal effects, Irwin's military prestige means that, narratively, the harsh dehumanizing processes that characterize *Lock Up* and *The Shawshank Redemption* are mostly absent. Indeed, he attracts admiration from his fellow inmates, especially from Aguilar (Clifton Collins), while Winter's self-preening for his arrival signifies Irwin's importance. Moreover, Winter addresses him politely and within the confines of his private suite, which could be anywhere but a prison. He is hospitable towards Irwin, but, rather incongruously, asks 'are you hungry? May I offer you some lemonade,' as if addressing a small child. Winter, therefore, while clearly admiring Irwin, still attempts to infantilize him. Furthermore, although he shows Irwin the prison layout from the vast window that overlooks the yard, he also reminds him of their power relationship, pointing out to Irwin 'the laundry where [he has] had [him] assigned'. (The laundry is a consistent and potentially emasculating theme of the prison genre.) As they look out over the yard, a blue searchlight simultaneously sweeps across it. A similar

blue reflection persistently appears in Winter's spectacles through-out the film, perhaps emphasizing his surveillant gaze.

In the same sequence, Winter's admiration for Irwin is further seen when he asks him to sign a copy of his book, *The Burden of Command*. As Winter goes to his bookcase to retrieve it, Irwin examines his military memorabilia and comments to Peretz that 'any man with a collection like this is a man who has never set foot on a battlefield.' Winter overhears this remark and feels humiliated, for Irwin has challenged his military prowess. The two men are consequently established as opponents, but Winter (who wears glasses and is overweight) is visually represented as physically inferior. Their equivalence, however, is implied in one shot in the sequence in which they are positioned within the frame as if mirror images. It is also suggested earlier, when the position Winter's self-admired reflection occupies in one scene is replaced by an image of Irwin in the next. The concept of their equivalence is explored through the duration of the film and the narrative structure reflects the shifts in power between them. Winter obviously admires Irwin and wants to be him. He thus narcissistically identifies with Irwin but also wants to maintain control over him. At the same time, he apparently experiences feelings of inadequacy based on his own lack of masculine qualities.

The concept of narcissistic identification in film studies, based on Lacan's mirror stage, is one that Mulvey[4] proposed to explain one of the pleasures of narrative cinema. Here, the window in Winter's office, as well as delineating his personal space, so offering a Foucauldian vantage point, also functions as a form of cinematic screen in that it affords him the potential for narcissistic identification. It is also possible to explain Winter's feelings of inadequacy through Neale's[5] consideration of masculinity and the cinematic gaze. Neale considers that narcissistic identification is not only concerned with the construction of an ideal ego, but

is a process involving profound contradictions. While the ideal ego may be a 'model' with which the subject identifies and to which it aspires, it may also be a source of further images and feelings of castration, inasmuch as that ideal is something to which the subject is never adequate.[6]

Neale thus describes both masochism in the relationship between the spectator and the image, and an erotic element in the narcissistic male image; consequently, the image hovers between identificatory and contemplative modes. While Neale refers to the spectator's relationship with the film image, there is clearly a parallel to be drawn in Winter's observation of Irwin.

It is further relevant to consider Mulvey's[7] explanation of voyeurism in analysing Winter's observation of Irwin. Taking Mulvey's application of Freud's notion of scopophilia as a way of interpreting *The Last Castle*, the window simultaneously functions as a keyhole in that it permits a voyeuristic observation of him. As noted earlier, Freud[8] links the sadistic-anal stage of a child's psychosexual development to scopophilia. Mulvey's theory has some relevance to this analysis in that the gaze, with its implications for gender, operates as a controlling force in *The Last Castle*.

Conversely, the controlling gaze that Foucault[9] refers to is allegedly neutral in terms of gender, though it is possible to argue that, since Foucault based his writing on male dominated institutions, gender is implicated in his views on surveillance. He refers to a look that appears devoid of sexual objectification and one that replaces a previous regime of physical torture. As well as surveillance as a means of punishment, Foucault is interested in the physical discipline of the body, particularly in relation to time and space, so that 'through the demands that it imposes, it conveys, imperceptibly, the forms of a rigorous power; it bends bodies to regulate movements, it excludes agitation and distraction, it imposes a hierarchy and a surveillance that are all the more accepted.'[10]

Foucault argues that the panopticon offers a system for observing prisoners so that they are always aware that they may be being watched. This differs significantly from Mulvey's (initial) hypothesis[11] concerning the male gaze, wherein the female is object of a voyeuristic, illicit look. However, gender is implicated in *The Last Castle*, since physical submission, mediated through the gaze, is a way of signifying loss of masculinity. While Foucault considers the panopticon 'the most direct way … of making it possible to substitute for force or other violent constraints the gentle efficiency of total surveillance', in *The Last Castle* surveillance is a precursor to violence.

Therefore, while Mulvey[12] describes the existence of a gendered, voyeuristic gaze entailing a sado-masochistic power relationship, and Foucault[13] defines a gender neutral, but equally controlling, surveillant gaze, it would seem that Winter's observation of the prisoners is a hybrid of the two. In his close and purposeful watching of them, he attempts to assert both power and masculinity by feminizing the inmates as objects of his gaze, and controlling them through observation. However, while Foucault's notion of power rests almost entirely on the gaze, here it is linked to violence. This scenario also deviates from Mulvey's hypothesis in that Winter is rarely physically active. Indeed, he is presented as a source of visual ridicule. In one scene, he is dressed in combat gear and carries a small briefcase, adding emphasis to his large, bulky frame. In another scene, and similarly inappropriately dressed, he obsessively polishes his battle artefacts. Winter's gaze also differs from Mulvey's hypothesis in that the look is not illicit but acknowledged by the prisoners. This is indicated by the inmates' frequent point of view shots of Winter looking down on them and is made explicit by Beaupre (Brian Goodman), who comments, 'we're only doing this to keep Johnny fucking eyeballs off our back.' Therefore, they modify their behaviour as predicted by Foucault, who refers to 'an inspecting gaze, a gaze which each

individual under its weight will end by interiorizing to the point that he is his own overseer, each individual thus exercising this surveillance over, and against himself'.[14] Within the open space of the yard they are especially susceptible to Winter's visual monitoring.

Ordinarily, Winter remains in his office, which is positioned high up and overlooks the yard. From here, he directs the activities of both the prisoners and the guards. Having had Irwin threaten his masculinity, Winter orders Peretz to 'put out only one baseball'. He thus deliberately provokes disruption in the yard, a space over which he thinks he holds dominion, as suggested when he comments, 'you see how easy it is to manipulate men.' Winter therefore believes that he can control the inmates by watching them. He also thinks that, by constant surveillance, he will gain knowledge of how their minds work and thus be able to predict how they will behave. As he anticipates, the baseball strategy indeed causes the yard to become a site of violence and aggression. It is interesting to note that, even at this stage, Irwin stands apart from the crowd of prisoners as they watch a fight develop and seems to suggest that Irwin is not susceptible to Winter's manipulation. At a point of potential violence between the prisoners, Winter then orders Peretz to 'end it'. A siren sounds and the guards instruct the inmates to lie face down. From a high angle shot in Winter's office, Peretz and Winter look down on the randomly arranged and physically submissive prisoners. Winter thus apparently exercises complete control over the prisoners, inciting them to violence at will and subsequently rendering them completely docile. This is reinforced by the framing of the scene that highlights Winter's dominance and the felling of one of the prisoners with a rubber bullet.

Within the space of the yard, therefore, there are constant challenges to masculinity and the threat that Winter's sadistic gaze persistently imposes regulates the men's actions. Conversely, Irwin's masculinity is rarely in question, even when, during a visit

from his daughter Rosalie (Robin Wright Penn), she tells him 'you weren't a father at all,' suggesting that his duty to his country overrode his parental duties. Although there is evidence of failed personal relationships, with no mention of his wife, frequent reference to Irwin's military accomplishments sustains his masculine image. His 'country' therefore appears to replace his family. This is suggested by the allegiance that some of the prisoners have with him in the knowledge that he led their fathers in battle. Irwin's masculinity is further apparent in a comparison with Winter. Not only is Winter's masculinity equivocal, but his sexuality is also ambiguous, in part encouraged by the constant presence of the feminized Peretz. Peretz not only has fine features and meticulously styled hair, but is also framed in such a way that he appears physically much smaller and shorter than Winter does.

Irwin displays his masculinity in his leadership of the prisoners. They hold him in high regard, especially Aguilar, for whom Irwin becomes a father figure. Aguilar shows his respect by repeatedly saluting Irwin. The salute is important to the film because it both offers a means of solidarity between the prisoners and relates to identity and mutual respect. Irwin explains its significance to Aguilar, telling him that historically it means, 'this is who I am.' This is important in the overall context of abjection and subjectivity and therefore significant to the narrative in that it shows that the prisoners are reclaiming their identities and refusing to be subordinated or feminized.

Unlike Irwin, Winter commands little respect from the prisoners. Visually, the camera focuses on his rotund body, which the tightness of his clothing emphasizes. Winter's spectacles are also significant since he constantly polishes them, and removes them to assert authority. They are an important prop in that they facilitate his controlling gaze but at the same time accentuate a physical weakness. Upon observing the 'proper salute' scene, he punishes Aguilar. He thus tries to re-establish his masculinity in relation to

162

Aguilar, who is presented as pre-Oedipal (he is infantilized and has difficulty with speech, which Kristeva associates with the semiotic) rather than confronting the more masculinized Irwin. He orders Aguilar to stand and salute in the yard overnight in the rain, thus again rendering the yard a site of extreme control. Aguilar, like Tommy in *The Shawshank Redemption* and First Base in *Lock Up*, functions as a narrative trigger for the spatial chaos that ensues.

Irwin's protest against Aguilar's punishment results in Winter assigning him an almost impossible test of his physical strength with a view to undermining his masculinity publicly. Winter, via Peretz, orders Irwin to move a pile of rocks. Despite the heat and the enormity of the task, Irwin does not submit to physical hardship. Moreover, as he removes his shirt and reveals his muscular torso, his masculinity is heightened, his physique again directly contrasting with Winter's overweight figure. The prolonged gaze by the spectator and by the other men (inmates and guards) and potential feminization of Irwin's body in the punishment sequence is thus countered by the tensing of muscles, the formation of sweat and by endurance and evidence of suffering. As he removes his shirt, he turns his back to the camera. The camera slowly zooms in to a close-up of several prominent scars on his body, which draw gasps of shock and admiration from the other inmates. Attention is also drawn verbally to the scars by Yates (Mark Ruffalo) who comments, 'electrical burn scars'. Tasker notes that there is a tendency for Hollywood to 'construct … the male body as spectacle with masculinity as performance – within this structure, suffering – torture in particular – operates both as a set of narrative hurdles to be overcome and a set of aestheticized images to be lovingly dwelt on.'[15] Here, the combination of endurance, suffering and musculature thereby enhances Irwin's masculine identity. Easthope also notes that masochism and signs of endurance may be signifiers of masculinity, commenting, 'masochism … perfectly combines with the narcissism of the male ego. If I can hurt my body freely, by an

act of my own will, then my mind is proved to be master of my body.'[16] Thus, although the body has been violated in *The Last Castle*, scarring marks the resealing of the taut body (and hence restored masculinity) and simultaneously signifies its ability to endure pain and suffering.

The scars also create a communal point of contemplation for audience and inmates. As previously discussed, Neale[17] argues that this is to be avoided, since any prolonged gaze at the male body by another man may serve to eroticize it. Any eroticization is, however, countered by Irwin's musculature, strength and his resilience, which again suggests Christ's suffering. Irwin does not succumb to physical pain and becomes a heroic figure among the inmates as they cheer him on, referring to him as 'General' or 'Sir'. The contemplative gaze at the body is also, as in *Lock Up*, displaced onto physical activity, and mitigated by various cinematographic techniques. A slow pan, together with the muffled sounds of the inmates' cheers, highlights Irwin's dizzying physical efforts. A slow motion point of view shot further emphasizes his exertions. The camera also cuts frequently between close-ups of Irwin's face, to emphasize sweat, grimacing and gritting of teeth, and his scars, thereby drawing attention to his endurance rather than his body. The camera intermittently cuts to close-ups of his feet as he relentlessly moves the rocks. As he moves the final rock, it is shown full frame to emphasize its size.

The rocks, symbolic of Irwin's strength and resistance to Winter's control, become increasingly significant within the narrative. As the antagonism between the two men grows, and Winter fails to undermine Irwin's masculinity, he orders Irwin to move the rocks back to their original location. Aware of Winter's constant observation, which is apparent through frequent point-of-view shots at Winter's window, Irwin continues with his task. The rocks therefore signify the power relationship that exists between the two men. They later form part of a wall, which becomes a metaphor for

the interface of control and resistance between Winter and the prisoners. The wall allows the prisoners to establish a sense of self. Moreover, narratively the rocks provide a place in which to hide various weapons for the final overthrow of the prison, as well as becoming weapons in themselves. The prisoners also conceal the flag there. The rocks thus constitute a series of hidden spaces that do not materialize until the final scenes, indicating that there are many unsurveyed acts. These spaces are significant in that they allow the men not only to overthrow the prison but also to become heroic. Even Yates, whom the prisoners openly despise through-out, becomes a heroic figure. Yates has a choice between serving the maternal body (Winter and the prison) as a 'snitch', or rejecting it to prove his masculinity to the father figure (Irwin) whom he resents. These spaces are therefore not only linked with solidarity but also to displays of heroic masculinity.

Most of the film's action centres on the yard, with few interior cell shots. Where these do occur they tend to display the noir aesthetic that characterizes *Lock Up*. This is evident as Irwin is first escorted to his cell, the blue toned, chiaroscuro lighting and formal geometric architecture of the prison's interior contrasting with the refinements and warm lighting of Winter's office. Within his cell Irwin stretches out to touch its walls, physically measuring his personal space and emphasizing its smallness to the viewer. His cruciform posture also carries a religious connotation that is further implied in the closing scenes.

Despite the attention drawn to the size of Irwin's cell, it is also occasionally depicted as a social space in which he plays chess, reads books and talks to other prisoners. Not only is space less constricted than in other prison films, but the usual emphasis on the hardships of solitary confinement is absent. Instead, Winter imposes control almost entirely within the open space of the yard. Even though the cells are not overly restricted, there are relatively few shots of Irwin in his cell and almost no display of personal

effects apart from his grandson's photograph, replaced at one point by a more recent one (to signal the passage of time). Paradoxically, Winter's presence in Irwin's cell tends to accentuate spatial restriction. In such scenes, we see Winter approaching, framed tightly within a viewing window and then peering into the cell (the same blue reflection in his spectacles still present to denote his watchful gaze). Alternatively, he squeezes into the cell, emphasizing his size and ungainliness. His tendency to dress in full military uniform is an attempt not only to establish authority but also to redefine his paunchy body. Inevitably, these scenes comment adversely on Winter's rather than Irwin's masculinity. In one such scene, Winter interrupts a game of chess between Enriquez (Michael Irby) and Irwin. On Winter's exit, Enriquez knocks over the king, signifying their plan to topple him. The spectator, situated in Irwin's cell as object of Winter's gaze, is thus encouraged to identify with Irwin. Since the audience is made to share the belief with the other inmates that Irwin is intrinsically good, there is a narrative advantage in this identification; not only is the spectator invited to 'identify with a perfect man'[18] but also to justifiably enjoy transgressive action.

In one scene when Winter visits Irwin's cell, discussion revolves around Winter's knowledge of the inmates, which he considers vital to maintaining power. He uses knowledge, however, to justify brutality rather than understand and rehabilitate offenders, revealing to Irwin that 'whenever I am filled with doubt, whenever sentiment creeps in, I just have to open an inmate's file, to see what he's done, I see what he's capable of, I see the worst in him.' Winter believes that constant monitoring of the prisoners will give him power and thinks that he understands Irwin criminologically. His ideas therefore equate to those of Foucault, believing that if he observes he will understand and therefore dominate. Foucault describes punishment as taking several forms in prison, including that of 'surveillance, … but also knowledge of each inmate, of his

behaviour, his deeper states of mind, his gradual improvement; the prisons must be conceived as places for the formation of clinical knowledge about the convicts.'[19] Winter uses his knowledge to counter support for Irwin by humiliating him in front of the other prisoners. Ultimately, the empirical evidence that Irwin has led eight men to their deaths is negated; on Irwin's return to the tiers from solitary confinement, the men bang their dog tags repeatedly on the bars in support of him. The cinematography, with an upwards-spiralling pan to show the entire prison population hitting the bars in unity, emphasizes their solidarity.

Other than these few scenes of Irwin's cell, most of the film takes place in the yard. The film draws attention to its garrisons where the threat of physical violence, mediated through the guards' gaze, regulates the prisoners' activity. The spectator also becomes aware of a historic wall positioned centrally within this space. The wall, which the men continually demolish and then rebuild, is an oddity in that it is merely a wall, and does not enclose a space. In the early part of the film, the prisoners consider it an enterprise to keep them occupied. As one prisoner notes, 'Winter just makes us work it [the wall] to keep us occupied,' while another prisoner comments, 'like we're a bunch of little kids or something'. Irwin, engendering a sense of communality among the men, orders them to demolish the wall as a repudiation of Winter's power, exclaiming, 'it's not his wall, it's your wall!' In the latter part of the film, it therefore comes to represent a potent sign of solidarity, resistance and masculine identity for the inmates, as it did for Irwin earlier in the film. Rebuilding it at their initiative, with Aguilar in charge, gives the men a sense of autonomy and they continue to erect this monument to Irwin regardless of the pouring rain.

While the film is largely devoid of excremental metaphors, this scene, like the football scene in *Lock Up*, has suggestions of the abject. Certainly, the yard functions as an abject space in that building the wall promotes the formation of self-esteem and ego. In

part, this arises through the communality of the project, while the prisoners literally inscribe their identities into the mortar. On its completion, Irwin says to Aguilar, 'I'm proud of you and you should be proud,' further implying a father–son relationship. Moreover, Beaupre, who previously ridiculed Aguilar, invites him to be the first to carve his name in the wall, as if finally acknowledging Aguilar's worth.

The wall therefore establishes solidarity among them, though Peretz denigrates their efforts by saying to Winter, 'he [Irwin] can have their hearts and minds as long as we have them by the balls.' He thus literalizes the stranglehold on their masculinity that prison life inflicts. As Winter questions Irwin on his motives, Irwin stands looking down on the warder and the yard. Visually, the high angle shot from behind Irwin places the warder in a position of inferiority. In the ensuing confrontation between the two men, Winter states that he too shares the 'burden of command'. Narratively, this reference to Irwin's book infers that Winter thinks that he is Irwin's equal. A cut to a low angle shot of Winter magnifies the miniature cannon on his desk, while the Stars and Stripes flag is again visible in the background. This shot visually confirms that Winter sees himself as the commander of an army and an equivalent force to Irwin. The control of the wall and the space of the yard, in particular, therefore become sites of conflict between the two men. In a counter display of his masculinity, Winter, in turn, orders the demolition of the wall, which Aguilar, having supervised, interprets as a personal destruction of his recently developed adult masculinity. The wall's apparent strength and then demonstrable fragility shows the balance of power to be in a constant state of tension and always on the brink of collapse. Standing in front of the demolition vehicle, Aguilar refuses to lie down on the sound of the siren. Winter therefore orders him to be shot. The constitution of Aguilar's adult identity through the wall, and his complete resistance to Winter's orders parallel maternal

abjection. Moreover, a close-up shows his fatal head wound and, through a display of immorality and criminality rather than visceral repulsion, further renders the open space of the yard as abject. As Kristeva notes, 'any crime, because it draws attention to the fragility of the law, is abject, but premeditated crime, cunning murder, hypocritical revenge are even more so because they heighten the display of such fragility.'[20]

Aguilar's death clearly weighs heavily on Irwin's conscience, as a slow circling overhead zoom into his concerned face as he lies on his bunk indicates. Throughout the film, there is an emphasis on Irwin's morality and conscience, either through his frank admission of guilt, or by looks of remorse when his previous failure as a squadron leader is highlighted. Psychoanalytically, this suggests that Irwin's superego, which is synonymous with the symbolic, is well developed. Kristeva clearly outlines the relationship of the superego to the abject when she asserts that, 'what is abject, on the contrary, the jettisoned object, is radically excluded and draws me to the place where meaning collapses. A certain "ego" that merged with its master, a superego, has flatly driven it away.'[21]

As a direct consequence of Aguilar's death, Irwin decides to take command of the prisoners. A crosscut to Winter's office shows him polishing the barrel of a small handgun, its size signifying his rapidly diminishing power. Meanwhile, in the yard, the inmates rally into an army, assuming unity and order through their precise positioning. They not only display physical order but also sing in unison. As they establish Irwin as their leader, Winter begins to lose control and his constant observation of them becomes futile. In addition, he fails to regulate the prisoners' salutations to each other, and so 'permits' Irwin to perform them. Irwin, as a father figure and signifier of the symbolic, attempts to eject the emasculated Winter by demanding his resignation.

Winter's various strategies for counteracting Irwin's leadership include the threat of six months solitary confinement. He also

claims to his superior, General Wheeler (Delroy Lindo), that Irwin needs psychiatric treatment. Cinematography and framing in scenes that feature Wheeler and Winter together show Winter to be almost miniaturized visually, further suggesting his emasculation. In contrast, scenes of Wheeler and Irwin, previously friends and colleagues, show them to command similar screen space, implying their equal standing and mutual admiration. In a meeting between the two men, the guard advises Wheeler that, 'folks are limited to one embrace at the beginning and one at the end. Hands must be visible at all times,' to which Irwin replies, 'I guess that rules out the hand job,' the use of humour being an attempt to rule out any homoerotic undertones.

Winter's continued and escalated use of violence as a form of control serves to strengthen the prisoners' resolve to unite against his excessive regime. In leading the men, Irwin says to them, 'our captors have the power. They can try to humiliate us, and they can beat us. They can lock us away in a dark hole, but they can't take away from us who we are.' Emphasis is therefore placed on retaining identity despite attempts to break the prisoners down and humiliate them. Ultimately, such an emphasis manifests as a reclaiming of the open space of the yard through strategic planning and physical domination. The claiming of the yard is dependent on a network of hidden spaces of which the spectator is unaware. These hidden spaces are significant in that they enable the agency of characters and hence narrative progression. Simultaneously, reclaiming space results in acts of heroism and resistance to immorality.

Unlike the other films considered thus far, *The Last Castle* lacks the internal, underground and highly confining spaces associated with restrictions to identity. Instead, the yard consistently presents as one of the prison's most significant sites. From the outset there is a suggestion that this vast open area surrounded by high perimeter walls is a dirty, disordered space. Winter refers to it as a place for 'those animals' and it is characterized by displays of

aggression and hyper-masculinity. Its visual representation often features mud, rain and clouds of steam, and editing is usually rapid. The *mise-en-scène*, cinematography, lighting, sound and narrative distinguish it from Winter's office. Generally static, slow cinematography and warm lighting characterize Winter's office as a clean, controlled space. It is situated in an elevated position overlooking the yard. In other words, although this film lacks certain features that are contiguous with institution films, there are parallels between Winter's office and the upper levels of other institutions, while the yard functions in lieu of the underground tunnels that have been evident thus far.

Indeed, it is in the yard that identity and masculinity are tested and proven. This is shown through Irwin's punishment, Aguilar's refusal to lie down and the building of the wall. It also materializes in the taking over of the yard and transgression of its garrisons. Despite not operating like other institution films, *The Last Castle* nevertheless shows evidence of abjection, notably within the space of the yard as it is a place where prisoners refuse to relinquish their identity. While this results in Aguilar's death, the inscription of his name in the wall literally marks his adult identity. It is also the place where prisoner autonomy, determined through precise and orderly rank formation, replaces Winter's controlling and sadistic gaze. Attempts to repress masculinity and control through cruelty therefore lead to the taking of space, which the prisoners achieve primarily by taking control of the prison boundaries. The prisoners are mobilized to the yard while prison personnel search their cells.

Irwin uses his strategic expertise to lock the officers inside, thus reversing the spaces of the prison to allow the prisoners to destroy the prison towers and Winter's office. A ghosting of Winter's image over the space of the yard signifies his fading authority. Even though Winter extends his vision with binoculars, he cannot interpret what he sees and fails to comprehend that the structure the men have constructed is a medieval siege engine. As he retreats

from his observation window, it is smashed by a rock with Aguilar's name inscribed on it. The reclamation of the prisoners' identity in the yard therefore literally destroys his, which the fetishized memorabilia cabinet partly symbolizes. The theft of the flag with which he has been repeatedly visually associated also directly threatens his masculinity. He attempts to regain control through a number of increasingly drastic measures, first with a huge water cannon and then with a helicopter. The loss of water supply renders the phallic hose impotent and useless, again signifying Winter's flagging masculinity. Winter and Peretz have little alternative but merely to observe what is happening, with Peretz providing an ongoing commentary.

Having destroyed the boundaries of the yard, particularly the observation towers, the prisoners reassemble in orderly rows, with an emphasis on their spatial relationship to each other. They complete a series of manoeuvres, signalling highly efficient, self-regulated bodies. While the focus on their bodies might invite contemplation, their erect, tense and ordered positioning is potentially remasculinizing. When Winter finally emerges in the yard, he is wearing combat gear rather than his polished uniform, as if ready for action (which is essentially over) and shoots Irwin in the back. Irwin's apparent masochism, however, arguably depicts a final demonstration of masculinity rather than weakness, as he is symbolically crucified at the flag head. The yard thus becomes a site of abjection, visually represented as total chaos and devastation. Nevertheless, it allows liberation from Winter's cruel regime. The men therefore undergo horror and abjection to gain freedom from oppression, though continually resist Winter's efforts to emasculate them, often through adherence to ritual.

The most noticeable ritual in this film is the salute. As Irwin explained, the salute relates to identity as well as signalling solidarity between the prisoners. Connected to the salute is the process of 'falling in', in which the prisoners assume rank

position. Like the salute, this demonstrates their autonomy as opposed to being under Winter's rule. There is also a focus on physical cleanliness, especially by Winter, who fetishistically polishes his military artefacts. Like the rifle-polishing scene in *Full Metal Jacket*, this obsessive cleaning offsets the real implication of the weapons as killing devices. Irwin points this out in one of the early scenes when he comments that Winter's sword 'cost some poor bastard a wall of pain'. As well as disavowing the real meaning of artillery, the collection of polished military artefacts has another function. Dyer[22] argues that masculinity is bound up with sexuality, asserting that 'acts of power and domination, such as rape and murder are seen as acts of sexuality.' Dyer discusses the symbolic nature of sexuality in general, in which the symbol inevitably stands in for the erect penis. In *The Last Castle* a series of weapons indicate Winter's flagging masculinity, including initially the long hard sword and later, the small pistol as a scaled down version of his depleted power.

The prisoners, especially Irwin, focus on maintaining bodily cleanliness. There are several scenes of Irwin shaving and washing in his cell. Indeed, one of the first things he does on entering the prison is to wash his face. Many of the prisoners are clean-shaven and wear spotless clothing to maintain some sort of normality. Although the scenes of solitary confinement are not detailed, when the prisoners leave their incarceration they appear unshaven and dishevelled. While narratively signalling their isolation, it is interesting to note how constriction of space intrinsically correlates with dirt and bodily neglect.

The inscription of Aguilar's name into the mortar of the newly built wall is a further example of a ritualized process. For Aguilar, the invitation to be the first to do this symbolizes a rite of passage to manhood. Building the wall is analogous to the construction of adult masculinity and is therefore highly significant to the prisoners' self-esteem.

Perhaps the most familiar ritual within the film is the memorial service for Aguilar. Kristeva specifically aligns religious ritual, such as burial, with the abject. While not strictly a burial, the process of ritual in *The Last Castle* serves the similar purpose of recognizing Aguilar's death. In placing his dog tag among the fallen rocks, identity is again literally associated with the wall. Narratively, Aguilar's death is important because it triggers Irwin's final act of resistance to Winter through his attempt to overthrow the prison. As previously noted, it therefore has parallels with the deaths of Tommy and First Base in *The Shawshank Redemption* and *Lock Up* respectively.

In general, however, *The Last Castle* lacks some of the visual and narrative iconography common to institution films. Even though the prison is called 'the Castle', its *mise-en-scène* deviates from the Gothic enclosures that typify prison films. The labyrinthine passageways and almost inevitable escape tunnel are absent. It mostly lacks the specifics of abjection and never overtly refers to homosexuality. Furthermore, the key protagonist, Irwin, resists Winter's attempts to emasculate him. Despite the removal of the accoutrements of his identity, he retains a strong sense of self, which his conscience and guilt epitomise. The viewer is often made aware that he regrets the actions that led to his men's deaths. This suggests his well-developed superego and intact morality. In other words, he retains a sense of adult responsibility or identity. Nevertheless, the space of the prison, notably the yard, an open space as opposed to the basement spaces commonly associated with abjection, does become abject. It is still constraining, however, for Winter's persistent watchful eye limits the inmates' privacy within it.

Individual autonomy is restricted not only through surveillance but also through its association with more radical forms of control. Indeed, Winter cold-bloodedly murders prisoners in the yard. Significantly, a focus on the border, both the prison's perimeter and

the wall the prisoners reconstruct, characterizes the yard. While 'the Castle' perimeter fundamentally represents a division between 'cleanliness' and 'dirt', it is the erection of a boundary within the yard that consolidates subjectivities, even if in this case the boundary is a literal one. In addition, the overt transgression of the prison's perimeter, especially the observation towers, renders it an abject space. In the disorder that this entails, the yard transforms into a site of chaos. This, however, allows the men to reassert their threatened identities and masculinities and eventually to overthrow Winter's cruel regime. It fundamentally removes the surveillant gaze so that it can no longer control and feminize the prisoners.

In summary, in prison films where extreme control by spatial restriction is a feature, the close interaction of male bodies and a potentially contemplative gaze at these bodies is averted by physical activity or a focus on musculature. Alternatively, the gaze is diverted to settings that provide a noir aesthetic. These settings tend to contain convoluted interior passageways that either require investigation or provide escape (by penetration). They therefore afford a reclaiming of masculinity, allowing men to be physically active. Since these spaces also facilitate separation from the maternal castrating prison, and a regaining of a proper place in society, they have a tendency for abjection. When spatial constriction is not a key feature of the prison narrative, then an arena for conflict through riot or escape is present. It is likely that aspects of the action genre within multi-genre films necessitate open rather than constricted spaces.

In *The Last Castle*, Irwin's masculinity remains intact, and he is not symbolically castrated in the way Leone and Dufresne are. The film therefore centres on masculinity, not only through displays of musculature, but also through physical conflict, morality and heroism. Irwin, however, through his sacrificial gesture, fails to escape from the prison. His heroic actions, signified by the wall in which the inmates' names and identities are inscribed, make him

part of it. Ironically, it is Winter who is removed from the prison, his masculinity redundant, his status negated and, furthermore, rejected by the faithful Peretz. Therefore, while *The Last Castle* adheres closely to Foucault's account of discipline through observation and spatial control of bodies, it demonstrates the failure of such regimes. There are many unsurveyed acts within *The Last Castle*, such as the stealing of the flag. This suggests that the prisoners have access to private spaces that are not apparent within the film and is further indicated by the armoury they amass. Even though there are clear displays of abjection through immorality and also the consolidation of identity, especially that of Aguilar, this film least demonstrates the corporeal qualities associated with the abject. Nevertheless, it remains abject through the notion of the boundary and the associated reclaiming of subjectivity.

Finally, *The Last Castle* repeatedly criticizes aspects of the Vietnam War and the political handling of it, as well as commenting on the hardships experienced there. Therefore, it follows the pattern hitherto established, in offering a critique of the prison system as well as of the American government.

PART III

THERAPY AS SURVEILLANCE: SPACES OF CARE

I often ask myself if I'm crazy ... It's a common phrase, I know. But it means something particular to me: the tunnels, the security screens, the plastic forks, the shimmering, ever-shifting borderline that like all boundaries beckons and asks to be crossed. I do not want to cross it again.[1]

In this section I consider films set in institutions of care and therapy, including *Girl, Interrupted*, *Coma* and *Bubba Ho-tep*. While care institutions arguably demonstrate a more conservative form of regulation than other types of institution, existing to improve health rather than exercise discipline, they are still concerned with bodily control. Foucault, in fact, recognizes all institutions as disciplinary spaces and asserts that 'the medical supervision of diseases and contagions is inseparable from a whole series of other controls.'[2] As in other places concerned with control, the surveillant gaze is significant. Foucault describes how medical surveillance had its origins in measures to control the plague at the end of the seventeenth century; movement on the streets was restricted and people were confined to their homes to ensure coherence to a regime that aimed to bring order to the chaos of disease.

According to Foucault, systems of surveillance shifted from domestic and town space to places of sickness, forming an antecedent to medical modes of observation. These evolved into

the complex and heterogeneous spatial structure of the present day hospital, with each space differentiated according to its function.

Currently, Foucault's concept of panopticism is readily discernible in ward spaces, where the nurses' station is inevitably the central mode of observation. This high profile space and the traditional 'Florence Nightingale' image of the nurse constitute the therapeutic, healing aspect of medicine common in visual representations of hospitals. The abject aspects of hospital life have tended to be less apparent in visual culture, though in recent years there have been increasingly realistic representations of hospitals, especially in television drama. Jason Jacobs notes that 'these dramas connected with and nurtured a popular fascination with decay, death and destruction of the body. They presented a morbid gaze – the visualization of the horrible but routine body trauma.'[3] This contrast between order and abjection is further apparent in a number of 1990s' films set in hospitals – for example, *Lorenzo's Oil* (1992), *The Doctor* (1991), and *Awakenings* (1990). Often, such films raise questions about institutional policies and the nature of medicine generally, perhaps prompted by issues in real-life hospitals that have dominated the public domain in recent decades.[4] Therefore, while Foucault describes medical institutions as orderly places, fictional representations increasingly depict them as spaces where undesirable aspects of the unruly body may emerge. These films show that the diseased body is liable to behave unpredictably or irrationally, and medicine cannot always provide an answer. In line with other institutions, in the following chapters I support a link between the abject body and the institutionalized body and, in examining the diseased, ageing and mentally ill, again find that the orderliness usually intrinsic to real institutions is inevitably susceptible to breakdown in their filmic versions.

Chapter 7

On the Edge: *Girl, Interrupted*

The film *Girl, Interrupted* (1999, directed by James Mangold) tells the true story of Susanna Kaysen's (Winona Ryder) self-admission to a psychiatric hospital following a suicide attempt. Susanna is diagnosed with borderline personality disorder, characterized, in part, by an inability to distinguish external space from her own mental world. As a result, memories and thoughts from the past intrude on her present reality, evident in disorienting flashbacks that signify her unstable mental state. Her disorder makes her introverted and causes her to engage in self-mutilating behaviour (though her medical records include 'promiscuity' as another reason for her referral). Kristeva[1] refers specifically to borderline personality disorder in her account of abjection. This has obvious spatial implications in relation to the mind–reality continuum, while it is in the resolution of Susanna's disorder that abject space also emerges. Apart from Susanna's mental state, abject space arises in the constraining practices of the institution itself.

The spatial aspect of compartmentalizing the mentally ill is important to this chapter in several respects. As James Moran and Leslie Topp note, 'spatial separation has been one of the most frequent social responses to madness'[2] and, historically, the insane have been segregated from the rest of society, usually in asylums. The internal spatial arrangements of asylums also relate to the treatment of mental illness. Annie Bartlett[3] describes how the containment of the mentally ill was an attempt to impose order and regulation on them in the belief that this was a way to cure madness. Such spatial orchestration emerges in *Girl, Interrupted*

179

where Susanna, apart from her general confinement, finds constraints on her personal and intimate space. Institutional space is therefore not only significant to society in general as a means of containing the insane, but it is also an important issue for patients confined within it. Kerry Davies notes how, in real life asylums, space dominates accounts of institutionalization, with 'patient and user accounts and identities remain[ing] somehow defined by hospital spaces as experienced at specific moments'.[4]

In *Girl, Interrupted*, the asylum, like many other fictional institutions, is characterized by a highly ordered regime that reflects in a stark and geometrical architecture. The patients' nocturnal excursions into a network of tunnels underneath the asylum give them some relief from its routine, for these underground tunnels provide opportunities to reclaim private space. Indeed, the narrative revolves around the creation or reclamation of pockets of private space. Again, such attempts to secure private space often result in conflict between patient and institution and lead to renewed repression and increased physical restraint. Sometimes the patients are made to undergo extreme forms of therapy, such as ECT, or are isolated for extended periods in seclusion cells. Conversely, moving outside prescribed areas results in social cohesion within the group. Despite also creating moments of extreme anxiety, such spatial transgression therefore proves mostly liberating. In the closing sequence, it allows the patients to confront aspects of their repressed selves, which, for Susanna in particular, is painful but ultimately therapeutic.

In this film, abject space arises in several ways. While it exists in a basic form through the exclusion of individuals from society, it primarily emerges through mental illness itself and the breaching of restricted space. The illnesses that implicate abjection are those of borderline personality disorder and obsessive-compulsive disorder, which directly involve space and the formation of boundaries. In the borderline personality, the recovering individual abjects its

exterior world as other to itself in the reformation of his or her identity. In the case of obsessive-compulsive disorder, the individual exhibits excessive and repetitive orderliness in relation to domestic or personal space. Therefore, in both examples, abjection emerges when the individual's sense of self is compromised. It occurs particularly at times when the individual is trying to re-establish the fragile boundaries of his or her identity and often surfaces during a renegotiation of the trauma that originally provoked the disintegration of these boundaries.

A feature of patient 'care' in *Girl, Interrupted* is the excessive use of surveillance and constraint. Such constraints, which regularly crop up in fictional institutions, tend to represent the manipulation and management of patients rather than their treatment. These restrictions invariably impinge on freedoms of space with resistance to such constraints often the focus of institution film narratives. In *Girl, Interrupted*, there are also implicit restraints on sexuality through the segregation of male and female wards, and the members of staff also regulate or prohibit other sources of leisure. For example, musical instruments are under lock and key so that they cannot be used without supervision, and the art room is designated as out of bounds. Furthermore, the physical body is a direct site of orchestration, with an inflexible regimen of 'lights out', 'checks' and supervised washing, causing intrusions into the normally private space of bedroom and bathroom. Indeed, not only is the bathroom communal, but the nurses also supervise the patients while they are bathing, so there is a complete lack of privacy.

A system of 'checks', whereby a nurse peers into the patients' rooms at short intervals, occurs repeatedly throughout the film. In Kaysen's own account, she comments on how the system of 'checks' 'murdered time ... – slowly – chopping off pieces of it and lobbing them into the dustbin with a little click to let you know that time was gone'.[5] Like Kaysen's version, the film represents this as an almost rhythmic and ritualistic occurrence to highlight its

repetitive nature, with a characteristic 'click', verbal announcement of 'checks', and 'click' again as the door closes. Private space is therefore continuously monitored, with efforts to assign constraints of time, as well as space, to the disordered body.

Time is an essential constituent of Foucault's analysis in that he discusses the importance of the timetable to the production of efficiency. Commenting on the development of institutional structures, he notes how the ethos of the timetable, which was to 'establish rhythms, impose particular occupations, [and] regulate the cycles of repetition'[6] became incorporated into hospital organization. In this film, patient resistance to such surveillance occurs in the design of personal pursuits that evade the checking system and instead concurs with Erving Goffman's study of asylums in which he describes how patients create their own hierarchies of territory and 'free places' in which to escape constant, intrusive surveillance.[7]

Apart from the system of persistent room checks, the nurses watch the patients continuously, especially if they are suicidal. Even the television room is under constant observation from the nurses' station. The nurses' station not only provides a surveillance point, but also a strongly contained space that is used to divide staff from patients and perhaps, as Bartlett observes in real asylums, 'to reinforce the hierarchy of the "them" and "us" distinction'.[8] Frequent shots of the asylum's barred windows further emphasize the patients' isolation from the outside world and their lack of private space. As Susanna's mental state improves, she earns 'grounds privileges' with her boyfriend, so that space is therefore a further means of regulation. Any deviation from the expected norm of behaviour results in loss of such concessions, often through confinement to the seclusion cell. One such deviation occurs during an outing when Lisa (Angelina Jolie) provokes an argument with Mrs Gilcrest (Mary Kay Place). Mrs Gilcrest has discovered that Susanna has slept with her husband and says to her, 'I hope you're put away forever.' Since the audience knows that Professor

Gilcrest actively sought Susanna's attentions, their sympathies lie with Susanna. The scene is significant because it demonstrates the social cohesion of the group in their support of Susanna. The use of humour further invites the audience to identify with the patients and encourages them to laugh with rather than at them. Susanna's comment of, 'taking us for ice-creams in a blizzard makes you wonder who the real whack jobs are' further highlights the tenuous division between sanity and madness.

Because of this incident, Lisa is confined to the seclusion cell. The purpose of the seclusion cell is ambivalent, both in this film and in real asylums. While its purpose is to protect the patient from self-harm, its constrictions and high degree of control have parallels with the maximum-security cell or isolation cell in penal institutions. Bartlett describes the use of seclusion cells in real asylums, noting how 'the explicit purpose of these rooms is to allow violent patients to calm down. However, their use has been considered controversial and there is little doubt that they can be considered punishment cells.'[9] Similarly, in *Girl, Interrupted* the seclusion cell seems to relate to punishment rather than treatment. In one scene, Polly (Elisabeth Moss), a patient who has a severely scarred face, finally acknowledges her disfigurement, which causes her extreme distress. Rather than comfort or reassure her, the nurses cruelly confine her to the seclusion cell. To console her, Lisa and Susanna break into the music store and play a guitar outside the door to Polly's cell. This transgression of boundaries brings comfort to Polly and the corridor, a loosely defined space, becomes transiently therapeutic.

While some areas have distinct margins, such as the nurses' station and the seclusion cell, the patients' areas generally have weaker boundaries, except for Daisy's room. As a result, the functions of private and public spaces often become inverted, evident when Susanna sleeps and has sex in the main corridor with a male orderly. Patient spaces therefore have easy access, apparent

in several scenes where various staff members come and go freely. John changes a light bulb in Susanna's room as she sleeps and Valerie breaks in easily when Lisa locks Susanna in her room.

Because of this lack of privacy, the patients tend to retain microcosms of personal space in any form they can. These include writing a diary for Susanna, secretly trading and hiding drugs, especially for Daisy and Lisa, and also for Daisy, the space beneath her bed. Furthermore, Lisa's frequent escapes from the asylum, which are not always obvious to the spectator, suggest a secret system of private spaces to which the patients have access. Indeed, Lisa has her own set of keys, and Cynthia (Jillian Armenante) is able to pick locks. Private space is particularly important to Daisy, who resents any intrusion into her room and displays a sign on her door saying, 'No trespassing'. Places with strongly demarcated boundaries, such as Daisy's room, tend to have links with abjection.

Apart from constraints on personal space, other forms of regulation include attempts to regiment bodily function through drugs. In fact, drugs are not used to treat the patients at all but to regulate them, since they are prescribed a regular regime of tablets, whether they need them or not, serving to undermine their autonomy still further. The compulsory use of laxatives and sleeping tablets seems particularly superfluous and detrimental. Moreover, partly because of their restricted autonomy, but also because their disorders fixate them at various stages of psychosexual development, the patients are generally infantilized.

This manifests mainly through *mise-en-scène*, especially figure-behaviour and costume, one example arising in the scene when Toby (Jared Lato) visits Susanna. Although Lisa attempts to delay the nurse's 'checks' to allow them more time together in Susanna's bedroom, Polly tries to peer under the door and Cynthia loiters outside. Like Freud's account of the primal scene in which the child curiously first observes the parents' intercourse,[10] their behaviour is clearly childlike. In fact, when Lisa rebukes Polly, she immediately

bursts into tears and runs away. Furthermore, although most of the girls are adolescents, many carry teddy bears and dolls, and read children's books. Polly wears her hair in pigtails, and they are all liable to behave unpredictably and uncontrollably. Only Daisy, Susanna and Lisa dress like adults, while Janet (Angela Bettis) is often deprived of her clothing altogether (as an incentive to gain weight). Their particular fixations arise out of traumatic episodes that each has undergone, and which remain unacknowledged. While these traumas are distressing or horrifying, ultimately, confrontation with them provides release and effects recovery from mental illness.

Space is relevant to the borderline personality in that external space often becomes confused with psychical space. While some scholars interpret Kristeva's concept of abjection in relation to the physical boundary of the body, it is also relevant to boundaries associated with psychiatric disorder. For Kristeva, the reconstruction of the border between the conscious and unconscious mind has potential for abjection. Kristeva describes how, in the dissolution of this boundary, 'an ego, wounded to the point of annulment, barricaded and untouchable, cowers somewhere.'[11] Such negation of ego is clearly evidenced in the character of Susanna, her confusion suggested in her opening words of, 'have you ever confused a dream with life?' The film mediates her disorientation through a combination of match cuts, eye-line matches, and sound bridges and in the early sequences of the film there are a number of occasions where time appears to shift. Susanna herself tells the psychoanalyst that she is 'unable to control time'. This temporal incoherence emerges in several scenes where the boundaries of the conscious and unconscious mind appear to dissolve.

From the opening basement scene, a sound bridge of a siren becomes audible and two hands come into view and push Susanna down onto a hospital bed. The static opening shots simultaneously give way to a series of fast edits and erratic cinematography as a medical team treat Susanna for a drug overdose. They force a tube

down her throat, tear her clothes off and violently insert a hypo-
dermic needle into her arm. The treatment is depicted as a scene of
assault, perhaps initiating the questioning of institutions that the
film raises. As Susanna lies there, the camera tilts through ninety
degrees, thus making her appear upright. Another sound bridge of a
psychiatrist's voice brings Susanna back to the present.

While editing visually suggests Susanna's disorientation, narra-
tively, it is supported by her explanation to the psychiatrist of
'sometimes it's hard for me to stay in one place.' Her persistent
sleeping and withdrawal also suggest her mental illness. Sleep is
especially associated with flashbacks – in one scene she is lying
down and a shot from her point of view shows Toby lying next to
her. As the camera cuts back to Susanna, a change in lighting and
make-up signifies the shift from the real to her imaginary world. In
the real world of the hospital, Susanna is very pale, lit usually by
natural lighting and dressed in a nightgown. In the scene she
imagines with Toby, the lighting is warm, she wears make-up and is
naked. As she opens the door to leave Toby, there is a cut back to
reality as a nurse stands at the door for 'checks'. The return to the
reality of the hospital world is coded for by extreme whiteness,
perhaps signifying its role in the 'purification' of the unstable mind.

Another aspect of borderline personality is what Kristeva terms
'affect', which can take the form of a 'painful fixation; the border-
line patient speaks of a numbed body, of hands that hurt, of
paralysed legs.'[12] Susanna, who believes she has no bones in her
hand and is a 'wrist banger' clearly displays such affect. In her
novel, Kaysen[13] describes the process of repetitively banging her
wrists to induce bleeding, while in the film this is shown as a close-
up of her bruised wrist, which later appears bandaged.

During Susanna's continuing discussion with the psychiatrist, she
appears persistently distracted. There is a further sound bridge and
eye-line match that seamlessly lead into a memory from her child-
hood. Mental space therefore forms a visual continuum with real

space. These scenes are significant because they demonstrate Susanna's initial lack of ego. As the film progresses, these disorienting scenes occur much less frequently and disappear completely towards the end. There are corresponding changes in the way Susanna is framed. Initially, she appears in the frame alone. When with others, the use of shallow depth of field emphasizes her isolation from them. One such scene occurs when the girls attend for their drug allocations. The camera retains Susanna in sharp focus as she wanders down the corridor after taking her sleeping tablets. The other patients remain out of focus, suggesting her mental and social detachment from them. As she subsequently becomes aware of Lisa in the seclusion cell, her point of view of Lisa progressively distorts as the drugs begin to take effect. In a further example of her inability to discern reality, the camera pans across to a white wall that then gives way to blue sky, and takes her back to her graduation ceremony, another occasion when she also fell asleep. The past again slides seamlessly into the present, and the conscious mind into the unconscious.

Kristeva's description of the borderline patient also explains some of Susanna's other symptoms. She notes that 'since they make the conscious/unconscious distinction irrelevant, borderline subjects and their speech constitute propitious grounds for a sublimating discourse ("aesthetic" or "mystical", etc.), rather than a scientific or rationalist one.'[14] There are several occasions when such mystical attributes surface, with Susanna believing that she has the power to foresee the future. In an interview with Dr Wick (Vanessa Redgrave), Wick suggests to Susanna that, 'you believe there's a mystical undertow in life, "a quicksand of shadows".' In a later discussion Susanna asks, 'you think maybe I'm gifted? Maybe I have ESP or something'. As Susanna begins to recover, another aspect of her fragile, but developing ego is her imitation of others' actions, in particular those of Lisa. We see Susanna deliberately blowing cigarette smoke into another patient's face, directly

copying Lisa's actions, and she also repeats Janet's previous racist abuse to Valerie (Whoopi Goldberg), the nurse, saying to her in a mock southern accent, 'oh is that your own medical opinion, huh? Is that what you've learned in your advanced studies at night school for welfare Negro mothers? Well you'z ain't no doctor, Miss Valerie, you'z ain't nothing but a black nursemaid.' These offensive actions may stem from Susanna's improving mental status, as Kristeva explains that during recovery from borderline personality disorder, there are attempts by the newly forming ego at abjection.

> It seems to be the first authentic feeling of a subject in the process of constituting itself as such, as it emerges out of its jail and goes to meet what it will become, but only later, objects. Abjection of self: the first approach to self that would otherwise be walled in. Abjection of others, of the other ('I feel like vomiting the mother'), of the analyst, the only violent link to the world.[15]

While Janet means to be insulting, Susanna's imitation of her racist abuse is therefore a weak attempt to re-establish her own identity by abjecting the other. In this struggle for ego development, a corresponding change in Susanna's relationship to the other patients becomes apparent, especially to Lisa. The mimicry of Lisa suggests a desire to be her. Since Susanna's disorder centres on a lack of ego formation, it is also relevant to refer to narcissistic identification. Recalling Lacan's work on ego, this identification occurs during the mirror phase, and signals the child's developing sense of self. In this case, the attachment to Lisa is perhaps significant. Although they initially appear as opposites, there are aspects of cinematography and narrative that suggest an increasing identification between them. Lisa is blonde, tall, assertive to the point of aggression, and has a well-formed ego, while Susanna is petite, dark and lacks confidence. The contrast between

the two characters is particularly emphasized through framing and *mise-en-scène*.

In the early part of the film, especially when she first meets Lisa, Lisa, shown in close-up, dominates the frame. Often, canted angles and hazy, natural lighting are associated with Susanna, while Lisa displays swaggering, almost masculinized figure behaviour. She is fascinating but anarchic, having no sense of guilt or conscience. In fact, she steals money from Daisy during the latter's suicide scene, though she refused to receive it as a gift because of its symbolic association (Daisy's father's incest). Clearly a leader among the patients, she is different from them in that she signifies a rebellious adolescent rather than a difficult child. While she dresses like an adult, and most of the others dress like children, she is still able to communicate with them (using a glove puppet). In some ways, her anarchic personality is a counterpart to McMurphy in *One Flew Over the Cuckoo's Nest*.

As the film progresses, Susanna becomes increasingly obsessed with Lisa, and depressed and suicidal when Lisa is transferred to another ward. Susanna evidently idealizes Lisa and, without her, her fragile sense of identity collapses. Conversely, in later scenes, when Susanna's ego is more fully constituted, she tends to dominate the frame. We see this when Lisa is locked in the seclusion cell. Susanna looks through the viewing window at Lisa who is barely visible and tightly framed within it. Even as Lisa approaches Susanna, her face remains mostly obscured, and eventually only her eyes are visible through the cell window. This visual and narrative containment suggests a psyche that has been constrained and implies that Susanna's own identity is defined in relation to her image of Lisa.

The final scenes in the basement particularly favour such an interpretation. Here Susanna tries to escape from Lisa but, when forced to confront her, recognizes in Lisa her inverted double. Susanna's differentiation between self and other signifies ego formation and hence recovery, indicated when she tells Lisa, 'you're

dead already. Your heart is cold. I'd rather be in it [the world] than down here with you [insanity].' The tunnels therefore provide a setting in which abjection manifests through the bounding of Susanna's ego. At the same time, revealing negative aspects of Lisa's personality conversely 'contains' Lisa's ego. A psychoanalytical argument might suggest that Susanna functions here to activate Lisa's conscience (and superego).

The girls' forays into the tunnels represent one of the key ways in which they create and define their own space. As discussed earlier, Goffman explains that the formation of such territories is important to inmates of total institutions because it allows a temporary reprieve from constant surveillance. In one example, he describes how, 'one of the most elaborate illustrations of territory formation in a free place in Central Hospital occurred in the disused basement of one of the continued-treatment rooms.'[16] In *Girl, Interrupted*, the basement space similarly allows a release from the tension of the 'upper' ordered world of the hospital. Here, the patients are unconstrained by the rigours of institutional life, reflected in their social cohesion and apparently normal behaviour. This is evident for example, in Janet's figure behaviour. During a therapy session, she sees Daisy leaving the hospital and has a tantrum, literally throwing herself to the floor. In one of the basement scenes, however, she appears happy and excited and even Susanna begins to overcome her lack of confidence.

Narratively, the basement is the place where the film begins and ends. Visually, the labyrinthine dark tunnels of the basement contrast with the sanitized and regulated spaces of 'normality' found in the sterile corridors above. The difference between the two spaces is emphasized by low-key lighting and erratic cinematography for the basement, and high-key or natural lighting and slower-paced cinematography for the upper hospital spaces. Symbolically, the spaces correspond to aspects of the patients' psyche. Freud explains how 'the ego seeks to bring the influence of

the external world to bear upon the id and its tendencies, and endeavours to substitute the reality principle for the pleasure principle which reigns unrestrictedly in the id.'[17] The upper level of the hospital therefore corresponds with the ego in its orderliness, its adherence to reality principles, and its tendency to moderation by the external world.

In contrast, the *mise-en-scène* of the off-bounds basement reflects the irrationality and emotional deviance of its nocturnal inhabitants and, like Žižek's[18] description of the cellar in the Gothic house of *Psycho* (1960) is analogous to the unstable id. Žižek proposes that in *Psycho* the three levels of the Gothic house relate to the id, ego and superego; the cellar functions like the id and is a 'reservoir of illicit drives' where there is 'radical ambiguity and a striving for pleasure' as well as 'primordial evil'. This description aptly fits the basement tunnels in *Girl, Interrupted*. The girls' descent into the tunnels therefore represents an exploration of their repressed unconscious. Todd Lippy comments on this dimension of the building in an interview with director James Mangold, suggesting to Mangold that 'that scene also calls up the struggle between the id and the ego, taking place as it does in the dark depths of the hospital's tunnels.'[19]

This exploration of their repressed unconscious begins in Dr Wick's office when the women secretly examine their medical records. Polly finds this particularly traumatic because she discovers a photograph of herself as a child at a time when she was without scars. For each of them, discovering the roots of their traumatic pasts initiates a journey towards a reconstituted self. This journey culminates in the basement, where, in the final scenes, Lisa steals Susanna's book and reads it aloud to the girls. In her book Susanna has revealed her true thoughts about each of the patients, saying for example, 'sometimes I think Polly's sweetness and purity aren't genuine at all but a desperate attempt to make it easier for us to look at her.' While this revelation induces shock and conflict, it ultimately enables them to progress towards a coherent subjectivity.

The space of the basement is therefore ambivalent for the patients and especially threatening for Susanna. In trying to escape from Lisa, she shuts her hand in a door, almost severing her fingers. The realization that she has broken her fingers is important because it contrasts with the earlier wrist-banging scene when she believed she had no bones in her hand. Even though it seems horrific, the scene indicates that Susannah has returned mentally to a real rather than a fantasized existence. In a final confrontation with Lisa, the latter shouts, 'I played the villain just like you wanted, because it makes you look good.' This suggests that Susanna's moral identity depended on Lisa. The tunnels thus provide the space that allows Lisa and Susanna to resolve their respective personality disorders.

Susanna's recovery is also signalled through parallels drawn with the film *The Wizard of Oz* (1939), which is referred to at several points during *Girl, Interrupted* and perhaps connects with Susanna's opening lines of 'have you ever confused a dream with life?' Georgina reads *The Patchwork Girl of Oz*[20] and is later seen watching *The Wizard of Oz* on television. At the point of Susanna's imminent discharge, there is a televised scene that shows Glinda, the good witch (Billie Burke), saying to Dorothy (Judy Garland), 'you've always had the power to go back to Kansas Dorothy.' There are obvious similarities with Susanna's return to the outside world, and her control over her own destiny.

For Susanna, one of the significant points in her recovery is through her experience of Daisy's death. Although Susanna is preoccupied with death in the early scenes, its reality dispels its attraction. Kristeva[21] considers that death is wholly abject, producing violent physical reaction in those who encounter it, more so when 'by fallacious chance'. We see this when Susanna finds Daisy's body suspended in the bathroom. Susanna, who is horrified and sickened, comments, 'seeing death, really seeing it makes dreaming about it seem fucking ridiculous.' Daisy's death is therefore a turning point in Susanna's recovery, because it reveals to her

the real consequence of her previous suicide attempt. Susanna also begins to regret her abuse of Valerie. Since Freud ascribes the superego, a part of the ego that internalizes parental functions, to the formation of conscience and guilt,[22] Susanna's feelings of remorse further suggest her recovery.

Daisy's dead body provides one example of abjection, but her mental illness is also intrinsically abject. Bartlett connects spatiality to obsessive-compulsive disorder, explaining that there is an attempt to control potential disorder within the environment, usually domestic, by ritualistic acts.[23] This scenario clearly applies to Daisy who behaves ritualistically with regard to food, and obsessively with regard to her neatly ordered hospital room and later, home. As Bartlett notes:

> Ritualistic activity involves order, even in the action itself and necessitates further repetition, if such order is broken. Equally, this is often reflected in the perfectionist approach to household spaces; walking into the obsessional's home you are confronted with rows, lines and piles of things, nothing can be moved without fear of recrimination.[24]

Moreover, while Lisa and Susanna resent taking drugs, so avoid doing so wherever possible, Daisy obsessively craves them. Indeed, she is dependent on laxatives. While laxative abuse is commonly associated with anorexia in young girls, it seems to have a more subversive meaning for Daisy. Connected to her need for laxatives, Daisy also has bizarre eating habits. In a number of scenes, we see her meticulously tearing strips of meat from chicken carcasses. Apart from her obsessive and secretive eating, Daisy has a further strange compulsion – the storage of the chicken carcasses under her bed. Her overly feminized bedroom, adorned with various ornaments, is therefore simultaneously disgusting. When Lisa and Susanna finally manage to get into her bedroom, they comment on

her unsociable behaviour, and the smell emanating from the room. Finding the rotting carcasses under the bed, Lisa comments, 'I think you want a poop Daisy and I think it's been days.' Her comment points to Daisy's obsession with laxatives and the inability to control her body.

For Kristeva, 'what goes out of the body, out of its pores and openings, points to the infinitude of the body proper and gives rise to abjection.'[25] As Kristeva further notes, 'faecal matter signifies, as it were, what never ceases to separate from a body in a state of permanent loss in order to become autonomous, distinct from the mixtures, alterations and decay that runs through it.'[26] For Daisy, there are particular problems mastering this separation, and thus difficulty in maintaining a clean and proper body. While Kristeva interprets anal control as 'the mastered repetition of a more archaic separation (from the maternal body)',[27] Daisy's dependence on laxatives and obsessive eating patterns seem to be linked more to her father than her mother, and the inability to resolve, or even acknowledge, their incestuous relationship.

Food is therefore a sign of exchange for Daisy and relates to sexual and excremental metaphors. Daisy makes the equation between eating and defecation explicit when she asks Susanna, 'what do you like better, taking a dump alone or with Valerie watching? Everyone likes to be alone when it comes out – I like to be alone when it goes in. Going to the cafeteria is like being with twenty girls at once taking a dump.' It transpires that Daisy receives chicken in exchange for incestuous sex with her father. The first hint of this incestuous relationship is seen through Susanna's point of view when Daisy reaches up to give her father a kiss.

A later scene in Daisy's apartment shows further evidence of Daisy's obsessive personality – everything is colour coordinated, even down to the daisy magnets on the refrigerator. Having escaped from the asylum, Lisa and Susanna seek refuge with Daisy. There is a further altercation between Lisa and Daisy, however, and

Lisa goads Daisy by saying, 'a man is a dick is a man is a dick is a chicken is a dad.' This statement, though seeming rather odd, again implies a connection between eating and incest. This may be explained by reference to Freud's essay *Totem and Taboo* in which he describes the ritualistic eating of totem animals as a prohibition against incest.[28] In these scenarios, sacred totem animals are ritually slaughtered and eaten. Freud describes this ambivalence towards the totem animal as stemming from the incestuous desire for, and simultaneous prohibition against, the parent. He therefore sees this emotional ambivalence as explaining obsessive-compulsive disorder. In one case he describes,[29] a child becomes similarly preoccupied with chickens, Freud concluding that eating the chicken related to having sex with his mother. This explanation may be relevant to Daisy in that chicken is similarly a symbol of exchange for incestuous sex with her father. The sexual analogy is further suggested when Lisa adds, 'taking daddy's money, eating his fucking chicken. Fattening you up like a prize heifer'. Lisa's final comment of, 'and everyone knows, everyone knows that he fucks you. What they don't know is that you like it' causes Daisy to reel visibly and likely leads to her suicide.

Freud also makes a link between obsessive personality types and bowel function. He refers to the stage of development when a child achieves mastery of his or her bowels, a stage that has implications for sexuality. Freud's explanation of this relationship lies in the potential for sexual pleasure in controlling defecation.

> Children who are making use of the susceptibility to erotogenic stimulation of the anal zone betray themselves by holding back their stool till its accumulation brings about violent muscular contractions and, as it passes through the anus, is able to produce powerful stimulation of the mucous membrane. In so doing it must no doubt cause not only painful but also highly pleasurable sensations.[30]

We may therefore interpret Daisy's obsessive personality in relation to Freud's theory of anal sexuality. However, Daisy's representation as a mother/wife figure perhaps indicates another explanation for the food–excrement–incest relationship. Freud goes on to discuss how the retention of faeces and mastery of the bowels have other meanings, stating that 'they [faeces] are clearly treated as part of the infant's own body and represent his first "gift": by producing them he can express his active compliance with his environment and, by withholding them, his dis-obedience.'[31] Thus, excrement not only represents sexual pleasure but is also a form of control. More significantly, Freud explains that this gift comes to represent another gift, that of a baby, 'for babies, according to one of the sexual theories of children, are acquired by eating and are born through the bowels.'[32] Therefore, Daisy's compulsive laxative abuse may indicate, according to Freud's account of anal erotism, a desire to defecate and produce a 'gift' in the form of a baby for the father. Lisa taunts her about her relationship with her father; while Daisy claims that 'my father loves me', Lisa responds with, 'I bet, with every inch of his manhood'.

For Daisy then the ritualized eating of chicken and abuse of laxatives allow her to deal with her incestuous relationship. As I have illustrated, a number of other rituals pervade the film. Regulation and monitoring are prominent, with the patients' lives ritualized through the system of 'checks' that regularly punctuates the film. One function of ritual is to contain the abject body, in this case, serving to control suicide as a potential source of abjection. Similarly, there is a routine administration of drugs, regardless of whether required or not, with a particular focus on the regulation of sleep and bodily waste. Kristeva notes how 'maternal authority is experienced first and above all, after the first essentially oral frus-trations, as sphincteral training.'[33] Ritual here therefore contributes to the function of the institution as a maternal entity in its

maintenance of a clean and proper body, as well as keeping a check on the aberrant mind.

Other forms of ritual include habitual self-harm. Lisa, Daisy and Susanna each engage in either wrist banging or arm-cutting. In her novel, Kaysen describes how the ritualistic nature of her wrist banging was a way of inflicting pain on herself with the minimum visible evidence. Although she is unclear of the reasons for this, she explains that 'I was in pain and nobody knew it, even I had trouble knowing it. So I told myself, over and over, you are in pain. It was the only way I could get through to myself. I was demonstrating, externally and irrefutably, an inward condition.'[34]

Thus, it seems that Susanna's self-harm is a means of producing a physical manifestation of a psychiatric problem. Later in the film this process translates more therapeutically into other forms, such as writing, painting and eventually into language (during her recovery she talks to Dr Wick three times a week). Valerie also refers to Susanna's disorder as a physical entity, advising Susanna to 'put it down, put it away, put it in your notebook, but get it out of you.' There is a sense, therefore, of addressing mental illness by bounding it into material form in order to exclude it.

Because private space in *Girl, Interrupted* is minimal and under constant surveillance, the patients create or reclaim pockets of private space (the basement), or transgress out of bounds areas (Dr Wick's office). Transgression of spatial boundaries, especially those of high control, leads to abjection. Spaces of high control include the asylum itself, Daisy's room and Dr Wick's office. Consequently, Lisa and Susanna's escape from the asylum leads to the scene of Daisy's death; their entry into Daisy's room reveals Daisy's anti-social habits and, in breaking into Dr Wick's office, they uncover some of their repressed childhood traumas. In the final sequence, the underground tunnels become abject spaces, notably in the generation of fear and conflict, but primarily through ego formation.

Their experiences of abjection not only bring liberation and friendship but also alleviate mental illness. Daisy's death enables Susanna to overcome her suicidal tendencies and the girls' encounters in the basement with repressed aspects of their traumatic pasts are therapeutic. In working through abjection, there is thus a development, especially for Susanna and Lisa, towards a coherent adult subjectivity.

The institution's signification remains somewhat ambivalent. While it is essentially matriarchal and functions as maternal authority, especially through the figure of Valerie, the institution as uterine metaphor is not explicit. Although there are references in Kaysen's novel to the hospital as a 'womb',[35] it paradoxically has patriarchal values, suggested in several ways. For example, the number of Susanna's sexual partners is considered promiscuous. In addition, Lisa refers to Dr Wick as Dr Dyke and Melvin (Jeffrey Tambor), the psychiatrist, as 'the-rapist', while the initial hospital assault on Susanna is depicted as rape.

In general, as with many of the institution films discussed in this book, *Girl, Interrupted* comments adversely on the institution. This emerges in the sequence where the patients watch a news programme on television. The commentator states that 'institutions we always trusted no longer seem reliable.' While it is unclear to which institutions this refers, the setting of the film in the late 1960s and repeated references to Kennedy and Vietnam suggest the American government. While *Girl, Interrupted* tells the story of questionable practices at one particular site, it perhaps also calls attention to wider subversive tendencies in institutions generally.

Chapter 8
Maintaining Life: *Coma*

Towards the end of *Coma* (1978, directed by Michael Crichton), the central female character, Susan Wheeler (Genevieve Bujold) uncovers a plot at the hospital in which she works as a doctor. The motive of the plot is to induce brain death in young and otherwise healthy adults, and to maintain their corpses in a living state for organ trading. As she investigates the coma deaths, Wheeler traverses a series of spaces that are, in various ways, horrific. Often, these labyrinthine spaces approximate to those of the human body, either in their physical structure or in their proximity to its visceral aspects. These include scenes of bodily transgression and decay, as well as the comatose patients themselves. While the female reproductive body is also a source of revulsion, aspects of abjection further relate to patriarchal values as the plot reveals that George Harris (Richard Widmark), the chief of staff, is responsible for the coma deaths.

Wheeler's investigation eventually leads her to the Jefferson Institute where the comatose patients are literally suspended from the ceiling, neither living nor dead but in a borderline state. It is the ambiguity of these living corpses that invites a fascinated horror in the spectator and constitutes one of Kristeva's key points about abjection, that of 'death infecting life'.[1] Thus, *Coma* offers a number of points at which the abject emerges, not only through the abortion of an unwanted foetus, but also in its focus on the corpse and dissection of decaying cadavers. While *Coma* demonstrates aspects of the medical institution as transgressive through the character of Harris, abjection is consistent with key narrative spaces

in the hospital, especially the operating theatre (OR8) and the Jefferson Institute.

Contemporary tabloid reviews of *Coma* were inclined to focus on these scenes of abject horror,[2] though academic commentaries have since tended to highlight the gender issues that arise in the film. Indeed, the differentiation of gendered professional roles is a recurring theme in *Coma*. While gendered roles have traditionally existed in real hospitals, particularly with regard to doctors and nurses, they are especially distinct in this film. There is a clear relationship between space and gender, which has implications for the production of abject space. These abject spaces, in part, motivate and propel the heroine, Susan Wheeler, through the film. Thus, while *Coma* is concerned with expressing gendered space as a social reality, it is also important in constructing narrative causal logic.

Gender is an issue right from the opening scenes when Susan Wheeler conducts a ward round with a group of predominantly male doctors, a probable hospital sight at the time of the film's production. While this functions as part of the film's narrative strategy, it also perhaps reflects Michael Crichton's concerns with realist representation within medical fiction.[3] The gendering of professional roles is further evident in the fact that all the nurses in the film are female. The ward round is also striking in its clinical, impersonal delivery. While Wheeler expertly delivers the update on the patient, there is no attempt at social interaction. Indeed, an emotional distance exists between doctors and patient, perhaps serving as one way of containing the diseased, abject body. This notion of 'parcelling up' and containing the diseased body is pivotal to the narrative of *Coma*. Thus, while fictional patients are usually peripheral to the central drama of the lives of the medical staff, this film instead focuses on them in relation to their regulation and commodification. Despite the medical, ethical and moral issues raised, however, academic attention tends to centre on the attempted 'containment' and surveillance of its other main source

of disorder, Susan Wheeler. Wheeler's character has been a focus for feminist academic interest[4] because she is a female doctor and the film's main protagonist and mediator of the narrative, which is unusual in films of this time. However, these approaches lack any discussion of space, even though Wheeler's assertiveness materializes specifically through her exploration of the film's various spaces, which tend to be male-dominated.

The importance of gendered space to *Coma* persists throughout the opening scenes as the camera first pans across the female locker room and then across the male locker room. Narratively, it is further apparent in a discussion that Susan has with her partner and work colleague, Mark Bellows. The scene takes place in Mark's apartment and is one of many that position Susan in spaces 'other' than her own. Disagreements about the realms of their own careers as well as their respective areas of domestic responsibility feature prominently in these early scenes, with Mark remarking, 'you don't want a lover; you want a goddamn wife.' His further comment, 'doctors! Why couldn't I have fallen in love with a nurse?' indicates his expectations of these two 'female' roles. His use of the word 'nurse' in this context suggests that he would prefer Susan to be caring, feminine and domesticated, since these are qualities usually attributed to the traditional role of the female nurse. Their respective gendered spheres are further evident as Susan remarks, 'politics, that's all you're interested in! I thought you were supposed to be a fourth year surgical resident.' Mark replies with, 'someone has to be interested in hospital politics. You certainly are not.' Their exchange therefore equates men with power and politics, and women with care and therapy. This division is generally reflected in the spaces that men and women occupy in the film, with men assigned to distinct, highly ordered spaces with clear boundaries (Susan is often seen knocking at the door or crossing a threshold), and women restricted to the zone of patient care. This dialectic of power

versus care continues to underpin the narrative and ultimately finds a point of intersection at the Jefferson Institute.

A gendered division of space is further apparent in Susan's personal life. For example, in a scene that provides one of the few glimpses into her private life and is only on screen for a short time, her home, in contrast to Mark's apartment, is shown to be dark and uninviting, with the heavy rain outside adding to its gloomy atmosphere. Throughout the film various forms of surveillance, including a sexually objectifying camera, closed circuit television (CCTV) and digital surveillance, constantly monitor Susan's personal spaces. In addition, the psychiatrist studies her and, later, a stalker follows her. Indeed, few spaces offer her safety or comfort. At work, she sleeps on a trolley in a corridor and mostly occupies the hospital's peripheral spaces, such as its corridors, stairwells and entranceways. Only the opening scenes of her driving her car and the dance class allow her to relax her professional profile and public face.

The dance class is a fluid, feminized space, which has attracted feminist criticism for its voyeuristic tendencies. Narratively, it also generates conflict with Mark who asks her to go to dinner rather than the class. She refuses, saying, 'that class is the only time I get out of this damned hospital.' Her subsequent conversation with Nancy Greenly at the dance class centres on Nancy's imminent abortion, from which the narrative sequence then unfolds. Few other spaces in the film offer Susan any privacy. When she later visits Nancy on the intensive care unit (ICU) and learns that she is brain-dead following the abortion, she turns away for a moment, covering her face with her hand. She creates a transient private space to express a moment of shock or grief and then turns back to the other doctors, quickly resuming her composure. Her apparent lack of emotion concerns both her male colleagues and her partner, Mark Bellows, and, one might assume, is surprising to an audience engendered with the notion of female hysteria. One of the doctors comments, 'if that had been a friend of mine I don't know if I

could have been that cool.' They seem to expect her to be grief-stricken, defining another stereotypical aspect of femininity to which Susan fails to conform. Instead, Susan examines Nancy's medical charts for some rational reason for her comatose condition. Mark misinterprets her detachment, commenting, 'I know you're upset,' to which Susan replies, 'I'm not upset! Do you think because I am a woman I'm going to be upset? I'm fine Mark. I just want to understand the variables as they apply to this patient.' Again, she refuses to assume a stereotypically feminine position.

Susan's investigation into Nancy's death subsequently leads her to explore the hospital's various spaces, which seem mostly areas concerned with surveillance, power, production, technology and investigation. While male technicians dominate these places, nurses instead tend to be located at the nurses' station, or otherwise move in prescribed patterns around the wards and patients' beds. Such activity is consistent with their roles of clinical surveillance, regulating the body and procuring knowledge of the patient.[5] Moreover, the spaces the nurses occupy seem more constricted and are often confined by glass or some other barrier.

Despite Mark's discouragement, Susan first enters the tissue-typing laboratory where she discovers that the hospital computer has automatically generated an anomalous tissue-typing request for Nancy. This narrative strategy subsequently leads Susan to the computer department where a technician (Gary Barton) has problems locating the coma patient data Susan requests. This is because the computers are actually used to bill patients rather than monitor their health records. When she finally obtains a list of all the cases of irreversible coma in the hospital, she expresses concern about them to several male colleagues. Referring to statistical analysis of the data, they argue that the number of coma cases is unremarkable. It seems that empirical measurement, which Kristeva associates with the symbolic, provides a means to rationalize the number of coma cases. Susan subsequently searches for the files of

the comatose patients, which she discovers are in Dr George's possession. His reluctance to let her see the files immediately raises Wheeler's suspicions about his part in the coma plot. Wheeler's glance back towards Dr George reveals him framed centrally and surrounded by three sinister looking female assistants, seeming to confirm her doubts about him.

One of the most rigorously controlled spaces that Susan explores is the operating theatre, OR8. A preliminary search of it reveals nothing unusual, though we later learn that this is where healthy beings are destined to become corpses. Nancy Greenly undergoes her gynaecological operation in OR8, proving it to be an ambivalent place, since Foucauldian notions of order closely intersect with concepts of abjection. While the abortion constitutes an example of the abject maternal body, Foucault's model of the 'docile' body is conspicuous in the observation of Nancy's bodily function.[6] Closely monitoring the body's temperature, rate of respiration and degree of consciousness, the anaesthetist comments, 'she's now experiencing complete muscular paralysis. I've got three minutes to breathe for this girl or she's going to suffocate.' The scene also has gender implications, since while Nancy's abortion is, in one sense, a demonstration of her independence (her husband is unaware of it), the process of anaesthetizing her and the subsequent abortion are displayed in unnecessary detail. Indeed, the whole procedure emphasizes the patriarchal nature of medicine that existed at the time of the film's release.

During the operation, the medical gaze intersects with a potentially sexually objectifying gaze, as two trainee anaesthetists 'visualize' Nancy's vocal chords and then inspect her cervix. Her feet are then placed, one at a time, in stirrups, with each foot shown in medium close-up to emphasize the vulnerability of her position. The procedure almost appears sexualized and violating, suggested by the surgeon's comment of 'red as a cherry down here' (though narratively this refers to the skin colour induced by

carbon monoxide poisoning). He even plays music as he performs the procedure. The implications of this scene run counter to the content of Crichton's novel, *A Case of Need*.[7] First published in 1968, the novel was a thriller about abortion and was part of the call for its legalization. While clearly representing the abortion from a patriarchal viewpoint, *Coma* therefore likely reflects medicine as a patriarchal institution rather than expressing Crichton's personal opinion.

During the surgery, a problem arises and, though the heart monitor registers a series of arrhythmias and Greenly's blood pressure falls, the doctors merely stand and observe her. A prolonged long shot of them watching the cardiac monitor emphasizes their inability to control her dysfunctional heartbeat. The technological control the medical staff exerts thus contrasts with the abjection an unruly body generates, the latter emphasized through both *mise-en-scène* and cinematography. The extracted bodily tissue is shown in medium close-up, with the surgeon drawing closer attention to it as he says 'these tissues can go to pathology' and also with his comment of 'let's get this mother off the table.' The word 'mother', usually signifying a maternal, caring image, is used ironically to denigrate Greenly's actions. The surgeon's patronizing comments, particularly when he says 'I'm going to get her out of a helluva mess,' suggest that the unwanted pregnancy was her fault.

Abortion relates directly to childbirth and, clearly, the spectator is encouraged to feel revulsion towards her actions. Kristeva considers that childbirth is fundamentally abject, asserting that 'devotees of the abject, she as well as he, do not cease looking, within what flows from the other's "innermost being", for the desirable and terrifying, nourishing and murderous, fascinating and abject inside of the maternal body.'[8]

Male investigation here establishes a connection between woman, womb and monstrosity, a link Kristeva proposed and Creed supported.[9] Creed asserts that 'the womb is horrifying *per se*

and within patriarchal discourses it has been used to represent the woman's body as marked, impure and a part of the natural/animal world.'[10] It therefore seems that, initially, this film supports Creed's implication of the feminine body as abject. As later transpires, however, the principal source of abjection lies in the process of inducing coma for illicit organ trading, suggesting that OR8 is doubly abject, not only in terms of the 'monstrous womb' but also as the causative space that produces living cadavers.

OR8 is one of a series of abject spaces through which Susan leads the spectator. Susan's exploration of these spaces precipitates narrative logic and, as the film unfolds, those areas normally linked with repressing or curing the diseased body instead give way to horror. They include the pathology laboratory, the anatomy laboratory, the cold store and, ultimately, the Jefferson Institute. As Susan investigates these places, she comes across a number of dead bodies in various stages of decay or dismemberment. For Kristeva, 'the corpse, ... that which has irremediably come a cropper, is cesspool, and death; it upsets even more violently the one who confronts it as fragile and fallacious chance.'[11] Such confrontation arises in the pathology laboratory where Susan watches Nancy undergoing a postmortem. As the pathologist (Richard Doyle) dissects sections of Nancy's brain, he scrutinizes each slice for evidence of trauma. Not only are the sections of brain shown in close-up, and under high key lighting that reflects and emphasizes their visceral quality, but they are also placed under a magnifying glass, further emphasizing their abject status. As Kristeva asserts:

The body's inside, in that case, shows up in order to compensate for the collapse of the border between inside and outside. It is as if the skin, a fragile container, no longer guaranteed the integrity of one's 'own and clean self' but, scraped or transparent, invisible or taut, gave way before the dejection of its contents.[12]

Such bodily transgression clearly renders this space abject, while Susan's discussion with the pathologist reveals the possibility of carbon monoxide toxicity, and motivates her further actions.

In the subsequent basement scene Susan arranges to meet a maintenance engineer (Frank Downing) who intends to show her how the gas line has been switched from oxygen to carbon monoxide. Before he can do so, however, he is electrocuted; an extreme close-up of sparks emitting from his eye draw attention to the horrific nature of his death. Undeterred, Susan continues to search the basement for the gas line leading to OR8. This involves exploring a series of enclosed spaces and shafts that shadow the highly ordered spaces of the hospital. Although free from the watchful gaze of the hospital in these hidden spaces, she is still subject to the camera's voyeuristic gaze and a low-angle shot looking up at her as she discards her tights proves to be a controversial point for feminist critics. By following the carbon monoxide line, she confirms that OR8 is indeed supplied by carbon monoxide and is therefore the place where coma is induced.

This discovery leads her to examine the coma patient files illicitly. A series of extreme close-ups of the words 'Jefferson Institute' and 'OR8' on each file indicate to Susan that these are common to all the coma cases. Realizing she is being followed, she escapes through the stairwells and corridors into the anatomy laboratory where a number of decaying corpses are laid out ready for dissection. Susan's assailant lifts the sheets off the bodies in his search for her and we see them in close-up, emphasizing their decay. Although Kristeva states that 'the corpse, the most sickening of wastes, is a border that has encroached upon everything',[13] the corpses both fascinate and revolt the spectator. Susan escapes into a darkened body store where, surrounded by decaying corpses, the abject literally threatens to engulf her. The bodies, however, subsequently provide her with a further means of escape when she buries her attacker under them.

After sealing her assailant in the cold store, Susan turns to Mark for support, but he is still under the opposing influence of power, promotion and politics. This patriarchal sphere of masculinity directly contrasts with Wheeler's caring characteristics. He, like Dr Harris, patronizes her as a hysterical woman and, to protect his career prospects, tries to sedate her with tranquillizers. When Susan realizes his true intentions, she escapes and takes refuge in a hotel, which proves to be another voyeuristic moment as the camera pulls back to see her standing naked at the hotel window, the size of the building engulfing her within the frame.

On returning to the Jefferson Institute and under pretence of taking a guided tour, Susan discovers that it is a depot in which to store comatose patients and to traffick their organs. The head nurse, who conducts the doctors' 'tour' of the institute, describes it as 'a quality life-support system for the comatose patient', saying 'we don't debate whether the patient is alive or dead,' though this is clearly an issue that the film's narrative raises. While the nurses return the 'patients' to their beds for visitors, they otherwise remain suspended within the highly controlled technological space of the institute. It almost seems a freak sideshow attraction, for the doctors put on sunglasses to 'take the tour'. The nurse describes how 'there's no need for patient contact,' and how, 'with the assistance of technology, these patients are maintained beautifully. Without it they would have died long ago.' Further, their bodily functions are on public display, almost as a spectacle for the 'sightseers'. This is suggested as the nurse artificially induces hypertension in one cadaver. The hiatus provided by the delay in the computer's response invites the gaze of both the doctors and the spectator. This gaze not only contemplates the digitized control of bodily function but also allows the legitimized study of a naked female cadaver. The scene therefore, like the control exercized over Greenly, suggests not only a Foucauldian aspect of the institute but also the patriarchal nature of medicine.

Another Foucauldian feature is the highly ordered *mise-en-scène*, with the bodies arranged in neat rows. Each corpse is connected to a life support system that constantly monitors it and the nurse comments on the cost of maintaining them. 'We expect to maintain patients for about five dollars per day, less than it costs to hire a babysitter for a few hours,' which implicitly suggests she has a maternal relationship with the cadavers. Her viability in fact depends on her maintaining these bodies in their 'foetal' state. As Kristeva notes, 'the child can serve its mother as token of her own authentication.'[14] Visually, the bodies appear to exist in a pre-semiotic state; connected to the computer by umbilical tube like connections, they float in space like foetuses in a giant technological uterus, their minimal state of dress further indicating their infantile status. Like Creed's[15] analysis of *Alien*, in which she posits the spaceship as analogous to the feminine body, the institution functions as a monstrous gestating mother. Moreover, though the cadavers are central to plot progression, they have no personal space. In addition, they lack agency or potential for character development because their subjectivity is completely absent. Exemplifying the overall premise of this book, the scene thus demonstrates an absolute relationship between space and subjectivity.

These living cadavers represent life at the brink of death, with the border between them both debatable and indiscernible. Traditionally, death results from the irreversible failure of cardiopulmonary functions; brain death is fraught with ambiguity, for whole brain death is difficult to determine.[16] Margaret Lock says that 'brain-dead patients remain betwixt and between, both alive and dead; breathing with technological assistance but irreversibly unconscious.'[17] These living cadavers are thus inevitably ambiguous. While representing the apotheosis of abjection, they paradoxically appear extremely ordered and rigorously controlled. Furthermore, they show little sign of bodily decomposition. In a

sense, they lack the repulsive qualities that accompany the truly abject. Not only are they clean and completely regulated, but they are also young and beautiful, which enhances their fascination. As in Foucault's[18] discussion of docile bodies, they are made to conform and move in predictable ways, but, in this case, external means fully effect their control. Thus, while visually the cadavers support Foucault's claim for a relationship between order and observation, they inevitably represent a much more chaotic and unstructured existence. In this sense, the Jefferson Institute compromises Foucault's theoretical position with regard to the institution.

In her further exploration of the Jefferson Institute, Susan encounters another dead body, a former patient of hers, who is lying face down with his back dissected. Inside the gaping wound, filmed in close-up, are various medical instruments. The positioning of the surgical instruments not only emphasizes the gross physical transgression of his body but also the absence of any internal organs. Again, such displacement readily addresses the abject, Kristeva noting that, 'in that compelling, raw, insolent thing in the morgue's full sunlight, in that thing that no longer matches and therefore no longer signifies anything, I behold the breaking down of a world that has erased its borders'.[19]

Overhearing a conversation, Susan realizes that his organs have been removed for sale to potential transplant patients. In a sense, compartmentalizing and packaging organs represents a transformation of the abject into highly valuable objects, providing 'sources of precious and highly fetishized commodities of obscure origins'.[20] As Susan further investigates, she overhears another discussion about the illicit organ trafficking and is led, wrongly, to assume that Dr George controls the macabre scheme. Consequently, she returns to the hospital, narrative logic again precipitated by her exploration of space. Framed tightly as she negotiates the claustrophobic labyrinthine shafts and other hidden spaces of the Jefferson

Institute, she finally escapes on the roof of an ambulance. The spaces she traverses, despite being abject, are thus liberating. Returning to the hospital with the intention of confiding in Dr Harris, she suddenly grasps that he is responsible for the coma cases. This is indicated through several close-ups, seemingly from Susan's viewpoint, of his medical certificates that focus on the name 'George'. At the same time, she also realizes that he has spiked her drink with a drug. As the drug starts to take effect, we witness Wheeler's increasing disorientation through wide angle, point of view shots that give a distorted perspective of Harris, while his echoing voice further indicates the drug's sedating effects. He reveals his rationale for his actions, and talks about doctors making decisions about life and death, and playing God, '[making] decisions about the right to die, about abortion, terminal illness, prolonged coma, transplantation, decisions about life and death ... No one's deciding. Society is leaving it up to us, the experts,' the sibilant 's' emphasizing his sinister character.

Because of her discovery, Harris has Susan taken to OR8 with the intention of performing an appendectomy (and hence inducing coma). The nurses, uniformed in white, appear to be a further point of deception. While normally associated with care and devotion to duty, here wide-angle shots also make them appear ambiguous and sinister. Susan subsequently undergoes the surgery and almost dies before she can prove to Mark that Harris is a criminal. Kristeva notes how abjection is not only concerned with the physical border but with the criminal mind,[21] while her remarks in relation to perversity are also relevant to *Coma*. She comments, 'the abject is perverse because ... it kills in the name of life – a progressive despot; it lives at the behest of death – an operator in genetic experiments.'[22] Mark's suspicions are raised when Harris insists on using OR8, and Susan pressing his bleep gives him an excuse to leave.

In Dr Harris's final diatribe to Wheeler, he makes some egoistic

211

claims that are relevant to a discussion of ritual in medicine. He not only likens hospitals to cathedrals but also suggests that doctors have a god-like status, a theme that persists through the film. This analogy also emerges in a study by Clive Seale, who, like Kristeva, locates aspects of religious experience in the processes and rituals associated with disease and death. He implicates the role of medicine as an alternative means to religion for containing the abject body, commenting that 'medicine can therefore be understood as containing some of the most fundamental classificatory ideas of our culture, dividing the healthy from the diseased, the normal from the pathological, the hygienic from the polluting, the living from the dead, the sacred and the profane.'[23] In Seale's discussion of the use of such ritual, he asserts that, 'the medical procedures that accompany death ... have both a technical rational and a ritual aspect, in that they frame and box experience, create new objects from anomalous or dangerous entities, and place individual deaths in the context of a progressive, scientific-rational system.'[24]

A number of medical rites Seale identifies are relevant to *Coma*. He asserts that such rites function to 'enclose and explain death, reduce its polluting effects, and symbolically to place individual deaths in a context which helps survivors turn away from death and towards continuing life.'[25] These rites may be identified in the certification of death, one of which, in this case, is the examination of Greenly's EEG. According to Seale's analysis the subsequent dissection of Greenly's body also constitutes a medical rite, the function of which, Seale asserts, 'is an exercise in dividing the normal from the pathological'.[26] As noted earlier, the ward round provides a further way to compartmentalize the diseased body. The focus on the empiricism of charts and blood results not only allows the medical staff to reach a diagnosis but also to distance themselves from the physical manifestations of disease. Other rituals associated with the containment of the diseased and decaying body include the use of body bags. While they function to contain the spillage of body

fluids, the body bags also represent a symbolical means of packaging the abject body. They literally re-form the deteriorating physical border of the body, while in the anatomy laboratory, order is further imposed on the decaying bodies by the fact that they are laid out in neat rows.

The clearest evidence of ritualized procedure in *Coma* includes pre-surgery protocols in which cinematography and *mise-en-scène* emphasize the formalization of cleanliness, notably with close-ups of hand scrubbing and 'gloving up' routines. While these are obviously precautions against contamination, they also provide a sense of order to the transgressive act of surgery. Another means of maintaining cleanliness in the hospital setting is through wearing a uniform. While providing a literal and psychological barrier against abjection, a uniform, according to Julie Hallam, has other meanings. Referring to the nurse's uniform, she proposes that while it offers a physical protection against the job, it also contributes to the image of nurses as clean and virtuous, in that 'starched white aprons, high white collars and stiff white hats signify an almost untouchable purity, calling to mind the cleanliness is next to godliness cliché.'[27] Hallam further suggests that a uniform affords the wearer a private space, stating, 'for the individual wearing it, the uniform was a crucial interface between a vulnerable private self and the public world of the hospital.'[28] This aspect has some relevance to *Coma* in that a uniform reflects differences in access to private space. While these differences are absent in surgery, Susan otherwise always wears her doctor's uniform, possibly to signify authority but perhaps also to maintain a degree of private space. The only characters not in uniform are Dr Harris, Mark Bellows and Dr Chandler, who have access to their own private space, thus reflecting the patriarchal structures of that time.

Coma therefore combines caring with gendered narrative strategies of power, hierarchy and money, and explores their interaction. As Rosemary Pringle comments, 'the wealth and prestige of

...can medicine is largely associated with the fact that not only is it private but it has largely been the monopoly of men.'[29] Indeed, the film questions the ethics of certain practices and fundamentally comments on the inefficiencies of medicine *per se*. Such criticisms of medicine are relayed through the subtext of the film – Mr Murphy complains that his surgery is repeatedly delayed; nurses' voices in the background report various hospital errors; and Mark Bellows comments on Greenly's anomalous tissue typing request that it 'is not the first time that the laboratory has made a mistake'. The psychiatrist, who says that 'medicine isn't perfect, and we all accept that,' further highlights the flaws of medicine. Occasionally, partly through the failure of all forms of surveillance, the film points to the futility of monitoring regimes in medicine.

Coma also draws attention to more prominent medical issues like abortion, brain death, organ donation and the increasing difficulties of determining death. The film comments on policies for transplants and donations, which raise ethical considerations[30] and, while there are obvious futuristic aspects of *Coma*, it is nevertheless grounded in a reality of global organ trafficking.[31] *Coma*'s focus on organ trafficking therefore highlights the fictional medical institution as a financial business. This becomes evident in the scene in which it is stated that the computers are installed for patient billing purposes. The film also suggests that power and careerism are more important to doctors than patient care, leading to sacrifices in patient care and compromises to medical ethics in the pursuit of financial gain.

Gender issues are apparent within the patriarchal structure of the institution, as the hospital's various spaces signify. *Coma* juxtaposes men and women through the differential articulation of space where doctors are mostly male and supervise the central spaces, and nurses are confined to prescribed areas such as wards and nurses' stations. Susan, the film's almost sole representative of a female doctor, consistently occupies peripheral and in-between spaces. Her

lack of private space and the inappropriate uses of space derive in part from the realities of hospital life, in that doctors sleep where and when they can. Constriction of space, however, appears to relate to character development. While women generally show little agency within the narrative, male characters who have their own spaces are more prominent. Susan, as an assertive female, resists oppressive patriarchal forces and creates her own network of hidden spaces that are off limits. While Susan encounters horror in places such as the Jefferson Institute, the hidden and often abject spaces she negotiates allow her to uncover the truth about the coma victims. It is also through these abject spaces that she secures an escape route. Susan not only enters places in which decaying and dismembered corpses surround her, but also almost dies to uncover the conspiracy. Thus, the highly controlled OR8, where Harris tries to kill her, is finally liberating.

To summarize, men, as doctors, occupy distinct spaces with clear boundaries while women (usually nurses) occupy ephemeral spaces that are much less distinct. These spaces are reflected in a *mise-en-scène* that constructs patriarchy as highly controlling, surveillant and concerned with power as opposed to a feminine world that is caring and linked to reproduction and uterine imagery. The Jefferson Institute, however, is anomalous. It exhibits characteristics of both, showing institutional space as extremely ordered and thus conforming to Foucault's ideas, but at the same time inherently chaotic and thus abject.

Chapter 9

Confronting Death: *Bubba Ho-tep*

The film *Bubba Ho-tep* (2002, directed by Don Coscarelli) explores a fear of ageing and physical deterioration through the figures of its two main protagonists, as well as their quest to overcome a mummy that haunts the rest home in which they reside. The film is set in a Texas retirement home in which the two men, one of whom believes he is Elvis Presley (Bruce Campbell), and the other that he is President Jack Kennedy (Ossie Davis), are spending their remaining lives. The home provides the setting for a series of deaths that 'Elvis' investigates. He reveals the killer to be a mummy who stalks the corridors of the rest home – the mummy is an obvious metaphor for the residents' decline and imminent death. Initially incapacitated by the physical signs of old age, especially his problematic cancerous penis, 'Elvis' befriends another character who thinks he is John Kennedy. Together, they overcome their physical inadequacies to destroy the mummy.

As an institution, the rest home varies from the highly disciplined places that Foucault[1] describes and from the clearly defined spaces that appear in *Coma* and *Girl, Interrupted*. Rather, its spaces are fluid, with loosely defined borders, especially in relation to private and public areas. An initial lack of temporal coherence within the narrative accompanies these weakly differentiated spaces.

Similarly, the character of the main protagonist, Elvis, appears to be vague and ill-defined, with little motivation or agency. In fact, at first his identity is confusing within the narrative, for it apparently fluctuates between 'Sebastian Haff' and 'Elvis Presley'. His day-dreams and fantasies suggest that his previous identity was Elvis,

but the nurses refer to him as Sebastian Haff. Although it is clear that he is not Elvis Presley, as the story progresses, identification with the character strengthens and he gains credibility. Elvis's increasing awareness of spatial and mental borders and his reassessment of private and public boundaries also characterize the narrative progression. At the same time, the narrative becomes more temporally coherent.

Moreover, as his newfound heroism and aggression render him increasingly independent and eventually masculinized, Elvis's character changes in nature. Through his confrontation with aspects of the abject, his remasculinized body becomes heroic, arising in part from the contaminating male body and in part from the processes of ageing and death. It further materializes in the figure of Bubba Ho-tep (Bob Ivy), the mummy that haunts the home. A progression from the semiotic to the symbolic marks the narrative closure, which the protagonist's death signals. This transition is indicated by Elvis's recognition and reformation of physical and mental borders. It is further characterized by a reinstatement of certain socio-cultural and moral boundaries as well as the use of language commensurate with Elvis's personality. Moreover, it is accomplished through a rejection of the maternal body, which, in this case, the nurse (Ella Joyce) and the institution signify. In this chapter I therefore examine abjection in relation to the male body and masculinity. I also consider the process of confronting old age and death within the institutional setting of a care home.

The film opens with a tracking shot through an empty, dark corridor in the care home, with a series of discontinuous edits emphasizing its apparent endlessness. This introduction shows that the corridor is significant within the narrative because it is there that the mummy usually materializes. Low-key lighting partly accounts for the corridor's threatening appearance; its dark red, shiny linoleum floor gives it a corporeal quality, which the deep, pulsating sounds that pervade it reinforce further. The potential for the corridor as an

abject space lies in its metaphorical sign as the journey to death, a state that most of the institution's residents are approaching.

The residents' bedrooms and bathrooms are the other significant spaces in the care home. The bedrooms, with their loose divisions between them and the main corridor, also seem to be vulnerable spaces. Sibley's work on social geographies is relevant here, since he comments that 'strongly classified spaces have clear boundaries, their internal homogeneity and order are valued and there is, in consequence, a concern with boundary maintenance in order to keep out objects or people who do not fit this classification.'[2]

Conversely, he considers that weakly defined spaces are prone to infiltration and abjection. While Sibley's work on boundaries relates to the city's periphery as potentially vulnerable, his theory is relevant in this context because the mummy readily infiltrates the weak boundaries that separate the internal spaces of the care home. Sibley's study is further salient in the way he considers that strongly bounded spaces are less susceptible to contamination because the abject is excluded. It follows, therefore, that the strengthening of boundaries relates to the process of abjection. Indeed, in *Bubba Ho-tep*, the formation of socio-spatial boundaries and the development of ego lead to a confrontation with and radical exclusion of the abject (in the form of the mummy).

The initial tracking shot takes the spectator fluidly from the corridor through to Elvis's bedside, illustrating the easy penetrability of his bedroom. The bedroom is loosely structured and lacks the regimentation normally associated with an institutional setting, which the permanently opened door suggests. Fluidity of space emphasizes Elvis's complete lack of privacy – a number of orderlies, nurses and other staff members wander continuously in and out throughout the sequence. Because his ego is undeveloped, Elvis appears unconcerned by this invasion of his privacy, and remains focused on his own mental world. Furthermore, the care home lacks the clinical whiteness and geometrical architecture that

219

generally characterize an institutional setting and that reflect its purifying and regulating function. Instead, the colours here tend to be muted and the décor, like the residents, appears tired and shabby, an aspect that may symbolize their failing struggle for life.

The film reiterates the lack of temporal coherence of the opening scenes by further discontinuous edits that imply that Elvis is drifting in and out of sleep. As members of staff wander in and out, a combination of jump cuts and time-lapse cinematography renders them mechanized and functional rather than caring, which serves to highlight Elvis's isolation and detachment from an adult world of language and social interaction. It appears that Elvis, his roommate and the other residents of the care home have regressed into an infantilized state.

This infantilism relates to Kristeva's enunciation of the semiotic *chora* in several respects. Not only do the characters fail to interact socially to begin with, and tend to sleep incessantly, but their use of language is also either limited or absent. Furthermore, Kristeva asserts that the semiotic *chora* occurs before awareness of time and space, stating that 'the *chora*, [original emphasis] as rupture and articulations (rhythm), precedes evidence, verisimilitude, spatiality and temporality.'[3] Certainly, in its early stages the film appears both spatially and temporally incoherent. Moreover, the world that Elvis's character inhabits seems largely unreal with the narrative initially centred on his internal, mental state. His thoughts, presented to the spectator through his voiceover, further destabilize his masculinity in that they suggest the male body as diseased and contaminating. He asks himself, 'what is that growth? Cancer? Nobody's talking; no one seems to know the truth or wants to.' As he lies there, his voiceover continues:

I was dreaming … dreaming my dick was out and I was checking to see if that infected bump on the head of it had filled with pus. If it had I was gonna name that bump after

my ex-wife Cilla and bust it by jacking off. Or I'd like to
think that's what I'd do. Dreams let you think like that.
Truth was, I hadn't had a hard-on in years.

Therefore, the early scenes establish the male body not only as
impotent and desexualized, but also as a source of disgust. The
cancerous growth is repulsive, particularly to its owner, who
therefore comes across as old, desexualized and disgusting.

While Kristeva describes revulsion associated with certain
aspects of the corporeal body, she generally attributes this to the
female rather than the male. While aspects of the feminine body as
a source of abject horror and disgust materialize in some films,
clearly, *Bubba Ho-tep* challenges Kristeva's views with respect to the
male body. As discussed earlier in this book, some critics have
already questioned Kristeva's distinctions. Grosz argues that there
is an incongruity in the concept that menstruation is polluting and
seminal fluid is not. She asserts that such ideas of female sexuality
have 'enabled men to associate women with infection, with disease,
with the idea of festering putrefaction'.[4]

Linda Williams also discusses abject representations of the body
in the films of David Cronenberg. Like Creed, she situates the
abject within the context of the horror genre, but associates it with
the male rather than female body. She qualifies this observation,
however, when she states that 'femininity is central to Cronenberg's
masculinity, precisely because of its interiority',[5] thus implying the
inevitability of the abject as feminine.

While Elvis in *Bubba Ho-tep* is not overtly feminized through his
proximity to the abject, but merely appears disgusting, he is emascu-
lated. However, despite his abject body, he reclaims his masculinity
as the film progresses. In this instance, Grosz's argument is more
relevant to the depiction of the male sexual body, where the cancer-
ous growth on Elvis's penis is disgusting and infected. It is associated
with fluidity, but through infective rather than reproductive seepage,

though this remains ambivalent (particularly with reference to pus and its possible equation to seminal fluid). The abjection of the male genitals is emphasized in a scene where the nurse massages in corticosteroid cream, the sequence focusing on the look of disgust on her face and the viscous sounds of the cream. Clearly, this film determines masculinity and sexuality as being primarily undermined by the processes of ageing and imminent death.

Indeed, ageing in *Bubba Ho-tep* is strongly associated with impotence and repulsiveness, with the film highlighting the decline from active male sexuality to the inactivity of old age. It also accentuates other undesirable aspects of the ageing male body, especially lack of physicality and muscular definition. During Elvis's extended episodes of sleep, there are frequent flashbacks to scenes of him as a young and sexually desirable Elvis, which contrast with his current old and decrepit state. Now, his paunchy abdomen is prominent visually, highlighted by several medium close-ups that profile his physique. He is physically inactive and he has difficulty walking unaided. However, as mentioned above, his self-image manifests solely through the cancerous growth on his diseased penis, and it is the first thing that the spectator discovers about him.

Bubba Ho-tep further emphasizes decay and old age through Elvis's roommate (Harrison Young) who lies in the adjacent bed choking and coughing. His roommate seems unable to talk and the two men never appear to converse. Although he reaches out his hand to Elvis in a final fit of coughing before he dies, he tries, but is unable to formulate any words, consistent with a return to the prelingual semiotic state of infancy.

After his roommate's death, Elvis incongruously thinks about lunch, and subsequently about sex with Priscilla (his wife), his voiceover saying, 'if Priscilla discovered I was still alive, would she come to see me? Would we still want to fuck … or merely talk about it? Is there finally and really anything to life other than food, shit and sex?' His thoughts seem to centre on basic and fundamental desires

and are suggestive of Freud's account of infantile instincts. Freud defines these instincts (or drives) as based on a pleasure principle, which is sexually motivated but may be displaced from the sexual organs.[6] He outlines three key infantile sexual satisfactions, explaining that 'the sexual aim of the infantile instinct consists in obtaining satisfaction by means of an appropriate stimulation of the erotogenic zone.'[7] As noted earlier, he defines these zones as oral, anal and genital, with the oral stage linked to the satisfaction derived from the mother's breast. The infant also obtains sexual stimulation during the later anal stage. The final stage of an infant's psychosexual development is the genital stage, initiated through masturbation.

These phases of development in Freud's definition of infantile sexuality correspond to Elvis's immediate thoughts. A focus on pleasure gratification suggests that the id dominates Elvis's psyche and that he has an undeveloped ego. The subsequent development of his ego corresponds with the cinematic visualization of these psychosexual stages. It is also pertinent that he refers to excrement together with activities normally associated with pleasure, suggesting that he finds a similar satisfaction in defecation. Freud's anal phase therefore finds equation in Kristeva's[8] discussion of the semiotic infant who is unable, in its earlier stages, to differentiate the clean and proper self. Elvis's thoughts thus indicate his regressed psychosexual state. His deterioration in aspects of self-management may be associated with dementia and end-of-life trajectories.[9] As a result, the character becomes increasingly dependent on the care home in the same way as an infant relies wholly on the maternal body. Elvis ceases to function as an autonomous being, identifying solely with the maternal body (in this case the institution) and his sense of ego diminishes (though ageing also contributes to this process).

Although the film signifies male sexuality as abhorrent, the ageing female body is equally repellent. In *Bubba Ho-tep*, women are overweight and physically unattractive. One such female resident (Edith

Jefferson) wanders through the institution's corridors, an incoherent figure who communicates through grunts and various infantile sounds. Similar to the opening scene of *Girl, Interrupted*, these sounds seem to reverberate, suggesting enclosure in a deep space or vessel. Given the frequent uterine metaphors of institution films and the infantilized status of these characters, it is feasible to consider the care home as a maternal vessel. Several distorting, wide-angle crane shots of the patient wandering through the corridor not only suggest that she is being watched, but also indicate her possible dementia. Furthermore, she is motivated by infantile desires similar to those of Elvis, appearing to lack conscience or adult reason. She behaves in a childish and cruel manner by stealing one resident's chocolates and by removing the spectacles from another. The *mise-en-scène* of dolls and broken toys in her bedroom further suggests such infantilism.

In a similar way to Elvis, the female patient appears unattractive; the film highlights this with an unflattering low angle shot of her wearing a hairnet as she looks down to the floor. An extreme close-up of her face intercuts with shots of broken toys, suggesting her incomplete, fragmented psyche. The disgust of the decaying female body is later alluded to after her death as one of the funeral attendants sprays the body bag with deodorant and comments that 'she smells pretty ripe.' The ageing dying body therefore seems inextricably bound to redundant sexuality and decay, with institutionalization appearing both to desexualize and infantilize the residents.

Elvis's infantilized psyche is mapped topographically onto the spaces of the institution, so that the weakly formed boundaries of the self are transposed onto the boundaries of physical space. Initially, his existence revolves around the bedroom, and the processes of sleeping, eating and defecation. He sleeps and daydreams much of the time as an infant does (sleep also signalling impending death). While institutional regimes tend to control sleep through sleeping tablets, 'lights out' and morning calls, in *Bubba Ho-tep* it

remains unregulated. Indeed, in the early part of the film, Elvis sleeps almost continuously, his sleep fractured only by single frame flashbacks as fantasies and daydreams. In these images, we see him as sexualized and independent. The inability to discern reality and fantasy is shown literally, using a split screen in which the top half of the frame reflects reality while the bottom half of the frame shows his fantasy world. These fantasy images signal his increasing confusion and impending dementia, while his excessive sleeping habits further suggest his infantilized psyche.

Simon Williams and Gillian Bendelow describe how sleep 'is socially patterned in various ways according to a broader range of socio-structural and demographic factors'.[10] In this case, the social patterning associated with adult behaviour is absent and that associated with infants is evident. As Williams and Bendelow comment, 'babies ... spend more time sleeping than adults.'[11] Moreover, while sleep forms part of a process that should be essentially private, in this context, it lacks privacy. In the opening scenes, Elvis is therefore physically inactive, again suggesting a lack of masculinity (masculinity is often represented in film through physical activity and pronounced musculature). He is initially inseparable from the care home, with physical space forming a continuum with mental space.

In one scene, as he looks in the mirror, a memory of himself, or more likely a fantasy image, replaces his mirror image. He thus constructs a more structured and coherent identity. His fantasies function in a similar way to a child's first recognition of itself in the mirror, but like the child his recognition of himself is a misperception. As noted previously, the Lacanian mirror phase represents the child's formation of ego, being the point where it defines self from its surroundings, and from its mother. Elvis's imaginary image therefore functions like the mirror stage in the re-formation of his disintegrated ego. By subsequently resuming his fantasized Elvis persona, he reclaims his ego and distances himself from his abject body. His masculinity as the imaginary Elvis is mediated through

the sexual body in flashback, with slow motion for emphasis (and to signal memory), as a fan throws her underwear on stage. This is, however, antithetical to his current status. Such scenes highlight the journey from active male sexuality into old-aged impotence. Now, his sleep is only punctuated by using the bedpan, eating and having his 'little problem' (his diseased penis) treated.

The boundaries of privacy, which are associated with what Elias terms the 'civilising process' and which normally appear in the transition to adulthood, are therefore absent. Elias[12] describes how a sense of shame and embarrassment associated with bodily function accompany the shift from childhood to adulthood and, consequently, there is an increased privatization of such functions. This necessarily involves a demarcation of private space. He notes how the repression of such functions and primitive drives translates into psychic structures, so that such repressions become habitual and eventually equate with the Freudian concept of the superego.[13] In *Bubba Ho-tep*, however, because space is loosely defined and heterogeneous, opportunities for privacy are absent and such psychic structures are unable to develop.

Thus, Elvis's slide towards death involves a reversion to the unclean and repulsive, linked to the repressed maternal world of the care home. The id is significant because Elvis is dominated by primary drives such as eating, sleeping and defecating, while his ego and superego remain diminished. In this 'prelingual' stage, he cannot recognize or separate himself from the maternal body of the institution.

Prompted by the deaths of the other inmates and through the actions of his roommate's daughter (Heidi Marnhout), Elvis eventually confronts his abject ageing body. His roommate's daughter comes in to collect her father's possessions, one of which is a Purple Heart medal awarded to wounded soldiers by the United States military. The medal suggests that these men, now decrepit and undesirable, were once attractive and honourable. This is

indicated visually by Elvis's point of view shot of a photograph of his roommate as a young man standing in uniform with two beautiful young women. His roommate's daughter, who is also young, beautiful and desirable, further emphasizes the gulf between youth and old age. As she bends over, Elvis looks up her skirt at her bare legs and realizes his own undesirability. Moreover, he realizes that she is indifferent to the fact that he is looking, his voiceover saying, 'to her it was the same as a house cat having a peek.'

The nurse and his roommate's daughter further draw attention to his impotent sexuality by ridiculing him for his 'little problem' (referring to his cancerous penis). The sexualized appearance of both the nurse, who is wearing a tight, low cut uniform, and the daughter, serve to emphasize his asexuality. The nurse is also a maternal figure, representing the semiotic world of the institution, both through her denigration of his masculinity and because she consistently infantilizes him. The nurse is dismissive of his claims of mistaken identity and refers to him throughout as 'Mr Haff'. Elvis protests and, either in his state of progressive dementia, or in a reclaiming of true identity (this is not made clear), he demands to be called Elvis.

Elvis's progression towards a coherent adult identity is evident in his increased awareness of his socially unacceptable habits. He awakes one night to use the bedpan but decides 'that's it, no more piss or crap in the bed.' He therefore begins to display aspects of the civilizing process Elias describes by designating social boundaries. As Elvis's masculine identity develops, he demarcates these boundaries more strongly, but still leaves the bathroom door ajar when he urinates and the door to his bedroom permanently open. The reclaiming of space and spatial boundaries correlates with, indeed dictates, narrative structure, particularly the opposition of private and public, and inside and outside. However, his progress is slow, partly because boundaries between the rooms are weak, with little containment. Furthermore, he cannot get to the toilet without using a walking frame, indicating his continued physical frailty.

In one scene, a scarab beetle, which Elvis calls a cockroach, appears in his room. He adopts a pseudo karate stance as if to appear menacing but is unable to stand unaided. He grabs at a fork for attack, but inadvertently picks up a spoon, which proves ineffective as a weapon for attack and penetration. This is a metaphor for his masculinity and his decaying penis. He falls over, but then grabs the fork, stabs the beetle and holds it on the electric fire, saying, 'even a big bitch cockroach like you should never fuck with the king.' His actions and words thus begin to re-establish his masculinity in relation to the abject and feminized other.

He ventures outside his bedroom to discuss the 'cockroach' incident with his friend the resident who is convinced he is Jack Kennedy. As he enters Jack's room, Elvis's point of view of its *mise-en-scène* is edited synchronously with the sound of gunshots as if to authenticate Jack's history. (Jack's identity is, like Elvis's, clearly implausible and highly suggestive that their identities are a product of their dementia). Elvis, however, finds him lying on the floor after the mummy has also attacked him.

Elvis later recounts the story of the cockroach to the warder of the care home, commenting that the place is infested and adding 'what do I care, I got a growth on my pecker.' The warder's reply of, 'don't worry Mr Haff, we'll call an exterminator tomorrow and deal with the problem,' implies that Elvis's cancerous genitals are also contaminating. The nurse who treats Elvis later reinforces this as she pulls on a pair of rubber gloves, further suggesting the possibility of contamination. As Elvis lies in a passive reclining position, the camera frames him so that the spectator is positioned at the foot of the bed and looks between his legs. Framing therefore not only accentuates his fragile masculinity but also forces the viewer to acknowledge the disgust of the male ageing body. This is further emphasized by the nurse who, as she massages in the cream, says 'doctor said this should heal the inflammation ... stop the pus,' at which point Elvis unexpectedly has an erection.

Signification of masculinity is here equated to and marked by sexual response. Yet, though expressed through genital sexuality, the re-formation of ego is really motivated by other thoughts, as explicated through his voiceover that says, 'I was thinking about something that interested me, not about my next meal, or going to the crapper. I'd been given a dose of life again.'

The mummy is the focus of Elvis's newly restored motivation and he and Jack discuss its attack on the latter. Jack says, 'he had his mouth over my ass.' Elvis responds with the question, 'a shit-eater?' again referring back to the abject, infantilizing activities of childhood. There are also potentially homoerotic implications in the mummy's bizarre activities, though this remains unresolved. In discussing the mummy's toilet habits and trying to explain the mysterious appearance of hieroglyphics on the toilet wall, Jack suggests that 'he's just like anybody else when he takes a dump. He wants a nice, clean place with a flush.' In comparison with Elvis's lax toilet habits, Jack's response suggests that he has neither relin-quished his adult identity nor succumbed to institutionalization. Indeed, his incisive verbal articulation, authoritative demeanour and pristine mode of dress, particularly emphasized in the final scenes when he wears a suit, encourage the plausibility of his clearly impossible claim to be Kennedy.

The two men become increasingly mobile and independent of the care home when they begin to investigate the mummy's activi-ties further. For the first time, the viewer sees Elvis outdoors, the external world signified visually by nature and the diegetic sound of birdsong. His movements become more purposeful and he is seen exiting the frame to the side as he begins to occupy new spaces. The character's increased determination is reflected in the narrative orchestration of the film, which becomes more spatially and temporally coherent. Significantly, Elvis also rejects the nurse as a maternal authority. When it is time for his next treatment, he tells her: 'fuck off you patronizing bitch. I'll lube my own crankshaft

from now on. You treat me like a baby again and I'll rap this walker around your head.' He subsequently applies the cream himself, signifying the genital stage of sexual development (masturbation) to which Freud[14] refers, and indicating his growing masculinity. His final quest is not, however, related to sexuality but to confronting the abject that manifests in the figure of the mummy.

The mummy that haunts the sanatorium is an unquestionably abject figure. For Kristeva, the corpse, especially one without a soul, is the utmost in abjection and signifies 'fundamental pollution'. Not only is the border of the physical self transgressed through decay, but the psychical self, which Kristeva refers to as the soul, is negated:

> A decaying body, lifeless, completely turned into dejection, blurred between the inanimate and the inorganic, a transitional swarming, inseparable lining of a human nature whose life is indistinguishable from the symbolic – the corpse represents fundamental pollution. A body without a soul, a non-body, disquieting matter, it is to be excluded from God's territory.[15]

The notion of the soul is clearly significant to the concept of abjection and has some relevance to the representation of the dead in *Bubba Ho-tep*, since the body's integrity is not only compromised by death and disease, but also by the activities of the mummy – he kills his victims by sucking their souls 'from their asshole'. While the mummy itself exemplifies the abject, decaying corpse, the anus also has obvious connotations of disgust. There is specific reference to this in the absurd dialogue between the two men, as they discuss the mummy 'taking a dump'. The mummy's presence therefore perpetually reminds them of a return to a primordial state, especially with reference to it as a 'shit eater'. The constant reappearance of the mummy, however, furthers their progression

to the symbolic. In this way, the abjection associated with the mummy that results in the deaths of the inmates constantly reinvigorates their efforts to reclaim independence.

In reclaiming masculinity, Elvis and Jack reinstate their original (or fantasized) identities. Therefore, when attacking the mummy, they wear clothing associated with their former imagined status, namely Elvis's sequinned suit and Jack's sombre presidential clothing. Through dress, they conceal and redefine the inadequacies of their abject bodies, presenting the impenetrable outline typical of the masculinized body. As they go in search of the mummy, Elvis's voiceover even notes that 'the walker was swinging along easier tonight.' Before attacking the mummy, Elvis shows Jack a picture of his daughter, who comments, 'no regrets, under the circumstances we were the best fathers we could be.' This indicates a further reclaiming of adult masculinity through proof of fatherhood. Elvis then asks Jack, 'what about Marilyn, what's she like in the sack?' Jack's exclamation of approval confirms a return to the symbolic, both through displays of sexual desire and in their rejection of the institution. Their final attainment of a coherent adult identity comes through their deaths, which are noble and heroic. When the mummy kills Jack, Elvis refers to him as Mr President and salutes him. Although the mummy rises up again after Elvis has set fire to it, suggesting how difficult it is to repress the abject, he eventually destroys it. Therefore, by suppressing the abject and incapacitated body, he reclaims masculinity. While film signifies masculinity in various ways, typically through musculature, use of weaponry, agility and sexuality, Elvis and Jack achieve it through bravery and self-sacrifice.

Part of the process of this masculinization involves strengthening the boundaries between self and other and between clean and unclean. These psychic structures are mapped topographically onto the institution. The narrative is thereby structured around the spaces of the institution and the agency of the characters within these spaces.

Initially, the boundaries between the main narrative spaces are indeterminate, with private and public areas overlapping. As psychical and physical domains increasingly differentiate, the narrative also becomes more coherent. With the development of identity and masculinity, Elvis begins to acknowledge and repress his abject self, and rejects the nurse as maternal body. By renouncing identification with the mother, he is therefore released from maternal power.[16]

More significantly, as Elvis ventures into the corridor that the mummy dominates and eventually out of the care home, and aligns himself with the paternal outside world, the narrative accelerates. He addresses his abject body through the rituals of hygiene, dressing and managing himself. Elvis also reacquires particular verbal expressions synonymous with the adult Elvis, whereas previously his language is limited. Furthermore, he becomes more socially interactive compared with his initial withdrawn, isolated existence. Although it is difficult in the early scenes of the film to distinguish his fantasy from conscious thought, since blurring of this is achieved by discontinuity editing, the film later becomes more coherent. While, in reality, Jack and Elvis were icons of power and sexuality, in *Bubba Ho-tep* they appear antithetical to this. Elvis is particularly disgusting, asexual and impotent. However, they regain masculinity, not through power and sexuality, but by repelling the morally ambiguous, which Kristeva asserts disturbs order.[17]

Ultimately, the two men accept the inevitability of death, but they embrace it as a means of reclaiming their masculinity through morality and they therefore become heroic. The mummy's death signals narrative closure. Although the hero dies, he does not become the soulless corpse Kristeva describes. Kristeva, however, indicates that being overwhelmed by the abject is inevitable since death is inevitable. She describes death as 'something rejected from which one does not part, from which one does not protect oneself as from an object. Imaginary uncanniness and real threat, it beckons to us and ends up engulfing us.'[18]

Arguably, therefore, in this film confrontation with the abject, the mummy, is a positive event because it serves to strengthen and consolidate the ego. This ego formation is important to the narrative arc in that it propels the hero into different spaces, notably that of the outside world of the symbolic. It is likely, given the ambivalent structure of the opening scenes, that the identities of these two men are founded on fantasy or dementia, and therefore primarily signal a loss of conscious thought and a regression into an internal psychic world.

While representing the fantasies of two ageing characters, the film also comments adversely on the treatment of the elderly. The funeral company particularly suggests this ambivalence and contempt for the old. One of the hearse drivers says, 'makes you wonder what kind of life this old guy had' to which the other responds, 'who gives a shit?' The film suggests that residential care homes encourage a childlike dependence that translates into a 'falling back under the sway of the maternal',[19] with a consequent loss of desire to abject oneself from the institution. While the regression of old age inversely correlates with infantile development, old age is an aspect of subjectivity that Kristeva does not really consider. As Jorunn Drageset notes, 'just as there is an orderly pattern of development, there is an ordered regression as part of the natural process of ageing. The loss of functions may begin with those activities that are most complex and least basic.'[20] While *Bubba Ho-tep* presents an image of the decaying physical body as repellent, especially apparent in the liminal status of the mummy, it ultimately demonstrates the positive aspects of old age and the fallibilities of youth. Further, it demythologizes the contemporary centring of masculinity around the penis. Thus, while youth is depicted as beautiful, but cruel and feminized, the abject, as represented through the ageing bodies of JFK and Elvis, is seen as noble and heroic.

Conclusion

Following a pattern established in *One Flew Over the Cuckoo's Nest*, in this book I reveal the existence of abject space across an extensive range of genres, with the common link between them being their institutional setting. Abject space is usually associated with institutions that function as castrating maternal bodies, but it is also apparent in repressive patriarchal structures. It is not only evident in spaces that anatomically resemble the interior body, but may also emerge through the oppression of identity. In this book I have uncovered certain visual and narrative consistencies across the 'institution film', which stem largely from the excessive control exercised there. These consistencies range from a *mise-en-scène* that includes scenes of inmate homogenization to certain noir tendencies of lighting, characterization and spatial architecture. Scenes of homogenization, which are often filmed with slow or static camera movements or symmetrical framing, chiefly feature uniformity of dress and figure movement, control of bodily function and repression of sexuality. Various other practices, which serve to erase individuality, range from compulsory drug administration to restricted social interaction.

Mostly, however, fictional institutions restrict private space as a means of control. Such spatial restriction tends to affect characters in various ways, either inhibiting character agency or, in extreme cases, resulting in a transient but identifiable loss of self. This applies especially to total institutions, such as prisons, where constriction of space tends to be excessive, exemplified by Leone's solitary confinement in *Lock Up*. In general, however, as in *One Flew Over the Cuckoo's Nest*, attempts to suppress individuality meet resistance, which often constitutes the primary narrative disorder of institution films. Efforts to reclaim space and, therefore, identity

mean that such disorder usually develops through the transgression or destruction of boundaries. Inevitably, individuals encounter abjection in a literal sense (escaping through the sewers) or undergo horrific experiences. Alternatively, they try to maintain subjectivity in other ways. These might include displays of excessive masculinity, or the 'creation' of private space that enables some autonomy consistent with normal adult activity. The abject is therefore synonymous with efforts to regain space, either through transgressing boundaries, or exploring spaces that are normally out of bounds. Reclaiming or retaining an adult identity may also involve assuming a moral position, which can sometimes lead to the death of a character.

From this study it is apparent that disorder is inevitable in films set in institutions, and that it arises because of the presence of constraint or excessive orderliness. Ultimately, institution films involve the protagonist re-establishing boundaries of private space, which may be physical or mental, to encourage ego formation. Without private space, these characters cannot function in an adult capacity. This arises, for example, in *Carrie*, in which the central character, Carrie, has little private space at home and none at school. Similarly, in *Coma*, Susan Wheeler's private space is restricted and she must therefore occupy peripheral spaces. Again, she undergoes literal abjection (through confronting death) and almost dies. Invariably then, a feature of 'the institution film', as defined in the context of this book, is the production of abject space.

It is interesting to note that the spaces identified as abject within these institutions are predominantly located in low-lying, subterranean or hidden locations. Consequently, abject spaces involve transgressive practice in that they are either prohibited or uninhabited. They are invariably chaotic and disordered and frequently characterized by low-key lighting, erratic camera movements and, often, a noir aesthetic. An affinity for noir characteristics seems to be especially associated with scenes of sadism. Typically, underground tunnels and labyrinthine passageways, much like those that

Creed identifies in her description of *Alien*, are synonymous with abject space. In some respects, however, *The Last Castle* differs from the other films examined here. One reason for this lies in its multi-generic nature, in which elements of the action genre are dominant. This demands that the film's main activity takes place in an open central courtyard. It is thus largely devoid of the labyrinthine underground scenes that tend to typify abject space. Rather, it is more concerned with the control of the body through constant observation and the threat of physical abuse than with acute constraints on personal space. Even so, it clearly demonstrates the characteristics of abject space I have defined, both through the transgression of spatial boundaries and the infantilizing of the prisoners. Moreover, it reveals a form of abjection through the criminal tendency of one of its main characters, Colonel Winter. *The Last Castle* is therefore perhaps the least abject visually and therefore defines the limit of this study, but it contributes to a resolution of my claim for institutional settings as abject spaces.

In keeping with an affinity for noir aesthetics, abject space is distinctly associated with a *mise-en-scène* of darkness. In *Girl, Interrupted* the girls descend into the basement at night, while in *Bubba Ho-tep* the mummy attacks under cover of darkness; in *Coma*, darkness is especially associated with threat and in *The Shawshank Redemption*, Andy escapes during the night. Both *Lock Up* and *Full Metal Jacket* culminate in night-time scenes. While perhaps providing a visual means of increasing narrative tension, such noirish tendencies may also suggest that the abject is associated with the emergence of the repressed unconscious during sleep, or more likely, reflects freedom from surveillance.

Mostly, scenes of horror or disorder involve a renegotiation of, or literal passing through, the abject and a rejection of the castrating maternal body of the institution. Institutions, however, as evident in *Coma*, may also function as patriarchal structures. Alternatively, scenes of abjection signify a return to the semiotic world

associated with the maternal figure, and in some cases show an inability ultimately to separate from it. In *Girl, Interrupted*, fixation at the Oedipal stage results in neurosis while in *Coma*, the main protagonist, though sustaining temporary neurosis and almost dying, proves resistant to patriarchal practices. *Bubba Ho-tep* and the three prison films examined also involve a renegotiation of abjection to reclaim adult subjectivity. Conversely, in *Full Metal Jacket*, the maternal institution returns the inmates to a stage of psychosexual development from which they are unable to return, leading to perversion that is sadistically/anally motivated. *Carrie* also demonstrates a protagonist unable to separate from the maternal figure and who is thus similarly engulfed by the abject. In other scenarios, the inmate may become institutionalized and thus struggles to survive on the 'outside'. Nevertheless, despite provoking anxiety or horror, and despite the negative connotations film theorists previously attached to the abject, experiences of abjection in these films paradoxically often lead to positive or liberating outcomes. *Remember the Titans* and *The Shawshank Redemption* particularly demonstrate this. It is interesting to note that both fared well commercially.[1] This conclusion has some commonality with Krzywinska's[2] claim that certain transgressive practices may be liberating.

A further consistency of the institution films examined in this book is the incidence of ritual or scenes of ceremony, which figure prominently in *Remember the Titans*, *Full Metal Jacket* and *Carrie*. The presence of ritual in these films relates to its value in containing or confronting abjection. Kristeva's account predominantly refers to religious and spiritual rituals as ways of both addressing and containing abjection; the similar rituals that feature in *Carrie* and *Bubba Ho-tep* perform comparable functions. In *Remember the Titans*, prayer is associated with racial cohesion and team spirit, while the ritualized procedures evident in each of the prison films, as well as *Full Metal Jacket*, are different. Rather than religious or spiritual cleansing, their daily regimes relate to physical cleanliness and

orderly containment, but serve the similar purpose of keeping the abject at bay. *Coma*, on the other hand, is concerned with the protocols and practices of managing diseased or decaying bodies, though this too ties in closely with the imposition of boundaries aimed at containing abjection (literally in body bags and organ transplant boxes). Humour, which Kristeva[3] suggests is an alternative way of displacing abjection, is also evident in *Full Metal Jacket*.

An incidental finding in this study is the common narrative presence of a father–son relationship in which the 'son' dies. This is apparent in a number of male-dominated institution films and is consistent with theoretical discussions of masculinity and the development of 'new masculinities' in films of the 1980s and 1990s. In the context of this book, however, such relationships also serve to remobilize the adult identity of the 'father' figure and provide the narrative impetus for these characters to break away from the maternal institution.

At the same time, the analysis of abjection in these films challenges other research. While it shows that the abject is present in hitherto unexpected genres/films, it also proposes alternative contexts for films that have already been associated with the abject. For example, Creed identifies abjection in *Carrie* with regard to the 'monstrous-feminine' body, while my argument for abjection centres on the spaces the protagonist occupies and on a further examination of monstrosity in relation to amorality and religiosity. While Creed's work on *Carrie* discusses maternal abjection in relation to attempts to break away from the maternal figure, my argument incorporates Kristeva's theological approach to the maternal figure as abject.

This examination of the 'institution film' has therefore broadened the application of abjection in film through a consideration of aspects as diverse as nationalism, theology, sport, language, music, medicine, mental illness, point of death and imprisonment. The interpretation of language within a filmic context is relevant since

Kristeva's views on the abject with regard to subjectivity relate closely to the use of language. For Kristeva, the point of maternal abjection may be signified through acquisition and use of language. In this study I therefore outline the use of text and speech as signifiers of the symbolic. I also demonstrate how the semiotic *chora* may be signified through sport and music, and represented through distinctive styles of cinematography, such as whip pans and fast tracking shots, which are techniques that are often associated with sports films.

Some examples here reveal Kristeva's account of abjection to have limitations. For example, in this book I find abjection associated with the male reproductive body (*Bubba Ho-tep*) and therefore challenge Kristeva's concept of abjection. This is in line with arguments presented by Grosz[4] who similarly questions Kristeva's distinction between the male and female reproductive body. Clearly, the depiction of filmic institutions also compromises Foucault's[5] analysis of discipline. The films suggest that surveillance and physical ordering of the body do not necessarily produce entirely regulated subjects as he indicates in *Discipline and Punish*. In fact, pervasive surveillance and intense spatial restriction do not maintain orderliness at all. Rather, these practices merely generate resistance and conflict, which supports my argument that institutions are inherently abject. This perhaps ties in with other messages that the films convey.

While it was not my original intention in this book to identify and explain emergent perspectives on the nature of real institutions, it is impossible to ignore the common messages that have become apparent through a study of these films. These consistently comment on the individual institution and often the larger establishment of United States politics. It is interesting to note that the criticisms of individual institutions, which inevitably indicate their general failure, correlate with a trend towards deinstitutionalization, care in the community, electronic tagging and 'revolving door' care (short-stay patients with frequent admissions).[6] While these films

are mostly fictional, several draw on real experiences and perhaps reflect anxieties concerning institutions.

The most pointed criticism of the institution occurs in *One Flew Over the Cuckoo's Nest* where a series of controlling and cruel punishments replace any form of care. Its more recent counterpart, *Girl, Interrupted*, while not as damning, raises similar questions about the treatment and diagnosis of mental illness. In the broader context, one scene from *Girl, Interrupted* specifically references the unreliability of the United States government (apparently in the context of Vietnam). In *Coma*, medicine is shown to be a corrupt, patriarchal and purely commercial enterprise, with the organ depot named the Jefferson Institute and the chief of staff portrayed as a political figure. In *Carrie*, the abject home of Carrie and Margaret White – a picket-fenced white house –turns out to be repressive and cloyingly religious. This space therefore clearly comments on the strictures of American life, while the collapse of the Whites' house likely comments on the breakdown of family structures and perhaps some of the failures of US politics.

The entire narrative of *Full Metal Jacket* centres on a critique of America's political stance on Vietnam, while the prison films discussed here appear to reflect recent concerns about the nature of discipline, poor conditions and the current growth of prison populations.[7] In fact, *The Shawshank Redemption*, as well as commenting adversely on programmes of rehabilitation, contains scenes of explicitly Nixonian politics. The political undertone of *The Shawshank Redemption* leads Wilson and O'Sullivan to comment that 'this benchmark of failure is just as much a failure of wider social and cultural phenomena as it is of each institution.'[8] Given the era of American politics from which many of these films emerge, it is likely that they not only refer to processes of institutionalization but also allude to American political strategies, especially with regard to Vietnam and Watergate. It is therefore possible that the institutions shown in these films are metaphors

for US political establishments, which, as in the institutions analysed here, are ultimately unstable.

In sum, since abjection exists in films that are set in institutions, the generic range of abjection may therefore be extended beyond the horror film. In analysing the development or regression of subjectivity in relation to space, I suggest that the agency of characters is influenced by the spaces they occupy. By examining a coherent body of films that involve restricted spatialities, therefore, it has been possible to locate notions of the abject in films that deal primarily with identity, either in its formation, maintenance or decline. This furthers previous perspectives that forged links between abjection and the horror film, the monstrous-feminine and the disgusting body. Rather, a broadening of the scope of abjection, largely in line with Kristeva's views, but sometimes moving beyond them, has allowed alternative readings of abject space and found that its presence is inevitable in fictional institutions.

Notes

Introduction: Institutions, Abjection and Subjectivity

1. J. Kristeva, *Powers of Horror: An Essay on Abjection*, translated by L. Roudiez (New York: Columbia University Press, 1982).
2. Ibid.
3. M. Douglas, *Purity and Danger* (London: Routledge, 2002).
4. Kristeva, *Powers of Horror*, p. 71.
5. Douglas, *Purity and Danger*.
6. Kristeva, *Powers of Horror*, p. 4.
7. Ibid.
8. Ibid.
9. Ibid.
10. Ibid., p. 13.
11. Ibid., p. 54.
12. B. Creed, '*Alien* and the Monstrous-Feminine', in A. Kuhn (ed.) *Alien Zone: Cultural Theory and Contemporary Science Fiction Cinema* (London: Verso, 1990) p. 131.
13. Creed, '*Alien* and the Monstrous-Feminine', p. 128.
14. S. Freud, *The Standard Edition of the Complete Psychological Works: An Infantile Neurosis and Other Works*, vol. 17, translated by J. Strachey (London: Hogarth Press, 1995) pp. 219–52.
15. Ibid., p. 219.
16. M. Fiddler, 'Projecting the Prison: The Depiction of the Uncanny in *The Shawshank Redemption*', *Crime Media Culture*, vol. 3, 2007, pp. 192–206; L. Mulvey, *Fetishism and Curiosity* (Bloomington and Indianapolis: Indiana University Press and BFI Publishing, 1996); E. Young, '*The Silence of the Lambs* and the Flaying of Feminist Theory', *Camera Obscura*, vol. 27, 1991, pp. 5–35; S. Žižek, *The Pervert's Guide to Cinema*. DVD directed by Sophie Fiennes (UK/Austria/Netherlands: A Lone Star, Mischief Films, Amoeba Film Production, 2006). Presented by Slavoj Žižek. Available as commercially published DVD from www.pervertsguide.com2006.
17. Mulvey, *Fetishism and Curiosity*, pp. 6–18.
18. Ibid., p. 64.
19. Žižek, *The Pervert's Guide*.
20. Fiddler, 'Projecting the Prison'.
21. B. Jarvis, *Cruel and Unusual: Punishment and US Culture* (London: Pluto Press, 2004).
22. Ibid., p. 174.

23. Young, 'The Silence of the Lambs and the Flaying of Feminist Theory'.
24. Kristeva, Powers of Horror, p. 5.
25. Ibid.
26. J. Kristeva, 'Reading the Bible', in D. Jobling, T. Pippin and R. Schleifer (eds) The Postmodern Bible Reader (Oxford: Blackwell Publishing, 2001) pp. 92–101.
27. N. Elias, The Civilising Process (Oxford: Blackwell, 2000).
28. Ibid., p. 160.
29. D. Sibley, 'Outsiders in Society and Space', in K. Anderson and F. Gale (eds) Cultural Geographies (Melbourne: Longman Cheshire, 1999) pp. 135–51.
30. Douglas, Purity and Danger; Kristeva; Powers of Horror.
31. D. Sibley, Geographies of Exclusion: Society and Difference in the West (London: Routledge, 1995) p. 80.
32. Ibid., p. 33.
33. Ibid., p. 25.
34. Ibid., p. 27.
35. Freud, An Infantile Neurosis, p. 127.
36. Kristeva, Powers of Horror.
37. M. Foucault, Discipline and Punish: The Birth of the Prison (Harmondsworth: Penguin, 1991).
38. Ibid., p. 201.
39. M. Foucault, 'Of Other Spaces', Diacritics, vol. 16, 1986, p. 25.
40. For Goffman, 'the central feature of total institutions can be described as a breakdown of the barriers … separating [sleep, play and work]. First, all aspects of life are conducted in the same place, … in the immediate company of a large batch of others, all of whom are treated alike and required to do the same thing together. Third, all phases of the day's activities are tightly scheduled. … Finally, the various enforced activities are brought together into a single rational plan.' E. Goffman, Asylums: Essays on the Social Situation of Mental Patients and Other Inmates (Harmondsworth: Penguin Books, 1991) p. 17.

Part 1. Becoming a Man/Woman: Spaces of Training

1. Foucault, Discipline and Punish, p. 146.
2. Ibid., p. 152.
3. Ibid., p. 153.
4. Elias, The Civilising Process, p. 53.
5. T. Boon, 'Health Education Films in Britain, 1919–39: Production, Genres and Audiences', in G. Harper and A. Moor (eds) Signs of Life: Medicine and Cinema (London: Wallflower Press, 2005) pp. 45–57.
6. Ibid., p. 45.
7. J. Hay, 'Rethinking the Intersection of Cinema, Genre and Youth', Scope: An Online Journal of Film and Television Studies, June 2002, pp. 1–17 <http://www.nottingham.ac.uk/film/journal/articles/cinema-genre-youth.htm> cited 13 June 2003.

8. Ibid., p. 7.

9. Ibid., p. 8.

10. P. Stallybrass and A. White, *The Politics and Poetics of Transgression* (London: Methuen, 1986) p. 144.

11. Douglas, *Purity and Danger*; C. Knight, *Blood Relations: Menstruation and the Origins of Culture* (New Haven: Yale University Press, 1995).

12. G. Weiss, 'The Abject Borders of the Body Image', in G. Weiss and H. F. Haber (eds) *Perspectives on Embodiment: The Intersections of Nature and Culture* (London: Routledge, 1999) pp. 41–59.

1. Schooling and the Feminine Body: *Carrie*

1. The film grossed $33,800,000 at the box office (USA) and received two Oscar nominations (Anon, IMDb, *Carrie*, n.d.) <http://uk.imdb.com/title/tt0074285/> cited 30 December 2007. See C. Clover, *Men, Women and Chainsaws: Gender in the Modern Horror Film* (London: BFI Publishing, 1993) p. 3.

2. V. Sobchack, 'Bringing it All Back Home: Family Economy and Generic Exchange', in B. Grant (ed.) *The Dread of Difference: Gender and the Horror Film* (Austin: University of Texas Press, 1996) pp. 143–63; R. Wood, *Hollywood: From Vietnam to Reagan and Beyond* (New York: Columbia University Press, 1986).

3. Wood, *Hollywood*.

4. P. Hutchings, *The Horror Film* (London: Pearson Longman, 2004); T. Modleski, 'The Terror of Pleasure', in K. Gelder (ed.) *The Horror Reader* (London: Routledge, 2000) pp. 285–93; W. Paul, *Laughing Screaming: Modern Hollywood Horror and Comedy* (New York: Columbia University Press, 1994).

5. R. Worland, *The Horror Film: An Introduction* (Oxford: Blackwell Publishing, 2007).

6. B. Creed, *The Monstrous-Feminine: Film, Feminism, Psychoanalysis* (London: Routledge, 1993); K. MacKinnon, *Misogyny in the Movies: The De Palma Question* (London: Associated University Presses, 1990); S. Stamp Lindsey, 'Horror, Femininity, and Carrie's Monstrous Puberty', in B. Grant (ed.) *The Dread of Difference: Gender and the Horror Film* (Austin: University of Texas Press, 1996) pp. 279–95.

7. See MacKinnon, *Misogyny in the Movies*.

8. Creed, *The Monstrous-Feminine*.

9. Kristeva, *Powers of Horror*.

10. B. Creed, 'Horror and the Monstrous-Feminine: An Imaginary Abjection', in M. Jancovich (ed.) *Horror, the Film Reader* (London: Routledge, 2002) p. 72.

11. Kristeva, *Powers of Horror*.

12. Worland, *The Horror Film*, p. 240.

13. Ibid., p. 29.

14. V. Clemens, *The Return of the Repressed: Gothic Horror from the Castle of Otranto to Alien* (Albany: State University of New York Press, 1999) p. 7.

15. A. Best, *Prom Night: Youth, Schools, and Popular Culture* (London: Routledge, 2000).

16. Ibid., p. 165.

17. Stallybrass and White, *The Politics and Poetics of Transgression*, pp. 144–5.
18. Sobchack, 'Bringing it All Back Home'.
19. Ibid., p. 144.
20. Ibid., p. 146.
21. Kristeva, *Powers of Horror*, p. 13.
22. Bruce Babington ('Twice a Victim: Carrie meets the BFI', *Screen*, vol. 24, no. 3, May–June 1983, p. 12) comments that the volleyball court markings evident from an overhead shot have a similarity to male and female genitalia.
23. MacKinnon, *Misogyny in the Movies*, p. 126.
24. Creed, *The Monstrous-Feminine*, p. 79.
25. J. Kristeva, *Revolution in Poetic Language*, translated by M. Waller (New York: Columbia University Press, 1984) pp. 43–56.
26. Best, *Prom Night*.
27. Ibid., p. 2.
28. Ibid., p. 4.
29. Ibid., p. 35.
30. Ibid., p. 38.
31. Ibid., p. 112.
32. Ibid., p. 112.
33. R. Combs, 'Carrie', *Monthly Film Bulletin*, January 1977, pp. 3–4.
34. M. Pye and L. Myles, *The Movie Brats: How the Film Generation Took Over Hollywood* (London: Faber & Faber, 1979) cited in MacKinnon, *Misogyny in the Movies*, p. 123.
35. For further reading, refer to Stallybrass and White, *The Politics and Poetics of Transgression*, pp. 27–79.
36. Kristeva, *Powers of Horror*, p. 96.
37. Ibid.
38. Ibid., p. 17.
39. Kristeva, 'Reading the Bible', p. 95.
40. J. Kristeva, 'Stabat Mater', in T. Moi (ed.) *The Kristeva Reader* (Oxford: Basil Blackwell, 1986) pp. 160–86.
41. Kristeva, 'Reading the Bible', p. 96.
42. D. Jonte-Pace, 'Situating Kristeva Differently: Psychoanalytic Readings of Woman and Religion', in D. Crownfield (ed.) *Body/Text in Julia Kristeva* (New York: State University of New York Press, 1992) p. 9.
43. Best, *Prom Night*, p. 2.
44. For further information, refer to L. Nead, *The Female Nude: Art, Obscenity and Sexuality* (London: Routledge, 1992) pp. 5–33.
45. Creed, *The Monstrous-Feminine*.
46. Creed (ibid., pp. 105–21) also refers to the fear of the castrating female genitals as a source of monstrous femininity.
47. Combs, 'Carrie', p. 4.
48. Clover, *Men, Women and Chainsaws*.

49. Ibid., pp. 3–4, quoting Stephen King.
50. L. Ehlers, 'Carrie: Book and Film', *Literature Film Quarterly*, vol. 9, no. 1, 1981, p. 36.
51. Sobchack, 'Bringing it All Back Home', p. 146.

2. Training the Athletic Body: *Remember the Titans*

1. J. Kristeva, *Strangers to Ourselves*, translated by L. Roudiez (New York: Columbia University Press, 1991); J. Kristeva, *Nations without Nationalism*, translated by L. Roudiez (New York: Columbia University Press, 1993).
2. Creed, *The Monstrous-Feminine*.
3. Kristeva, *Revolution in Poetic Language*, p. 48.
4. J. Lacan, 'The Mirror Stage', in A. Easthope (ed.) *Contemporary Film Theory* (London: Longman, 1993).
5. Kristeva, *Revolution in Poetic Language*, p. 25.
6. Ibid.
7. Ibid.
8. J. Kristeva, *Desire in Language: A Semiotic Approach to Literature and Art*, edited by L. Roudiez and translated by T. Gora, A. Jardine and L. Roudiez (New York: Columbia University Press, 1980).
9. Kristeva, *Revolution in Poetic Language*.
10. An African-American cultural movement of the 1920s and 1930s that centred on the Harlem district of New York.
11. R. Dyer, *The Matter of Images: Essays on Representation* (London: Routledge, 2002) p. 16.
12. S. Hall (ed.) *Representation: Cultural Representations and Signifying Practices* (Milton Keynes: Open University Press, 1997) p. 258.
13. L. Wynter, *American Skin: Pop Culture, Big Business and the End of White America* (New York: Crown Publishing, 2002).
14. Kristeva, *Powers of Horror*, pp. 12–13.
15. Kristeva, *Strangers to Ourselves*, p. 1.
16. Ibid.
17. Kristeva, *Nations without Nationalism*, p. 51.
18. N. Moruzzi, 'National Abjects', in K. Oliver (ed.) *Ethics, Politics and Difference in Julia Kristeva's Writing* (London: Routledge, 1993) p. 143.
19. Ibid., p. 144.
20. Sibley, *Geographies of Exclusion*.
21. D. Hook, 'Racism as Abjection: A Psychoanalytic Conceptualization for a Post-Apartheid South Africa', *South African Journal of Psychology*, vol. 34, no. 4, 2006, pp. 672–703.
22. S. Freud, *The Standard Edition of the Complete Psychological Works: The Ego and the Id and Other Works*, vol. 19, translated by J. Strachey (London: Hogarth Press, 1961) pp. 31–2.

23. Freud describes the superego as the conscience, which is usually associated with the father figure (*The Ego and the Id*, pp. 28–39).
24. Kristeva, *Strangers to Ourselves*, p. 1.
25. Lacan, 'The Mirror Stage'.
26. Kristeva, *Revolution in Poetic Language*, p. 16.
27. Kristeva, *Desire in Language*, p. 172.
28. Ibid., pp. 167–8.
29. S. Freud, *The Standard Edition of the Complete Psychological Works: A Case of Hysteria, Three Essays on Sexuality and Other Works*, vol. 7, translated by J. Strachey (London: Hogarth Press, 1953) pp. 173–206.
30. V. Burstyn, *The Rites of Men: Manhood, Politics and the Culture of Sport* (Toronto: University of Toronto Press, 1999) p. 18.
31. Ibid., p. 19.
32. D. Graves, 'World Waits on Beckham's Broken Bone. From No 10 to the Pub Pundit, from Leading Surgeons to Big Business, Everybody has an Opinion about the England Captain's Foot', *Daily Telegraph*, London (UK), 12 April 2002, p. 4.
33. Burstyn, *The Rites of Men*, p. 24.
34. Creed, *The Monstrous-Feminine*.
35. Kristeva, *Revolution in Poetic Language*, p. 25.
36. Kristeva, *Strangers to Ourselves*, p. 195.
37. Kristeva, *Powers of Horror*, p. 15.
38. Moruzzi, 'National Abjects', p. 146.

3. Ordering the Military Body: *Full Metal Jacket*

1. S. White, 'Male Bonding, Hollywood Orientalism, and the Repression of the Feminine in Kubrick's *Full Metal Jacket*', in M. Anderegg (ed.) *Inventing Vietnam* (Philadelphia: Temple University Press, 1991) pp. 204–30.
2. S. Jeffords, *The Remasculinization of America: Gender and the Vietnam War* (Bloomington: Indiana University Press, 1989).
3. S. Jeffords, *Hard Bodies: Hollywood Masculinity in the Reagan Era* (New Brunswick: Rutgers University Press, 1994) p. 166.
4. Freud, *A Case of Hysteria*, p. 185.
5. In the biblical tale of Samson and Delilah, Samson's masculine strength was removed by the cutting of his hair.
6. G. Sykes. *The Society of Captives: A Study of a Maximum Security Prison* (Princeton: Princeton University Press, 2007) p. 66.
7. E. Grosz, *Volatile Bodies: Towards a Corporeal Feminism* (Bloomington: Indiana University Press, 1994) p. 201.
8. J. Naremore, *On Kubrick* (London: BFI Publishing, 2007) pp. 35–41.
9. For further reading, refer to M. Bakhtin, *Rabelais and His World*, translated by H. Iswolsky (Bloomington: Indiana University Press, 1984).
10. P. Williams, '"What a Bummer for the Gooks": Representations of White

NOTES

American Masculinity and the Vietnamese in the Vietnam War Film Genre 1977–87', *EJAC*, vol. 22, no. 3, 2003, p. 233.

11. Freud, *A Case of Hysteria*, p. 193.
12. Ibid., p. 198.
13. L. Mulvey, 'Visual Pleasure and Narrative Cinema', *Screen*, vol. 16, no. 3, 1975, pp. 6–18.
14. Freud (*The Ego and the Id*) refers to the superego in relation to the development of a conscience.
15. The id is responsible for unrestrained behaviour (Freud, *The Ego and the Id*).
16. A. Easthope, *What a Man's Gotta Do: The Masculine Myth in Popular Culture* (London: Routledge, 1992) p. 54.
17. Ibid., pp. 51–2.
18. Y. Tasker, *Spectacular Bodies: Gender, Genre and the Action Cinema* (London: Routledge, 1993) p. 91.
19. Jeffords, *Hard Bodies*, p. 166.
20. Quoted in Tasker, *Spectacular Bodies*, p. 94.
21. R. Castle and S. Donatelli, 'Kubrick's Ulterior War', *Film Comment*, vol. 34, no. 5, 1998, p. 24; L. Quart and A. Auster, *American Film and Society Since 1945* (Westport, CT: Praeger Publishing, 2002) p. 148.
22. T. Rafferty, 'Remote Control', *Sight and Sound*, vol. 56, no. 4, 1987, p. 257.
23. Kristeva, *Powers of Horror*, p. 8.
24. Jeffords, *Hard Bodies*, p. 166.
25. Freud, *A Case of Hysteria*, p. 183.
26. Toilets in American film are often depicted as places of abjection and bloody death. This threat materializes mostly in relation to men, specifically marking toilets as places of vulnerability for them.
27. R. Barcan, 'Dirty Spaces: Communication and Contamination in Men's Public Toilets', *Journal of International Women's Studies*, vol. 6, no. 2, 2005, p. 8.
28. Ibid., p. 7.
29. G. Hasford, *The Short Timers* (New York: Bantam, 1985).
30. Easthope, *What a Man's Gotta Do*, pp. 52–4.
31. Kristeva, *Powers of Horror*, p. 71.
32. Grosz, *Volatile Bodies*, p. 199.
33. Freud, *A Case of Hysteria*.
34. Jeffords, *The Remasculinization of America*; Williams, 'What a Bummer for the Gooks'.
35. Kristeva, *Powers of Horror*, p. 9.
36. Ibid., p. 3.
37. Freud, *A Case of Hysteria*.
38. P. Willoquet-Maricondi, 'Full-Metal-Jacketing, or Masculinity in the Making', *Cinema Journal*, vol. 33, no. 2, 1994, p. 16.
39. Ibid., p. 13.
40. Ibid., p. 13.

41. Ibid., p. 15.
42. Ibid., p. 18.
43. Jeffords, *The Remasculinization of America*, p. 173.
44. Ibid., p. 174.
45. Ibid., p. 169.
46. Williams, 'What a Bummer for the Gooks', p. 234.
47. W. Palmer, *The Films of The Eighties: A Social History* (Carbondale: Southern Illinois University Press, 1993) p. 47.
48. Willoquet-Maricondi, 'Full-Metal-Jacketing', p. 6.
49. J. Newsinger, 'Do You Walk the Walk? Aspects of Masculinity in Some Vietnam War Films', in P. Kirkham and J. Thumim (eds) *You Tarzan: Masculinities, Movies and Men* (London: Lawrence and Wishart, 1993) p. 134.
50. Quoted in Tasker, *Spectacular Bodies*.
51. Jeffords, *Hard Bodies*.
52. Kristeva, *Powers of Horror*, p. 9.
53. Jeffords, *The Remasculinization of America*, p. 175.
54. Jeffords, *The Remasculinization of America*; White, 'Male Bonding, Hollywood Orientalism, and the Repression of the Feminine'.
55. R. Rambuss, 'Machinehead: The Technology of Killing in Stanley Kubrick's *Full Metal Jacket*, *Camera Obscura*, vol. 14, no. 42, 1999, pp. 97–114.
56. Jeffords, *Hard Bodies*, p. 166.
57. Jeffords, *The Remasculinization of America*; White, 'Male Bonding, Hollywood Orientalism, and the Repression of the Feminine'; Willoquet-Maricondi, 'Full-Metal-Jacketing, or Masculinity in the Making'.

Part II. Maintaining Self: Spaces of Discipline

1. P. Mason, 'Locating Hollywood's Prison Film Discourse', in P. Mason (ed.) *Captured by the Media: Prison Discourse in Popular Culture* (Taunton: Willan Publishing, 2006) p. 203.
2. M. Duncan, *Romantic Outlaws, Beloved Prisons: The Unconscious Meanings of Crime and Punishment* (New York: New York University Press, 1996).
3. Fiddler, 'Projecting the Prison'; Jarvis, *Cruel and Unusual*.
4. M. Nellis and C. Hale (eds) *The Prison Film* (London: Radical Alternatives to Prison, 1982).
5. Ibid., p. 8.
6. Ibid., p. 10.
7. Ibid., p. 64.
8. S. Neale, *Genre and Hollywood* (London: Routledge, 2000) p. 56.
9. Ibid., p. 143.
10. N. Rafter, *Shots in the Mirror: Crime Films and Society* (Oxford: Oxford University Press, 2000) p. 122.
11. Mulvey, 'Visual Pleasure and Narrative Cinema'.
12. Foucault, *Discipline and Punish*, p. 236.

13. J. McCorkel, 'Embodied Surveillance and the Gendering of Punishment', *Journal of Contemporary Ethnography*, vol. 32, no. 1, 2003, pp. 41–76.

14. Dews in R. Matthews, *Doing Time: An Introduction to the Sociology of Imprisonment* (London: Macmillan, 1999) p. 67.

15. D. Garland, *Punishment and Modern Society* (Oxford: Clarendon Press, 1991) pp. 157–75.

16. M. Foucault, *Power/Knowledge* (London: Longman, 1980) p. 159.

17. Matthews, *Doing Time*, p. 70.

18. Ibid., p. 72.

19. Ibid., p. 37.

20. S. Neale, 'Masculinity as Spectacle', in S. Cohan and I. Hark (eds) *Screening the Male: Exploring Masculinities in Hollywood Cinema* (London: Routledge, 1993) pp. 9–20.

21. Mulvey, 'Visual Pleasure and Narrative Cinema'.

4. Staying Clean and Proper: *The Shawshank Redemption*

1. S. King, *Rita Hayworth and Shawshank Redemption* (London: Time Warner, 1982).

2. M. Kermode, *Shawshank: The Redeeming Feature*, DVD directed by Andrew Abbott and presented by Mark Kermode (USA: A Nobles Gate Scotland Production available as commercially published DVD from Warner Home Video, 2004).

3. According to an IMDB poll, *The Shawshank Redemption* is currently at position two in the top 250 favourite films of all time (Anon., *The Shawshank Redemption* (IMDb, n.d.) <http://uk.imdb.com/chart/top?tt0111161> (cited 20 September 2007). The film received seven nominations for academy awards; it topped audience polls of America on-line and IMDB; it was voted the fourth best film of all time by *Empire* magazine readers and was the top renting videotape of 1995 (Kermode, *Shawshank: The Redeeming Feature*).

4. Kristeva, *Powers of Horror*, p. 72.

5. Freud, *A Case of Hysteria*, pp. 144–5.

6. Neale, 'Masculinity as Spectacle'.

7. Mulvey, 'Visual Pleasure and Narrative Cinema'.

8. P. Willemen, 'Anthony Mann: Looking at the Male', *Framework*, nos 15–17, Summer 1981, pp. 16–20.

9. Neale, 'Masculinity as Spectacle', p. 13.

10. Ibid., pp. 13–14.

11. Ibid., p. 14.

12. Freud, *A Case of Hysteria*.

13. Ibid., p. 193.

14. Ibid., p. 193.

15. M. Kermode, *The Shawshank Redemption* (London: BFI Publishing, 2003) p. 25.

16. Grosz, *Volatile Bodies*; L. Irigaray, *Speculum of the Other Woman*, translated by G. Gill (Ithaca: Cornell University Press, 1985); R. Longhurst, *Bodies: Exploring*

Fluid Boundaries (London: Routledge, 2001).

17. J. Wlodarz, 'Rape Fantasies: Hollywood and Homophobia', in P. Lehman (ed.) *Masculinity: Bodies, Movies, Culture* (London: Routledge, 2001) pp. 67–80.

18. Ibid., p. 79.

19. S. Gear, 'Rules of Engagement: Structuring Sex and Damage in Men's Prisons and Beyond', *Culture, Health and Sexuality*, vol. 7, no. 3, 2005, p. 200.

20. Gear, 'Rules of Engagement'; C. Man and J. Cronan, 'Forecasting Sexual Abuse in Prison: The Prison Subculture of Masculinity as a Backdrop for "Deliberate Indifference"', *Journal of Criminal Law and Criminology*, vol. 59, 2001, pp. 127–81.

21. Matthews, *Doing Time*, p. 53.

22. T. Foster, 'Mushfaking: A Compensatory Behaviour of Prisoners', *The Journal of Social Psychology*, vol. 117, 1982, pp. 115–24.

23. Ibid., pp. 121–4.

24. R. Eberwein, 'As a Mother Cuddles a Child: Sexuality and Masculinity in World War II Combat Films', in P. Lehman (ed.) *Masculinity: Bodies, Movies, Culture* (London: Routledge, 2001) p. 157.

25. Jarvis, *Cruel and Unusual*, p. 199.

26. Nellis and Hale, *The Prison Film*, p. 47.

27. Wlodarz, 'Rape Fantasies', p. 78.

28. Kermode, *The Shawshank Redemption*, p. 72.

29. Ibid., p. 75.

30. Fiddler, 2007, p. 199.

31. Ibid.

32. Kermode, *The Shawshank Redemption*, p. 50.

33. Ibid., p. 74.

34. Ibid., p. 73.

35. Jarvis, *Cruel and Unusual*, p. 175.

36. Ibid., p. 175.

37. Ibid., p. 174.

38. Ibid., p. 175.

39. Ibid., p. 199.

40. Neale, 'Masculinity as Spectacle'.

41. Kermode, *The Shawshank Redemption*, p. 68.

42. Ibid., p. 86.

43. Kristeva, *Powers of Horror*, p. 13.

44. Creed, '*Alien* and the Monstrous-Feminine', p. 131.

45. M. Kermode, *Shawshank: The Redeeming Feature*.

46. Kermode, *The Shawshank Redemption*, pp. 70–1.

47. D. Wilson and S. O'Sullivan, *Images of Incarceration: Representations of Prison in Film and Television Drama* (Winchester: Waterside Press, 2004) p. 167.

5. Performing Masculinity: *Lock Up*

1. Tasker, *Spectacular Bodies*, p. 127.
2. Jarvis, *Cruel and Unusual*, p. 177.
3. For more information refer to G. Deleuze, 'Coldness and Cruelty', in G. Deleuze and L. von Sacher-Masoch, *Masochism* (New York: Zone Books, 1989) pp. 15–134; and K. Silverman, 'Masochism and Male Subjectivity', in C. Penley and S. Willis (eds) *Male Trouble* (Minneapolis: University of Minnesota Press, 1993) pp. 330–64.
4. Refer to the report of Lord Justice Woolf, *Prison Disturbances April 1990* (London: HMSO, 1991) p. 18.
5. Nellis and Hale, *The Prison Film*, p. 9.
6. Foucault, *Discipline and Punish*.
7. Freud, *A Case of Hysteria*, p. 157.
8. Ibid., p. 169.
9. Mulvey, 'Visual Pleasure and Narrative Cinema'.
10. Jarvis, *Cruel and Unusual*.
11. Y. Tasker, 'Dumb Movies for Dumb People', in S. Cohan and I. Hark (eds) *Screening the Male: Exploring Masculinities in Hollywood Cinema* (London: Routledge, 1993) p. 237.
12. For more information refer to Silverman, 'Masochism and Male Subjectivity', p. 60.
13. Kristeva, *Powers of Horror*.
14. R. Dyer *Only Entertainment* (London: Routledge, 1992); Mulvey, 'Visual Pleasure and Narrative Cinema'; Neale, 'Masculinity as Spectacle'.
15. Gear, 'Rules of Engagement'; Man and Cronan, 'Forecasting Sexual Abuse in Prison'.
16. P. Kirkham and J. Thumim (eds) *You Tarzan: Masculinity, Movies and Men* (London: Lawrence & Wishart, 1993) p. 11.
17. Tasker, *Spectacular Bodies*, p. 154.
18. C. Holmlund, 'Masculinity as Multiple Masquerade: The "Mature" Stallone and the Stallone Clone', in S. Cohan and I. Hark (eds) *Screening the Male: Exploring Masculinities in Hollywood Cinema* (London: Routledge, 1993) pp. 213–29.
19. Ibid., p. 220.
20. Ibid., p. 221.
21. Foster, 'Mushfaking'.
22. Jeffords, *Hard Bodies*, p. 166.
23. Jarvis, *Cruel and Unusual*, p. 174.
24. Freud, *A Case of Hysteria*, p. 159.
25. Nellis and Hale, *The Prison Film*.
26. Tasker, *Spectacular Bodies*, p. 90.
27. Ibid., p. 18.

6. Resisting the Gaze: *The Last Castle*

1. Foucault, *Discipline and Punish.*
2. Kristeva, *Powers of Horror.*
3. Kristeva, *Strangers to Ourselves;* Kristeva, *Nations without Nationalism.*
4. Mulvey, 'Visual Pleasure and Narrative Cinema'.
5. Neale, 'Masculinity as Spectacle'.
6. Ibid., p. 13.
7. Mulvey, 'Visual Pleasure and Narrative Cinema'.
8. Freud, *A Case of Hysteria,* pp. 192–3.
9. Foucault, *Discipline and Punish.*
10. Ibid., p. 242.
11. Mulvey, 'Visual Pleasure and Narrative Cinema'. She later modified her views in L. Mulvey, 'Afterthoughts on Visual Pleasure and Narrative Cinema', in A. Easthope (ed.) *Contemporary Film Theory* (London: Longman, 1993) pp. 125–34.
12. Mulvey, 'Visual Pleasure and Narrative Cinema'.
13. Foucault, *Discipline and Punish.*
14. Foucault, *Power/Knowledge,* p. 155.
15. Tasker, 'Dumb Movies for Dumb People', p. 230.
16. Easthope, *What a Man's Gotta Do,* p. 53.
17. Neale, 'Masculinity as Spectacle', p. 19.
18. Rafter, *Shots in the Mirror,* p. 123.
19. Foucault, *Discipline and Punish,* p. 249.
20. Kristeva, *Powers of Horror,* p. 4.
21. Ibid., p. 2.
22. Dyer, *The Matter of Images,* p. 91.

Part 3. Therapy as Surveillance: Spaces of Care

1. S. Kaysen, , *Girl, Interrupted* (London: Virago Press, 2000)
2. Foucault, *Discipline and Punish,* p. 144.
3. J. Jacobs, *Body Trauma TV: The New Hospital Dramas* (London: BFI Publishing, 2003) p. 1.
4. For further information see S. Boseley, 'Surgery Scandal: Small Children Kept Dying ... but the Doctors Just Carried On', *Guardian,* Manchester (UK), 30 May 1998, p. 004; and I. Herbert, 'Parents of Stillborn Upset over Foetus Store', *Independent,* London (UK), 14 November 2000, p. 12.

7. On the Edge: *Girl, Interrupted*

1. Kristeva, *Powers of Horror,* pp. 7, 46–50.
2. J. Moran and L. Topp, 'Interpreting Psychiatric Spaces', in L. Topp, J. Moran and J. Andrews (eds) *Madness, Architecture and the Built Environment: Psychiatric Spaces in Historical Context* (London: Routledge, 2007) p. 1.
3. A. Bartlett, 'Spatial Order and Psychiatric Disorder', in M. Parker Pearson and C. Richards (eds) *Architecture and Order: Approaches to Social Space* (London:

Routledge, 1997) p. 179.

4. K. Davies, "'A Small Corner That's for Myself'": Space, Place and Patients' Experiences of Mental Health Care, 1948–98', in L. Topp, J. Moran and J. Andrews (eds) *Madness, Architecture and the Built Environment: Psychiatric Spaces in Historical Context* (London: Routledge, 2007) p. 316.

5. S. Kaysen, *Girl, Interrupted* (London: Virago Press, 2000) p. 54.

6. Foucault, *Discipline and Punish*, p. 149.

7. Goffman, *Asylums*, pp. 204–20.

8. Bartlett, 'Spatial Order and Psychiatric Disorder', p. 191.

9. Ibid., p. 191.

10. Freud, *An Infantile Neurosis and Other Works*, p. 45.

11. Kristeva, *Powers of Horror*, p. 47.

12. Ibid., p. 49.

13. Kaysen, *Girl, Interrupted*, p. 152.

14. Kristeva, *Powers of Horror*, p. 7.

15. Ibid., p. 47.

16. Goffman, *Asylums*, p. 219.

17. Freud, *The Ego and the Id and Other Works*, p. 25.

18. Žižek, *The Pervert's Guide to Cinema*.

19. J. Mangold, L. Loomer and A. Phelan, *Girl, Interrupted Screenplay* (New York: Faber & Faber, 2000) p. xvi.

20. L. Frank Baum, *The Patchwork Girl of Oz* (Chicago: The Reilly & Britton Company, 1913).

21. Kristeva, *Powers of Horror*, p. 4.

22. Freud, *The Ego and the Id and Other Works*, p. 34.

23. Bartlett, 'Spatial Order and Psychiatric Disorder', p. 188.

24. Ibid., pp. 188–9.

25. Kristeva, *Powers of Horror*, p. 108.

26. Ibid.

27. Ibid.

28. S. Freud, *The Standard Edition of the Complete Psychological Works: Totem and Taboo and Other Works*, vol. 13, translated by J. Strachey (London: Hogarth Press, 1958) p. 103.

29. Ibid., pp. 130–1.

30. Freud, *A Case of Hysteria, Three Essays on Sexuality and Other Works*, p. 186.

31. Ibid.

32. Ibid.

33. Kristeva, *Powers of Horror*, p. 71.

34. Kaysen, *Girl, Interrupted*, p. 153.

35. Ibid., p. 122.

8. Maintaining Life: *Coma*

1. Kristeva, *Powers of Horror*, p. 4.

2. The film generated headlines like 'The Crown Prince of Horror' (*Daily Mail*, 15 November 1978), 'Horrors in the Hospital' (*Observer*, 12 November 1978) and 'All Change for the Hospital Horrors' (*Morning Star*, 10 November 1978).

3. For further discussion on aspects of realism in *ER*, see J. Cassidy and D. Taylor, 'Doctor, Doctor, Where Can I Get an Aspirin?' *Guardian*, Manchester (UK), 12 December 1997, p. T.006.

4. E. Cowie, 'A Discussion of *Coma*', in C. Brunsdon (ed.) *Films for Women* (London: BFI Publishing, 1986) pp. 155–65; E. Cowie, *Representing the Woman: Cinema and Psychoanalysis* (Basingstoke: Macmillan Press Limited, 1997); C. Geraghty, 'Three Women's Films', in C. Brunsdon (ed.) *Films for Women* (London: BFI Publishing, 1986) pp. 138–45; C. Gledhill, 'Pleasurable Negotiations', in D. Pribam (ed.) *Female Spectators: Looking at Film and Television* (London: Verso, 1988) pp. 64–89.

5. D. Gastaldo and D. Holmes, 'Foucault and Nursing: A History of the Present', *Nursing Inquiry*, vol. 6, 1999, pp. 231–40.

6. Foucault, *Discipline and Punish*, p. 144.

7. M. Crichton, *A Case of Need* (New York: Dutton, 1993).

8. Kristeva, *Powers of Horror*, p. 54.

9. Creed (*The Monstrous-Feminine*), referring to a range of horror films that includes *The Demon Seed* (1977), *Xtro* (1982), *The Incubus* (1982) and *The Brood* (1979), also links birth to horror, disgust and fear.

10. Ibid., p. 49.

11. Kristeva, *Powers of Horror*, p. 3.

12. Ibid., p. 53.

13. Ibid., p. 3.

14. Ibid., p. 13.

15. Creed, '*Alien* and the Monstrous-Feminine'.

16. R. Blank, 'Technology and Death Policy: Redefining Death', *Mortality*, vol. 6, no. 2, 2001, pp. 191–202; M. Lock, 'Inventing a New Death and Making it Believable', *Anthropology and Medicine*, vol. 9, no. 2, 2002, pp. 97–115; L. Sharp, 'Bodies, Boundaries, and Territorial Disputes: Investigating the Murky Realm of Scientific Authority', *Medical Anthropology*, vol. 21, 2002, pp. 369–79; P. Singer, *Rethinking Life and Death: The Collapse of our Traditional Ethics* (Oxford: Oxford University Press, 1995).

17. Lock, 'Inventing a New Death and Making it Believable', p. 99.

18. Foucault, *Discipline and Punish*.

19. Kristeva, *Powers of Horror*, p. 4.

20. Sharp, 'Bodies, Boundaries, and Territorial Disputes', p. 370.

21. Kristeva, *Powers of Horror*, p. 15.

22. Ibid.

23. C. Seale, *Constructing Death: The Sociology of Dying and Bereavement* (Cambridge: Cambridge University Press, 1998) p. 75.

24. Ibid., p. 78.

25. Ibid., p. 81.
26. Ibid., p. 80.
27. J. Hallam, *Nursing the Image: Media, Culture and Professional Identity* (London: Routledge, 2000) p. 136.
28. Ibid., p. 139.
29. R. Pringle, *Sex and Medicine: Gender, Power and Authority in the Medical Profession* (Cambridge: Cambridge University Press, 1998) p. 4.
30. Highlighted by U. Fasting, J. Christenson and S. Glending, 'Children Sold for Transplants: Medical and Legal Aspects', *Nursing Ethics*, vol. 5, no. 6, 1998, pp. 518–26; Sharp, 'Bodies, Boundaries, and Territorial Disputes'; and G. Whyte, 'Ethical Aspects of Blood and Organ Donation', *International Medicine Journal*, vol. 33, 2003, pp. 362–64.
31. N. Scheper-Hughes, 'Commodity Fetishism in Organs Trafficking', *Body and Society*, vol. 7, nos 2–3, 2001, pp. 31–62.

9. Confronting Death: *Bubba Ho-tep*

1. Foucault, *Discipline and Punish*.
2. Sibley, 'Outsiders in Society and Space', p. 144.
3. Kristeva, *Revolution in Poetic Language*, p. 26.
4. Grosz, *Volatile Bodies*, p. 206.
5. L. Williams, 'The Inside-out of Masculinity: David Cronenberg's Visceral Pleasures', in M. Aaron (ed.) *The Body's Perilous Pleasures: Dangerous Desires and Contemporary Culture* (Edinburgh: Edinburgh University Press, 1999) p. 37.
6. Freud, *A Case of Hysteria, Three Essays on Sexuality and Other Works*, pp. 183–91.
7. Ibid., p. 184.
8. Kristeva, *Powers of Horror*.
9. K. Covinsky, C. Eng, L. Lui, L. Sands and K. Yaffe, 'The Last Two Years of Life: Functional Trajectories of Frail Older People', *Journal of the American Geriatrics Society*, vol. 51, no. 4, 2003, pp. 492–8.
10. S. Williams and G. Bendelow, *The Lived Body: Sociological Themes, Embodied Issues* (London: Routledge, 1998) p. 183.
11. Ibid.
12. Elias, *The Civilising Process*, p. 160.
13. Ibid.
14. Freud, *A Case of Hysteria, Three Essays on Sexuality and Other Works*.
15. Kristeva, *Powers of Horror*, p. 109.
16. Ibid., p. 13.
17. Ibid., p. 4.
18. Ibid., p. 4.
19. Ibid., p. 13.
20. J. Drageset, 'The Importance of Activities of Daily Living and Social Contact for Loneliness: A Survey among Residents in Nursing Homes', *The Scandinavian Journal of Caring Science*, vol. 18, 2004, p. 66.

Conclusion

1. *Remember the Titans* had grossed $115,648,585 by March 2001 against a budget of $30,000,000. See Anon, *Remember the Titans* <http://uk.imdb.com/title/tt0210945/business> (IMDb, n.d., cited 6 February 2008).

2. T. Krzywinska, 'Cicciolina and the Dynamics of Transgression and Abjection in Explicit Sex Films', in M. Aaron (ed.) *The Body's Perilous Pleasures: Dangerous Desires and Contemporary Culture* (Edinburgh: Edinburgh University Press, 1999) pp. 188–209.

3. Kristeva, *Powers of Horror*, p. 8.

4. Grosz, *Volatile Bodies*.

5. Foucault, *Discipline and Punish*.

6. Barham, *Closing the Asylum: The Mental Patient in Modern Society* (London: Penguin Books, 1992) p. 21.

7. For further information refer to Z. Bauman, 'Social Issues of Law and Order', *British Journal of Criminology*, vol. 40, 2000, pp. 205–21; J. Braithwaite, 'The New Regulatory State and the Transformation of Criminology', *British Journal of Criminology*, vol. 40, 2000, pp. 222–38; Garland, *Punishment and Modern Society*; P. Hirst, 'Statism, Pluralism and Social Control', *British Journal of Criminology*, vol. 40, 2000, pp. 279–95; M. Mauer, 'Crime, Politics, and Community Since the 1990s', in D. Sabo, T. Kupers and W. London (eds) *Prison Masculinities* (Philadelphia: Temple University Press, 2001) pp. 46–9; N. Rose, 'Government and Control', *British Journal of Criminology*, vol. 40, 2000, pp. 321–39; D. Sabo, T. Kupers and W. London, 'Gender and the Politics of Punishment', in D. Sabo, T. Kupers and W. London (eds) *Prison Masculinities* (Philadelphia: Temple University Press, 2001) pp. 3–18.

7. Wilson and O'Sullivan, *Images of Incarceration*, p. 167.

Filmography

A Beautiful Mind (2001) Director Ron Howard. USA.

Alien (1979) Director Ridley Scott. UK/USA.

Awakenings (1990) Director Penny Marshall. USA.

The Birds (1963) Director Alfred Hitchcock. USA.

Bubba Ho-tep (2002) Director Don Coscarelli. USA.

Carrie (1976) Director Brian De Palma. USA.

Coma (1978) Director Michael Crichton. USA.

Commando (1985) Director Mark Lester. USA.

Crash (2004) Director Paul Haggis. USA.

Die Hard (1988) Director John McTiernan. USA.

The Doctor (1991) Director Randa Haines. USA.

ER (1994–2009) [TV] Created by Michael Crichton. USA.

Escape from Alcatraz (1979) Director Don Siegel. USA.

The Exorcist (1973) Director William Friedkin. USA.

Fortress (1993) Director Stuart Gordon. Australia/USA.

Frankenstein (1931) Director James Whale. USA

Full Metal Jacket (1987) Director Stanley Kubrick. UK/USA.

Gilda (1946) Director Charles Vidor. USA.

Girl, Interrupted (1999) Director James Mangold. Germany/USA.

The Green Mile (1999) Director Frank Darabont. USA.

Indiana Jones and the Temple of Doom (1984) Director Steven Spielberg. USA.

In the Name of the Father (1993) Director Jim Sheridan. Ireland/UK.

L.A. Confidential (1997) Director Curtis Hanson. USA.

The Last Castle (2001) Director Rod Lurie. USA.

Lock Up (1989) Director John Flynn. USA.

Look Who's Talking (1989) Director Amy Heckerling. USA.

Lorenzo's Oil (1992) Director George Miller. USA.

Minority Report (2002) Director Steven Spielberg. USA.

Misery (1990) Director Rob Reiner. USA.

One Flew Over the Cuckoo's Nest (1975) Director Milos Forman. USA.

Papillon (1973) Director Franklin Schaffner. USA.

The Pickanninies (1894) Director Thomas Edison. USA.

Predator (1987) Director John McTiernan. USA.

Presumed Innocent (1990) Director Alan Pakula. USA.

Psycho (1960) Director Alfred Hitchcock. USA.

Rambo (1982) Director Ted Kotcheff. USA.

Regarding Henry (1991) Director Mike Nichols. USA.

Remember the Titans (2000) Director Boaz Yakin. USA.

Rocky (1976) Director John Avildsen. USA.

Rosemary's Baby (1968) Director Roman Polanski. USA.

Shallow Grave (1994) Director Danny Boyle. UK.

The Shawshank Redemption (1994) Director Frank Darabont. USA.

The Shining (1980) Director Stanley Kubrick. UK/USA.

The Silence of the Lambs (1991) Director Jonathan Demme. USA.

Taxi Driver (1976) Director Martin Scorsese. USA.

The Wizard of Oz (1939) Director Victor Fleming. USA.

Three Men and a Baby (1987) Director Leonard Nimoy. USA.

The Virgin Suicides (1999) Director Sofia Coppola. USA.

Bibliography

Ahmed, S. (2005) 'The Skin of the Community: Affect and Boundary Formation', in T. Chanter and E. Ziarek (eds) *Revolt, Affect, Collectivity: the Unstable Boundaries of Kristeva's Polis* (N ew York: State University of New York Press)

Anon. (2000) 'The Failure of Community Care', *Evening Standard*, London (UK), 19 December, p. 13

Anon. (n.d.) *Carrie* <http://uk.imdb.com/title/tt0074285/> (IMDb, cited 30 December 2007)

___ *Remember the Titans* http://uk.imdb.com/title/tt0210945/business (IMDb, cited 6 February 2008)

___ *The Shawshank Redemption* <http://uk.imdb.com/chart/top?tt0111161> (IMDb, cited 20 September 2007)

Babington, B. (1983) 'Twice a Victim: Carrie meets the BFI', *Screen*, vol. 24, no. 3, May–June, pp. 4–18

Bakhtin, M. (1984) *Rabelais and His World*, translated by H. Iswolsky (Bloomington: Indiana University Press)

Barcan, R. (2005) 'Dirty Spaces: Communication and Contamination in Men's Public Toilets', *Journal of International Women's Studies*, vol. 6, no. 2, pp. 7–23

Barham, P. (1992) *Closing the Asylum: The Mental Patient in Modern Society* (London: Penguin Books)

Bartlett, A. (1997) 'Spatial Order and Psychiatric Disorder', in M. Parker Pearson and C. Richards (eds) *Architecture and Order: Approaches to Social Space* (London: Routledge) pp. 178–95

Baum, L. Frank (1913) *The Patchwork Girl of Oz* (Chicago: Reilly & Britton Company)

Bauman, Z. (2000) 'Social Issues of Law and Order', *British Journal of Criminology*, vol. 40, pp. 205–21

Berenstein, R. (1996) 'It Will Thrill You, It May Shock You, It Might Even Horrify You: Gender, Reception and the Classic Horror Cinema', in B. Grant (ed.) *The Dread of Difference: Gender and the Horror Film* (Austin: University of Texas Press) pp. 117–42

Bergner, G. (1999) 'Politics and Pathologies: On the Subject of Race in Psychoanalysis', in A. Alessandrini (ed.) *Frantz Fanon: Critical Perspectives* (New York: Routledge, pp. 219–34

Best, A. (2000) *Prom Night: Youth, Schools, and Popular Culture* (London: Routledge)

Blank, R. (2001) 'Technology and Death Policy: Redefining Death', *Mortality*, vol. 6, no. 2, pp. 191–202

Bogle, D. (1994) *Toms, Coons, Mulattoes, Mammies and Bucks: An Interpretive History of Blacks in American Films* (Oxford: Roundhouse)

Boon, T. (2005) 'Health Education Films in Britain, 1919–39: Production, Genres and Audiences', in G. Harper and A. Moor (eds) *Signs of Life: Medicine and Cinema* (London: Wallflower Press) pp. 45–57

Boseley, S. (1998) 'Surgery Scandal: Small Children Kept Dying ... but the Doctors Just Carried On', *Guardian*, Manchester (UK), 30 May, p. 004

Braithwaite, J. (2000) 'The New Regulatory State and the Transformation of Criminology', *British Journal of Criminology*, vol. 40, pp. 222–38

Brandell, J. (ed.) (2004) *Celluloid Couches, Cinematic Clients: Psychoanalysis and Psychotherapy in the Movies* (New York: State University of New York Press)

Brien, A. (1978) 'Infirmary Blues', *Sunday Times*, London (UK), 12 November. Available from BFI National Library cuttings collection, London

Burstyn, V. (1999) *The Rites of Men: Manhood, Politics and the Culture of Sport* (Toronto: University of Toronto Press)

Cassidy, J. and D. Taylor (1997) 'Doctor, Doctor, Where Can I Get an Aspirin?' *Guardian*, Manchester (UK), 12 December, p. T.006

Castle, R. and S. Donatelli (1998) 'Kubrick's Ulterior War', *Film Comment*, vol. 34, no. 5, pp. 24–8

Chanter, T. (2008) *The Picture of Abjection: Film, Fetish, and the Nature of Difference* (Bloomington: Indiana University Press)

Cheatwood, D. (1998) 'Prison Movies: Films about Adult, Male, Civilian Prisons: 1929–1995', in F. Bailey and D. Hale (eds) *Popular Culture, Crime and Justice* (London: Wadsworth Publishing) pp. 209–30

Clemens, V. (1999) *The Return of the Repressed: Gothic Horror from the Castle of Otranto to Alien* (Albany: State University of New York Press)

Clément, C. and J. Kristeva (2001) *The Feminine and the Sacred* (New York: Columbia University Press

Clover, C. (1993) *Men, Women and Chainsaws: Gender in the Modern Horror Film* (London: BFI Publishing)

Combs, R. (1977) 'Carrie', *Monthly Film Bulletin*, January, pp. 3–4

Covinsky, K., C. Eng, L. Lui, L. Sands and K. Yaffe (2003) 'The Last Two Years of Life: Functional Trajectories of Frail Older People', *Journal of the American Geriatrics Society*, vol. 51, no. 4, pp. 492–8

Cowie, E. (1986) 'A Discussion of *Coma*', in C. Brunsdon (ed.) *Films for Women* (London: BFI Publishing) pp. 155–65

____ (1997) *Representing the Woman: Cinema and Psychoanalysis* (Basingstoke: Macmillan Press Limited)

Crang, M. and N. Thrift (eds) (2000) *Thinking Space* (London: Routledge)

Creed, B. (1990) '*Alien* and the Monstrous-Feminine', in A. Kuhn (ed.) *Alien Zone: Cultural Theory and Contemporary Science Fiction Cinema* (London: Verso) pp. 128–41

____ (1993b) *The Monstrous-Feminine: Film, Feminism, Psychoanalysis* (London: Routledge)

INDEX

___ (2002) 'Horror and the Monstrous-Feminine: An Imaginary Abjection', in M. Jancovich (ed.) *Horror, the Film Reader* (London: Routledge) pp. 67–76

Crichton, M. (1993) *A Case of Need* (New York: Dutton)

Davies, K. (2007) '"A Small Corner That's for Myself": Space, Place and Patients' Experiences of Mental Health Care, 1948–98', in L. Topp, J. Moran and J. Andrews (eds) *Madness, Architecture and the Built Environment: Psychiatric Spaces in Historical Context* (London: Routledge) pp. 305–20

Deleuze, G. (1989) 'Coldness and Cruelty', in G. Deleuze and L. von Sacher-Masoch, *Masochism* (New York: Zone Books) pp. 15–134

Dignam, V. (1978) 'All Change for the Hospital Horrors', *Morning Star*, London (UK), 10 November. Available from BFI National Library cuttings collection, London

Douglas, M. (2002) *Purity and Danger* (London: Routledge)

Drageset, J. (2004) 'The Importance of Activities of Daily Living and Social Contact for Loneliness: A Survey among Residents in Nursing Homes', *The Scandinavian Journal of Caring Science*, vol. 18, pp. 65–71

Duncan, M. (1996) *Romantic Outlaws, Beloved Prisons: The Unconscious Meanings of Crime and Punishment* (New York: New York University Press)

Dyer, R. (1992) *Only Entertainment* (London: Routledge)

___ (2002) *The Matter of Images: Essays on Representation* (London: Routledge)

Easthope, A. (1992) *What a Man's Gotta Do: The Masculine Myth in Popular Culture* (London: Routledge)

Eberwein, R. (2001) 'As a Mother Cuddles a Child: Sexuality and Masculinity in World War II Combat Films', in P. Lehman (ed.) *Masculinity: Bodies, Movies, Culture* (London: Routledge) pp. 149–66

Ehlers L. (1981) 'Carrie: Book and Film', *Literature Film Quarterly*, vol. 9, no. 1, pp. 32–9

Elias, N. (2000) *The Civilising Process* (Oxford: Blackwell)

Fasting, U., J. Christenson and S. Glending (1998) 'Children Sold for Transplants: Medical and Legal Aspects', *Nursing Ethics*, vol. 5, no. 6, pp. 518–26

Fiddler, M. (2007) 'Projecting the Prison: The Depiction of the Uncanny in *The Shawshank Redemption*', *Crime Media Culture*, vol. 3, pp. 192–206

Fleming, M. and R. Manvell (1987) 'Through a Lens Darkly', *Psychology Today*, vol. 21, pp. 26–8

Foster, T. (1982) 'Mushfaking: A Compensatory Behaviour of Prisoners', *The Journal of Social Psychology*, vol. 117, pp. 115–24

Foucault, M. (1980) *Power/Knowledge* (London: Longman)

___ (1986) 'Of Other Spaces', *Diacritics*, vol. 16, pp. 22–7

___ (1991) *Discipline and Punish: The Birth of the Prison* (Hamondsworth: Penguin)

___ (1998) *The History of Sexuality: Volume I* (Harmondsworth: Penguin Books)

___ (2001) *Madness and Civilization* (London: Routledge)

___ (2003) *The Birth of the Clinic* (London: Routledge)

Freud, S. (1953) *The Standard Edition of the Complete Psychological Works: A Case of*

Hysteria, Three Essays on Sexuality and Other Works, vol. 7, translated by J. Strachey (London: Hogarth Press)

___ (1955b) *The Standard Edition of the Complete Psychological Works: An Infantile Neurosis and Other Works*, vol. 17, translated by J. Strachey (London: Hogarth Press)

___ (1958c), *The Standard Edition of the Complete Psychological Works: Totem and Taboo and Other Works*, vol. 13, translated by J. Strachey (London: Hogarth Press)

___ (1961) *The Standard Edition of the Complete Psychological Works: The Ego and the Id and Other Works*, vol. 19, translated by J. Strachey (London: Hogarth Press)

___ (2004) *Civilization and its Discontents* (Harmondsworth: Penguin Books)

Garland, D. (1991) *Punishment and Modern Society* (Oxford: Clarendon Press)

Gastaldo, D. and Holmes, D. (1999) 'Foucault and Nursing: A History of the Present', *Nursing Inquiry*, vol. 6, pp. 231–40

Gear, S. (2005) 'Rules of Engagement: Structuring Sex and Damage in Men's Prisons and Beyond', *Culture, Health and Sexuality*, vol. 7, no. 3, pp. 195–208

Geraghty, C. (1986) 'Three Women's Films', in C. Brunsdon (ed.) *Films for Women* (London: BFI Publishing) pp. 138–45

Glass, L. (2001) 'After the Phallus', *American Imago*, vol. 58, no. 2, pp. 545–66

Gledhill, C. (1988) 'Pleasurable Negotiations', in D. Pribam (ed.) *Female Spectators: Looking at Film and Television* (London: Verso) pp. 64–89

Goffman, E. (1991) *Asylums: Essays on the Social Situation of Mental Patients and Other Inmates* (Harmondsworth: Penguin Books)

Graves, D. (2002) 'World Waits on Beckham's Broken Bone. From No 10 to the Pub Pundit, from Leading Surgeons to Big Business, Everybody has an Opinion about the England Captain's Foot', *Daily Telegraph*, London (UK), 12 April, p. 4

Greenspun, R. (1977) 'Carrie, and Sally and Leatherface among the Film Buffs', *Film Comment*, January–February, pp. 14–17

Grosz, E. (1994) *Volatile Bodies: Towards a Corporeal Feminism* (Bloomington: Indiana University Press)

Halford, S. and P. Leonard (2003) 'Space and Place in the Construction and Performance of Gendered Nursing Identities', *Journal of Advanced Nursing*, vol. 42, no. 2, pp. 201–8

___ (2006) 'Place, Space and Time: Contextualizing Workplace Subjectivities', *Organization Studies*, vol. 27, no. 5, pp. 657–76

Hall, S. (1997) (ed.) *Representation: Cultural Representations and Signifying Practices* (Milton Keynes: Open University Press)

Hallam, J. (2000) *Nursing the Image: Media, Culture and Professional Identity* (London: Routledge)

Hasford, G. (1985) *The Short Timers* (London: Bantam Publishing)

Hay, J. (2002) 'Rethinking the Intersection of Cinema, Genre and Youth', *Scope: An Online Journal of Film and Television Studies*, June, pp. 1–17 <http://www.nottingham.ac.uk/film/journal/articles/cinema-genre-youth.htm> cited 13 June 2003

Herbert, I. (2000) 'Parents of Stillborn Upset over Foetus Store', *Independent*, London (UK), 14 November, p. 12

Hirst, P. (2000) 'Statism, Pluralism and Social Control', *British Journal of Criminology*, vol. 40, pp. 279–95

Holmes, D. (2001) 'From Iron Gaze to Nursing Care: Mental Health Nursing in the Era of Panopticism', *Journal of Psychiatric and Mental Health Nursing*, vol. 8, pp. 7–15

Holmlund, C. (1993) 'Masculinity as Multiple Masquerade: The "Mature" Stallone and the Stallone Clone', in S. Cohan and I. Hark (eds) *Screening the Male: Exploring Masculinities in Hollywood Cinema* (London: Routledge) pp. 213–29

Hook, D. (2004) 'Racism as Abjection: A Psychoanalytic Conceptualization for a Post-Apartheid South Africa', *South African Journal of Psychology*, vol. 34, no. 4, pp. 672–703

Hutchings, P. (2004) *The Horror Film* (London: Pearson Longman)

Irigaray, L. (1985) *Speculum of the Other Woman*, translated by G. Gill (Ithaca: Cornell University Press)

Jacobs, J. (2003) *Body Trauma TV: The New Hospital Dramas* (London: BFI Publishing)

Jarvis, B. (2004) *Cruel and Unusual: Punishment and US Culture* (London: Pluto Press)

Jeffords, S. (1989) *The Remasculinization of America: Gender and the Vietnam War* (Bloomington: Indiana University Press)

___ (1994) *Hard Bodies: Hollywood Masculinity in the Reagan Era* ((New Brunswick: Rutgers University Press)

Jewkes, Y. (2002) *Captive Audience: Media, Masculinity and Power in Prisons* (Oregon: Willan Publishing)

Jonte-Pace, D. (1992) 'Situating Kristeva Differently: Psychoanalytic Readings of Woman and Religion', in D. Crownfield (ed.) *Body/Text in Julia Kristeva* (New York: State University of New York Press) pp. 1–22

Kaysen, S. (2000) *Girl, Interrupted* (London: Virago Press)

Kermode, M. (2003) *The Shawshank Redemption* (London: BFI Publishing)

___ (2004) *Shawshank: The Redeeming Feature*, DVD directed by Andrew Abbott and presented by Mark Kermode (USA: A Nobles Gate Scotland Production available as commercially published DVD from Warner Home Video)

King, S. (1982) *Rita Hayworth and Shawshank Redemption* (London: Time Warner)

Kirkham, P. and J. Thumim (eds) (1993) *You Tarzan: Masculinity, Movies and Men* (London: Lawrence & Wishart)

Knight, C. (1995) *Blood Relations: Menstruation and the Origins of Culture* (New Haven: Yale University Press)

Kristeva, J. (1980) *Desire in Language: A Semiotic Approach to Literature and Art*, edited by L. Roudiez and translated by T. Gora, A. Jardine and L. Roudiez (New York: Columbia University Press)

___ (1982) *Powers of Horror: An Essay on Abjection*, translated by L. Roudiez (New York: Columbia University Press)

___ (1984) *Revolution in Poetic Language*, translated by M. Waller (New York: Columbia University Press)

___ (1986) 'Stabat Mater', in T. Moi (ed.) *The Kristeva Reader* (Oxford: Basil Blackwell) pp. 160–86

___ (1991) *Strangers to Ourselves*, translated by L. Roudiez (New York: Columbia University Press)

___ (1993) *Nations without Nationalism*, translated by L. Roudiez (New York: Columbia University Press)

___ (2001) 'Reading the Bible', in D. Jobling, T. Pippin and R. Schleifer (eds) *The Postmodern Bible Reader* (Oxford: Blackwell Publishing) pp. 92–101

Krzywinska, T. (1999) 'Cicciolina and the Dynamics of Transgression and Abjection in Explicit Sex Films', in M. Aaron (ed.) *The Body's Perilous Pleasures: Dangerous Desires and Contemporary Culture* (Edinburgh: Edinburgh University Press) pp. 188–209

Kuhn, A. (1999) 'Classic Hollywood Narrative', in P. Cook and M. Bernink (eds) *The Cinema Book* (London: BFI Publishing) pp. 39–42

Kupers, T. (2001) 'Rape and the Prison Code', in D. Sabo, T. Kupers and W. London (eds) *Prison Masculinities* (Philadelphia: Temple University Press) pp. 111–17

Lacan, J. (1993) 'The Mirror Stage', in A. Easthope (ed.) *Contemporary Film Theory* (London: Longman) pp. 33–9

Lock, M. (2002) 'Inventing a New Death and Making it Believable', *Anthropology and Medicine*, vol. 9, no. 2, pp. 97–115

Longhurst, R. (2001) *Bodies: Exploring Fluid Boundaries* (London: Routledge)

McCorkel, J. (2003) 'Embodied Surveillance and the Gendering of Punishment', *Journal of Contemporary Ethnography*, vol. 32, no. 1, pp. 41–76

MacKinnon, K. (1990) *Misogyny in the Movies: The De Palma Question* (London: Associated University Presses)

Man, C. and J. Cronan (2001) 'Forecasting Sexual Abuse in Prison: The Prison Subculture of Masculinity as a Backdrop for "Deliberate Indifference"', *Journal of Criminal Law and Criminology*, vol. 59, pp. 127–81

Mangold, J., L., Loomer and A. Phelan (2000) *Girl, Interrupted Screenplay* (New York: Faber & Faber)

Mason, P. (ed.) (2003) *Criminal Visions: Media Representations of Crime and Justice* (Abingdon: Willan Publishing)

___ (2003) 'The Screen Machine: Cinematic Representations of Prison', in P. Mason (ed.) *Criminal Visions: Media Representations of Crime and Justice* (Abingdon: Willan Publishing) pp. 278–97

___ (ed.) (2006) *Captured by the Media: Prison Discourse in Popular Culture* (Abingdoon: Willan Publishing)

___ (2006) 'Locating Hollywood's Prison Film Discourse', in P. Mason (ed.) *Captured by the Media: Prison Discourse in Popular Culture* (Taunton: Willan Publishing) pp. 191–209

Matthews, R. (1999) *Doing Time: An Introduction to the Sociology of Imprisonment* (London: Macmillan)

Matusa, P. (1977) 'Corruption and Catastrophe in DePalma's *Carrie*', *Film Quarterly*, vol. 31, no. 1, pp. 32–8

Mauer, M. (2001) 'Crime, Politics, and Community Since the 1990s', in D. Sabo, T. Kupers and W. London (eds) *Prison Masculinities* (Philadelphia: Temple University Press) pp. 46–9

Mayne, J. (2000) *Framed: Lesbians, Feminists, and Media Culture* (Minneapolis: University of Minnesota Press)

Messerschmidt, J. (2001) 'Masculinities, Crime, and Prison', in D. Sabo, T. Kupers and W. London (eds) *Prison Masculinities* (Philadelphia: Temple University Press) pp. 67–72

Miller, V. (2007) 'Tough Men, Tough Prisons, Tough Times', in M. Bosworth and J. Flavin (eds) *Race, Gender and Punishment: From Colonialism to the War on Terror* (New Brunswick: Rutgers University Press) pp. 200–15

Modleski, T. (2000) 'The Terror of Pleasure', in K. Gelder (ed.) *The Horror Reader* (London: Routledge) pp. 285–93

Moran, J. and L. Topp (2007) 'Interpreting Psychiatric Spaces', in L. Topp, J. Moran and J. Andrews (eds) *Madness, Architecture and the Built Environment: Psychiatric Spaces in Historical Context* (London: Routledge) pp. 1–16

Moruzzi, N. (1993) 'National Abjects', in K. Oliver (ed.) *Ethics, Politics and Difference in Julia Kristeva's Writing* (London: Routledge) pp. 135–49

Mulvey, L. (1975) 'Visual Pleasure and Narrative Cinema', *Screen*, vol. 16, no. 3, pp. 6–18

—— (1993) 'Afterthoughts on Visual Pleasure and Narrative Cinema', in A. Easthope (ed.) *Contemporary Film Theory* (London: Longman) pp. 125–34

—— (1996) *Fetishism and Curiosity* (Bloomington and Indianapolis: Indiana University Press and BFI Publishing)

Naremore, J. (2007) *On Kubrick* (London: BFI Publishing)

Nead, L. (1992) *The Female Nude: Art, Obscenity and Sexuality* (London: Routledge)

Neale, S. (1993) 'Masculinity as Spectacle', in S. Cohan and I. Hark (eds) *Screening the Male: Exploring Masculinities in Hollywood Cinema* (London: Routledge) pp. 9–20

—— (2000) *Genre and Hollywood* (London: Routledge)

Nellis, M. and C. Hale (eds) (1982) *The Prison Film* (London: Radical Alternatives to Prison)

Newsinger, J. (1993) 'Do You Walk the Walk? Aspects of Masculinity in Some Vietnam War Films', in P. Kirkham and J. Thumim (eds) *You Tarzan: Masculinities, Movies and Men* (London: Lawrence and Wishart) pp. 126–36

Oliver, K. (1993) *Reading Kristeva: Unraveling the Double-bind* (Indianapolis: Indiana University Press)

Oliver, K. and B. Trigo (2003) *Noir Anxiety* (Minneapolis: University of Minnesota Press)

O'Sullivan, S. (2003) 'Representing 'the Killing State': The Death Penalty in Nineties Hollywood Cinema', *The Howard Journal*, vol. 42, no. 5, pp. 485–503

Palmer, W. (1993) *The Films of The Eighties: A Social History* (Carbondale: Southern Illinois University Press)

Parr, H. (1999) 'Bodies and Psychiatric Medicine: Interpreting Different Geographies of Mental Health', in R. Butler and H. Parr (eds) *Mind and Body Spaces: Geographies of Illness, Impairment and Disability* (London: Routledge) pp. 181–202

Paul, W. (1994) *Laughing Screaming: Modern Hollywood Horror and Comedy* (New York: Columbia University Press)

Pile, S. (1996) *The Body and the City: Psychoanalysis, Space and Subjectivity* (London: Routledge)

Pile, S. and N. Thrift (eds) (1995) *Mapping the Subject: Geographies of Cultural Transformation* (London: Routledge)

Pringle, R. (1998) *Sex and Medicine: Gender, Power and Authority in the Medical Profession* (Cambridge: Cambridge University Press)

Pye, M. and L. Myles (1979) *The Movie Brats: How the Film Generation Took Over Hollywood* (London: Faber & Faber)

Quart L. and A. Auster (2002) *American Film and Society Since 1945* (Westport, CT: Praeger Publishing)

Rafferty, T. (1987) 'Remote Control', *Sight and Sound*, vol. 56, no. 4, pp. 256–9

Rafter, N. (2000) *Shots in the Mirror: Crime Films and Society* (Oxford: Oxford University Press)

Rambuss, R. (1999) 'Machinehead: The Technology of Killing in Stanley Kubrick's *Full Metal Jacket*, *Camera Obscura*, vol. 14, no. 42, pp. 97–114

Rose, G. (1993) *Feminism and Geography: The Limits of Geographical Knowledge* (Minneapolis: University of Minnesota Press)

Rose, N. (2000) 'Government and Control', *British Journal of Criminology*, vol. 40, pp. 321–39

Sabo, D. (2001) 'Doing Time, Doing Masculinity: Sports and Prison', in D. Sabo, T. Kupers and W. London (eds) *Prison Masculinities* (Philadelphia: Temple University Press) pp. 61–6

Sabo, D., T. Kupers and W. London (2001) 'Gender and the Politics of Punishment', in D. Sabo, T. Kupers and W. London (eds) *Prison Masculinities* (Philadelphia: Temple University Press) pp. 3–18

Scheper-Hughes, N. (2001) 'Commodity Fetishism in Organs Trafficking', *Body and Society*, vol. 7, nos 2–3, pp. 31–62

____ (2002) 'The Ends of the Body: Commodity Fetishism and the Global Traffic in Organs', *SAIS Review*, vol. 22, no. 1, pp. 61–80

Schweitzer, R. (1990) 'Born to Kill: S. Kubrick's *Full Metal Jacket* as Historical Representation of America's Experience in Vietnam', *Film and History*, vol. 20, no. 3, pp. 62–70

Seale, C. (1998) *Constructing Death: The Sociology of Dying and Bereavement* (Cambridge: Cambridge University Press)

Sharp, L. (2002) 'Bodies, Boundaries, and Territorial Disputes: Investigating the Murky Realm of Scientific Authority', *Medical Anthropology*, vol. 21, pp. 369–79

Sibley, D. (1995) *Geographies of Exclusion: Society and Difference in the West* (London: Routledge)

____ (1999) 'Outsiders in Society and Space', in K. Anderson and F. Gale (eds) *Cultural Geographies* (Melbourne: Longman Cheshire) pp. 135–51

Silverman, K. (1993) 'Masochism and Male Subjectivity', in C. Penley and S. Willis (eds) *Male Trouble* (Minneapolis: University of Minnesota Press) pp. 330–64

Singer, P. (1995) *Rethinking Life and Death: The Collapse of our Traditional Ethics* (Oxford: Oxford University Press)

Smith, C. (1999) 'Finding a Warm Place for Someone We Know: The Cultural Appeal of Recent Mental Patient and Asylum Films', *Journal of Popular Film and Television*, vol. 27, no. 1, pp. 40–6

Smith, L. (2007) 'The Architecture of Confinement: Urban Public Asylums in England, 1750–1820', in L. Topp, J. Moran and J. Andrews (eds) *Madness, Architecture and the Built Environment: Psychiatric Spaces in Historical Context* (London: Routledge) pp. 41–62

Sobchack, V. (1996) 'Bringing it All Back Home: Family Economy and Generic Exchange', in B. Grant (ed.) *The Dread of Difference: Gender and the Horror Film* (Austin: University of Texas Press) pp. 143–63

Stallybrass, P. and A. White (1986) *The Politics and Poetics of Transgression* (London: Methuen)

Stamp Lindsey, S. (1996) 'Horror, Femininity, and Carrie's Monstrous Puberty', in B. Grant (ed.) *The Dread of Difference: Gender and the Horror Film* (Austin: University of Texas Press) pp. 279–95

Surette, R. (1998) *Media, Crime, and Criminal Justice: Images and Realities* (Belmont: Wadsworth Publishing Company)

Sykes, G. (2007) *The Society of Captives: A Study of a Maximum Security Prison* (Princeton: Princeton University Press)

Tasker, Y. (1993a) 'Dumb Movies for Dumb People', in S. Cohan and I. Hark (eds) *Screening the Male: Exploring Masculinities in Hollywood Cinema* (London: Routledge) pp. 230–44

____ (1993b) *Spectacular Bodies: Gender, Genre and the Action Cinema* (London: Routledge)

Useem B. and J. Goldstone (2002) 'Forging Social Order and its Breakdown: Riot and Reform in US Prisons', *American Sociological Review*, vol. 67, no. 4, pp. 499–525

Useem B. and P. Kimball (1991) *States of Siege: US Prison Riots 1971–1986* (New York: Oxford University Press)

Vidler, A. (1992) *The Architectural Uncanny: Essays in the Modern Unhomely* (Cambridge: The MIT Press)

Wahl, O. (1995) *Media Madness: Public Images of Mental Illness* (New Brunswick: Rutgers University Press)

Ward, D. and T. Werlich (2003) 'Alcatraz and Marion: Evaluating Super-Maximum Custody', *Punishment and Society*, vol. 5, no. 1, pp. 53–75

Weiss, G. (1999) 'The Abject Borders of the Body Image', in G. Weiss and H. F. Haber (eds) *Perspectives on Embodiment: The Intersections of Nature and Culture* (London: Routledge) pp. 41–59

White, S. (1991) 'Male Bonding, Hollywood Orientalism, and the Repression of the Feminine in Kubrick's *Full Metal Jacket*', in M. Anderegg (ed.) *Inventing Vietnam* (Philadelphia: Temple University Press) pp. 204–30

Whyte, G. (2003) 'Ethical Aspects of Blood and Organ Donation', *International Medicine Journal*, vol. 33, pp. 362–64

Willemen, P. (1981) 'Anthony Mann: Looking at the Male', *Framework*, nos 15–17, Summer, pp. 16–20

Williams, L. (1999) 'The Inside-out of Masculinity: David Cronenberg's Visceral Pleasures', in M. Aaron (ed.) *The Body's Perilous Pleasures: Dangerous Desires and Contemporary Culture* (Edinburgh: Edinburgh University Press) pp. 30–48

Williams, P. (2003) '"What a Bummer for the Gooks": Representations of White American Masculinity and the Vietnamese in the Vietnam War Film Genre 1977–87', *European* Journal *of American Culture (EJAC)*, vol. 22, no. 3, pp. 215–34

Williams, S. and G. Bendelow (1998) *The Lived Body: Sociological Themes, Embodied Issues* (London: Routledge)

Willoquet-Maricondi, P. (1994) 'Full-Metal-Jacketing, or Masculinity in the Making', *Cinema Journal*, vol. 33, no. 2, pp. 5–21

Wilson, D. and S. O'Sullivan (2004) *Images of Incarceration: Representations of Prison in Film and Television Drama* (Winchester: Waterside Press)

Wlodarz, J. (2001) 'Rape Fantasies: Hollywood and Homophobia', in P. Lehman (ed.) *Masculinity: Bodies, Movies, Culture* (London: Routledge) pp. 67–80

Wood, R. (1986) *Hollywood: From Vietnam to Reagan and Beyond* (New York: Columbia University Press)

Woolf, Lord Justice (1991) *Prison Disturbances April 1990* (London: HMSO)

Worland, R. (2007) *The Horror Film: An Introduction* (Oxford: Blackwell Publishing)

Wynter, Leon (2002) *American Skin: Pop Culture, Big Business and the End of White America* (New York: Crown Publishing)

Yarris, N. (2008a) *Life as a Death Row Inmate* (Wolverhampton: School of Legal Studies, University of Wolverhampton) 13 February

____ (2008b) *Life as a Death Row Inmate*, [email]. Message to Frances Pheasant-Kelly, 26 February [cited 26 February 2008]. Stored on Frances Pheasant-Kelly's home email system. Personal communication

Young, E. (1991) '*The Silence of the Lambs* and the Flaying of Feminist Theory', *Camera Obscura*, vol. 27, pp. 5–35

Young, I. M. (1990) 'Abjection and Oppression: Dynamics of Unconscious Racism, Sexism and Homophobia', in A. Dallery, C. Scott and H. Roberts (eds) *Crises in Continental Philosophy* (Albany: State University of New York Press)

Žižek, S. (2006) *The Pervert's Guide to Cinema*, DVD directed by Sophie Fiennes (UK/Austria/Netherlands: A Lone Star, Mischief Films, Amoeba Film Production). Presented by Slavoj Žižek. Available as commercially published DVD from www.pervertsguide.com

Note: All URLs were correct at the time of writing

Index

INDEX

INDEX

INDEX